Art of the *Electronic Age*

Art of the

Electronic Age

Frank Popper

Harry N. Abrams, Inc., Publishers

Title page
Rockne Krebs *The Green Hypotenuse* (1983)
A green line drawn into the vista of the L.A. Basin from the top of
Mount Wilson to the CalTech campus, one mile down and seven
miles away in Pasadena. Curated by Jay Belloli and sponsored by
CalTech.

Translated from the French by Bernard Hemingway

Library of Congress Cataloging-in-Publication Data

Popper, Frank, 1918–
 Art of the electronic age / by Frank Popper.
 p. cm.
 Includes bibliographical references and index.
 ISBN 0–8109–1928–1
 1. Art and electronics. 2. Art, Modern—20th century—Themes,
motives. I. Title.
N72.E53P66 1993
700'.9'048—dc20 92–37367
 CIP

Copyright © 1993 Thames and Hudson Ltd.

Published in 1993 by Harry N. Abrams, Incorporated, New York
A Times Mirror Company
All rights reserved. No part of the contents of this book may
be reproduced without the written permission of the publisher

Printed and bound in Singapore

Introduction

This book has a threefold aim. Its first objective is to establish an overview of each of the main advanced technological art sectors and the artists active in them.

A second aim is to give an account of the relationship between the technical and aesthetic factors in these areas on the assumption that the individual artists, though using different means in different ways and in different contexts, always have an aesthetic purpose that can be more or less clearly defined.

Finally, although this aesthetic purpose can vary widely among artists or groups of artists, we need to establish that, apart from the unifying presence of the specific technology, there are sufficient factors common to each of these art sectors to justify their description as laser, holographic, video, computer and telecommunication *art*; and that among these aesthetic factors some can be singled out which apply equally to all of them – – thus justifying the claim that what can be qualified as the art of our electronic age is a recognizable global phenomenon.

The descriptive terms that appear throughout this book are based on the assumption that the use of technology by the artists considered always refers overtly to its scientific basis. For thousands of years, science and technology constituted distinct activities, but in the 19th century they entered into a much closer relationship. This coincided roughly with their convergence with the arts, and this development led gradually to what in the late 20th century we may call technological or electronic art.

If the historical continuity and coherence of this art can be demonstrated, its distinctive characteristic, particularly in the public eye, is the technological sophistication of its products. The convergence and combination of the different technologies which mark its development have been exploited by artists for their maximum efficiency in producing visually and intellectually impressive works.

The term 'technological art' may, in some contexts, have a pejorative flavour, through its association with the one-sided idea that technology is invariably an alienating factor. But it is more than ever legitimate to

use this term for a number of recent developments connected with complex systems and, in particular, with respect to the interplay of such multi-media technologies as Digital High-Definition TV and computer parallel-data processing and networking. In these complex high technology systems, the speed of delivery and exchange of information has been prodigiously accelerated.

The nature of technological art can also be illustrated through the examination of attempts made by artists to implicate the spectator in the creative process and, in particular, through analysis of the transformation that was effected when they passed from a simple invitation to participate to an appeal for a more elaborate interactive involvement.

A preliminary distinction can be made between the terms 'participation' and 'interaction'. In the artistic context, 'participation' meant in the 1960s, and still means today, an involvement on both the contemplative (intellectual) and the behavioural level. It differed from traditional attitudes towards the spectator by this double invitation and by its political and social implications. Besides being invited to participate through the devices specific to the plastic arts, the spectator was often encouraged to take part in events resembling a ritual ceremony or tribal feast.

The term 'interaction' has a more recent history in this area and refers to a still more comprehensive involvement. Here the artist tries to stimulate a two-way interaction between his works and the spectator, a process that becomes possible only through the new technological devices that create a situation in which questions by the user/spectator are effectively answered by the art work itself. A global network is the usual form taken by these works, requiring equally global involvement from the spectator. The projects again have important social implications, though they are far less directly 'political' than those of the '60s. They tend to address more immediate daily problems or environmental issues, and can have a distinctly 'scientific' flavour. Thus, the term 'participation', in the context of contemporary art, refers to a relationship between a spectator and an already existing open-ended art work, whereas the term 'interaction' implies a two-way interplay between an individual and an artificial intelligence system.

Until recently, mainly in the U.S.A., the term 'interaction' was restricted to the interplay between the artist and the apparatus, but at present it is also applied to the relationship between the artist and the spectator, established through different networks, ranging from purely electric or electronic devices to those involving local or world-wide operational points. This in turn implicates creative activity in a context which has been widened to include not only professionals such as architects and composers, but also the wider public.

In this connection it should be noted that in many recent works of technological art, the element of sound is emerging strongly in the form of sculptural acoustic space and an ever-expanding combination of electronic images and sound based on pure data input. This development is associated with what has been called 'connectionism', an improvement of previous artificial intelligence systems, which links the work of numerous computers in order to obtain, in the first place, the 'connections' for a complete restitution of the input model, but also opening up the possibility of a more creative situation.

The object of this research – of particular interest for the technological artists – is to extend the range of artificial intelligence in passing from computational and rational to associative mental connections. Together with a development of remote sensing systems, this is perhaps the most promising advance at present in the area of interactivity between artists and spectators through the mediation of high-tech equipment.

Thus, although technological art is a relatively new art form, its coherence and continuity, as well as its aesthetic, sociological and cultural value, can be established. It is an international phenomenon, and its origins are traceable back to antiquity. However, it is only since the effects of the Industrial Revolution began to be felt in everyday life and the *rapprochement* between art, craft and technology had been achieved at the end of

the 19th century, that one can speak of a technological art as forming the origins of our contemporary art forms.

The argument will be developed along the following lines: the first chapter deals with the roots of technological art, running from Industrial Art, the Maschinenstil and Art Nouveau of the late 19th century to the light, kinetic and early electronic, environmental and participatory arts of the 1950s and '60s, by way of Futurism, Dadaism, Constructivism, and the Bauhaus art of the 1910s and '20s. Other roots are identified in photography, film, conceptual and early cybernetic art, which leads from the mechanical to the electronic era.

The five central chapters are concerned with the main trends in contemporary technological art:

The discussion of *Laser and Holographic Art*, after a short resumé of the technical history of the medium, analyzes the use of the laser by artists in combined visual/aural productions and long-distance environmental displays. This is followed by a panorama of the laser's main applications in Holographic Art, both in extending the three-dimensional illusionist characteristic of photography and as the latest development in art forms involving the use of light.

The chapter dealing with *Video Art* refers, first of all, to the historical work of artists who used video as a recording tool or for experimental research. Then there is an analysis of more recent art works that are primarily concerned with the formal research into plastic elements and their development; the recording of conceptual art events, often concentrated on the artist himself; and above all, the use of juxtaposed cameras and monitors in video sculptures, environments and other types of installation. The present-day combining of video with other advanced technologies (such as the computer) is also taken into account, along with the interplay between spatial and temporal factors in Video Art.

Computer Art is treated as a definitive art form, with an outline of its origins and an attempt to cover the wide range of computer-assisted works still on traditional supports, the great variety of animated paintings and digital images in general, as well as the

expanding area of sculptures and installations in which the computer plays a decisive role. There is a discussion of present-day and projected developments in Computer Art as a generator of 'virtual realities' or 'virtual environments' in 'cybernetic space'; and Computer Art is shown to function as a purveyor of abstract information rather than as a tool or medium.

Communication Art can claim its own identity and specificity. It is taken to emanate from electro-photography or copy art, and to include telematics, interactive networks and satellite art. It can be situated between what has been called 'the aesthetics of communication', centred on an international group of artists and theorists particularly concerned with this area, and an academic field now known under the term of 'cultural studies'.

The sixth chapter deals with works of art directly inspired by natural phenomena or by their scientific interpretations. They can often take the form of installations, demonstrations and performances.

In the last chapter of the book, the social and aesthetic implications and consequences of technological art are brought into relief. This involves mention of the main exhibitions and projects since the early 1980s and a rundown on recently founded teaching and research institutions in the field. The major aesthetic problems discussed here include the passage from audience participation to true interactivity, the relationship between the creative process and the finished work, between human and artificial intelligence, man and machine – and the interplay between simulation, virtuality and reality in relation to technological art.

The conclusion sums up the various aesthetic options exercised by artists in this area, and then seeks to determine the situation of these art forms in relation to the debate on Modernism and Postmodernism.

The Roots of Electronic Art

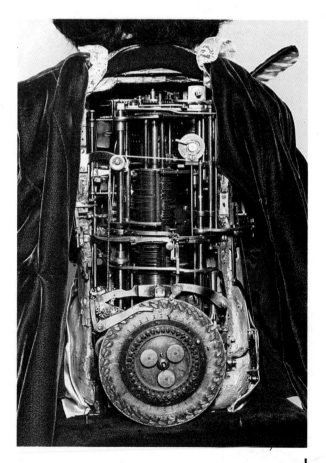

I
Pierre Jaquet-Droz
Mechanism of the writer, automaton (1774)
Museé d'art et d'histoire de la ville de Neuchâtel

Although displays of technical innovation have existed ever since antiquity, one can only speak of the direct influence of technique and technology on art since the Industrial Revolution, and more particularly when its effects entered everyday life at the end of the 19th century through the progressive design movements known as Art Nouveau and Jugendstil on the Continent and their precedent, the Arts and Crafts Movement, in England. The prominent figures in this context were William Morris, Henry van de Velde and Hermann Muthesius. Morris took a pioneering stand against the non-functional role ascribed to art when in 1861 he established a firm of artists based on the model of a craftsman's workshop. Essentially a revivalist, however, he demanded that the firm's products be distinguished from those made by machine, which he considered to be evil; this meant abjuring the use of new and cheaper materials and mechanical means of mass production.

The Belgian architect and designer, Henry van de Velde, was deeply influenced by Morris's philosophy in his search for a harmonious solution to the problems posed at all levels of life by the machine-artisan-art triad. Through both his practical and theoretical work, he attempted to articulate a socially committed, scientific aesthetic.

His most important contributions in this respect were made in Germany through his reorganization of the Arts and Crafts School and the Academy of Fine Arts in the Grand Duchy of Weimar in 1912, as well as through his work with the Deutscher Werkbund.

Despite the breadth of Van de Velde's vision, the views of the German statesman and designer Hermann Muthesius were more radical. During a visit to Great Britain in 1906, Muthesius learned the latest developments in both architecture and the plastic arts. He became the partisan of a movement which was taking account of the new industrial materials and of the role and working procedures of the engineer. Committed to what Nikolaus Pevsner has called 'rational objectivity', he tried to introduce British practices into Germany with regard not only to architecture but also typography and the plastic arts in general.

At first sight, this was an approach similar to that of Van de Velde's, but there was a subtle distinction between the two. Muthesius and the German art historian Alfred Lichtwark, who shared many of his ideas, were two socio-aesthetic theoreticians of the first order and propagators of important notions such as *Sachlichkeit*, *Nutzkunst* and *Maschinenstil* (Objectivity, Utilitarian Art and the Machine Style).

In fact, it was to be in Art Nouveau and its German variant, Jugendstil, that this problem was explored in a most comprehensive and thorough way. Art Nouveau, through the universality and eclecticism of its stylistic language, affected all domains of art, those considered as disinterested or transcendent as well as those considered as purely utilitarian. This mixing of the fine and the applied arts depended upon the development of an aesthetic equally applicable to non-artistic objects and phenomena; and this produced a characteristically radical simplification of plastic elements that brought Art Nouveau to a high degree of abstraction.

In 1907 Muthesius helped to found the Deutscher Werkbund, an association of manufacturers, architects, artists and writers determined to find new streamlined and functional design standards based in, and not foisted upon, the machine. 'There is no fixed boundary', announced a speaker at the Werkbund's first convention, 'between tool and machine.' The move towards acceptance of the new materials and the working methods of a rationalized industrial and technological society was furthered when Walter Gropius succeeded Van de Velde as head of the Weimar School of Arts and Crafts.[1] This school would become the Bauhaus in 1919 and through it and its American offspring, the Chicago Institute of Technology, founded by László Moholy-Nagy in 1937, the 'machine aesthetic' entered contemporary life. With it came two important problems: that of the aesthetic transformation of the environment deriving from the synthesis between the fine and applied arts and architecture, and the theorization of a new homogeneous culture based on the difficult rapport between art and science, man and the machine, and the necessity of overcoming their apparent contradictions.[2]

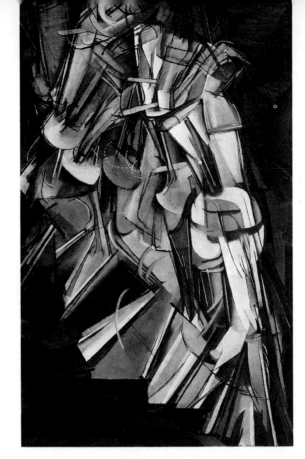

Three other artistic trends of the first quarter of the 20th century can be considered as having had an influence on the birth of the art of our electronic era: Futurism, Dadaism and Constructivism. Futurism, besides its exaltation of dynamism and speed, attempted to find abstract equivalents for all the forms and elements in the universe and advocated the fusion of art and science.[3]

In the aftermath of the First World War, the Dadaists chose primarily to make evident the absurd qualities of the machine as a critique of industrial civilization. However, the painter Picabia, a participant of the Dada movement for a time, was not alone in seeking new ways of representing the reality of modern society. He wrote: 'Almost as soon as I arrived in America I experienced the revelation that the genius of the modern world is the machine, and that in machine art we can discover a living form of expression.'

Duchamp, the main figure of Franco-American Dadaism, took the initiative in applying the machine aesthetic to the human being, as is most famously exemplified in the five versions of *Nude Descending a*

3
László Moholy-Nagy
Lichtrequisit (1923–30)

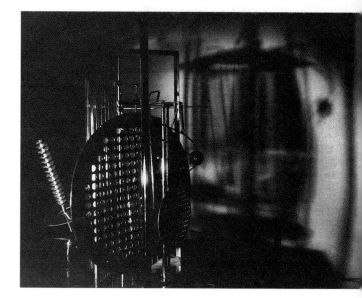

Staircase, 1911–18. He wrote concerning these works that they were not paintings, but 'an organization of kinetic elements – an expression of time and space through the abstract presentation of movement . . . [But] we must bear in mind that, when we consider the movement of form in space over a certain time, we are entering the realm of geometry and mathematics in the same way as when we construct a machine.' The *Nude* is only one of many explorations of movement undertaken by Duchamp, including his large work on glass – *The Bride Stripped Bare by Her Bachelors, Even*, his assisted ready-made *Bicycle Wheel*, as well as his experiments with 'optical machines', which can be seen in his film *Anemic Cinema*.

As for the Russian Constructivists, more than Malevich, who defended the idea of art as an autonomous spiritual activity, it was Tatlin who pioneered the idea, taken up and developed by his Productivist heirs, that artists should be retrained as qualified technicians and engineers in order to take their place with their fellow workers in the modern industrial society.

One of the most important sources of technological art is related to the new interpretation and use of light and motion as represented in Kinetic and Lumino-kinetic Art. The origin of these arts can be traced back to between 1913 and 1920, when Duchamp, Tatlin and

4
Man Ray
Obstruction (1920/64)
mobile composed of 63
coat-hangers

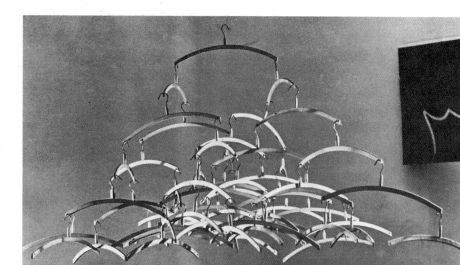

Gabo were producing their first works in which actual mechanical movement played a part, as well as formulating theoretical statements on the subject. This was also the period of the first mobiles, which emerged from the studios of Rodchenko, Tatlin and Man Ray; and among the experimental artists at the Bauhaus in Weimar, an art of combined light and movement was being developed. László Moholy-Nagy of the Bauhaus and Alexander Calder, independently of one another, pursued an art of actual movement during the 1920s and '30s, but it was not until the '50s that Kinetic Art came into its own. In the area of mechanical movement, the leading artists were Jean Tinguely, Nicolas Schöffer, Pol Bury and Harry Kramer. Gyorgy Kepes, Thomas Wilfred and F.J. Malina were most concerned with experiments in Lumino-kinetic Art, and in the case of mobiles the leading lights were Bruno Munari, George Rickey, Kenneth Martin and, of course, Calder.[4]

'Kunst-Licht-Kunst', the exhibition concerned with artificial light which took place in the Philips Corporation-dominated town of Eindhoven, Holland, in 1966 and which I helped to organize, apart from making public technical experiments with artificial light by artists, attempted to incorporate aesthetic preoccupations connected with the 'environment', an idea which was still young at the time. Although this

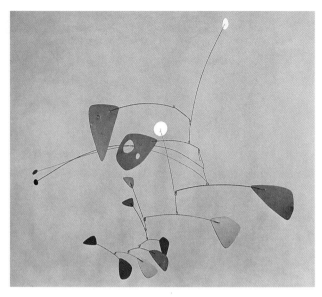

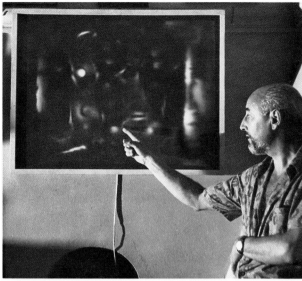

5
Alexander Calder
mobile with red and blue
parts (*c.* 1950)

6
Frank Malina in front of
one of his lumidyne paintings
No. 870 *Voyage III* (1958)

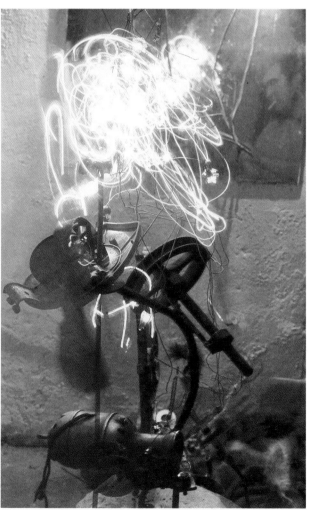

7
Nicolas Schöffer
Infinite Prism, Lux II and *Microtemps II*
shown at the Schöffer/Tinguely exhibition at the Jewish
Museum, New York, 1965

8
Jean Tinguely
Animation de petites ampoules (1962)

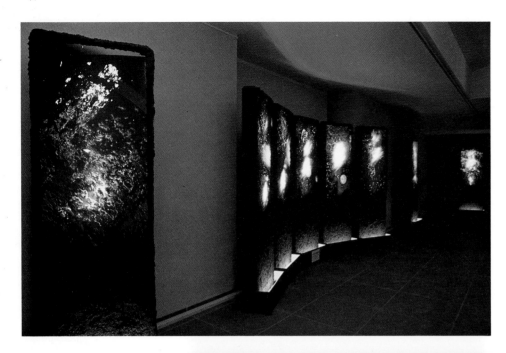

9
Frédéric Grandpré
L'Archéologie de la lumière
exhibited at Rheims, 1991

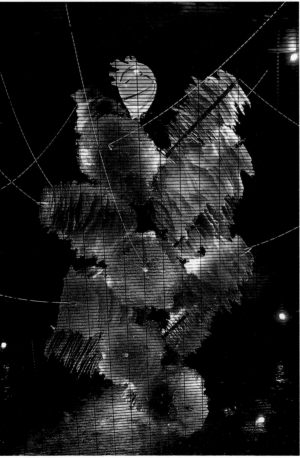

exhibition was not designed to be an historical survey of Light Art, it in fact established, with the aid of examples from its history, that a specific artistic current existed which combined aesthetic and social preoccupations with an up-to-date technology. It can now be considered as one of the founding moments of technological art.[5]

An exhibition held in 1991 at Rheims entitled 'Les Artistes et la lumière' confirmed this, since most of the works recalled aesthetic and technical problems previously raised in the fields of photography, light, environmental and spectator participation art while sharing in developments in these very areas. Frédéric Grandpré exhibited photographs in which he mixed material extracted from volcanic rock with light in such a way as to create metaphors of space and time; Liliane Lijn touched the poetic and dramatic sphere with her *Electric Bride*; Alain Le Boucher conferred on an object he called an *Astrolabe* a new environmental dimension by providing a link between the contemporary spectator and theories of the origin of the universe. On the other hand, Alejandro and Moira Siña with *Helix*, *Double Sprouts* and *Touch Plane*, Christian Schiess with *Turbo-Flora* and Karl X. Hauser with *Wall-o-Fish* provided a new type of visual illusion with the use of neon. Jürgen and Nora Claus's large project, *The Carousel of Suns*, shown at this exhibition, was an exemplary artistic demonstration of the dynamic relationship that can exist between natural and man-made environments.

10
Liliane Lijn
The Electric Bride (1989)
mixed-media performing sculpture (Photo: Stephen Weiss)

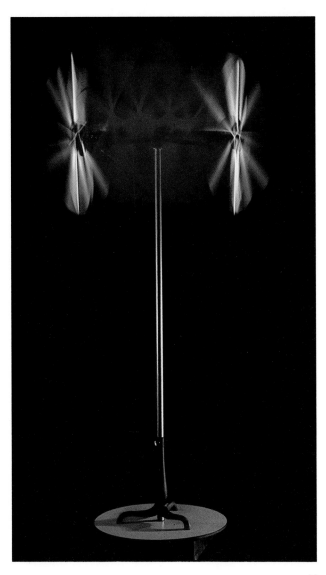

11
Christian Schiess
Turba Flora (1991)
kinetic neon sculpture

12
Alejandro and Moira Siña
Helix and *Double Sprouts* (1991)

13
Toma Naegerl
L'Accident (detail 1991)
project for a monumental sculpture

14
Piero Fogliati
Chiosco delle apparizioni (1991)
virtual images

15
Bill Bell
Lightsticks (1991)
shown at the 'Ars Futura'
exhibition in Barcelona, 1991

The development of virtual light images was represented by the works of Piero Fogliati and Bill Bell. Fogliati projected luminous images onto slim rods placed about 60 cm apart and suspended above the exhibition space. It was impossible for the spectator to focus on the two sets of luminous data at the same time. The resulting back-and-forth eye movements created the illusion of seeing real images in the space between the rods. Bell's saccadoscopic images (whose viewing demands rapid eye movements) are generated with luminous diodes and computer technology.

The evolution from the mechanical to the electronic era as far as notions of spectator participation and interactivity are concerned was demonstrated in Toma Naegerl's commentary on, and involvement with, road accidents and to an even greater extent in Jeffrey Shaw's *The Legible City*. In the latter's works in particular, the intense interactivity between the spectator and the installation conceived by the artist was made possible through the use of the combined technologies of video and the computer and shows a significant development since the artist's early days when, as a member of the Eventstructure Research Group, he produced works consisting mainly of air-inflated tubes that enabled spectators to walk on water.[6]

As mentioned previously, electronic art is essentially rooted in the research of artists belonging to the Kinetic, Lumino-kinetic and early Cybernetic art movements, who in the 1960s made abundant use of

16
Hugo Demarco
Environnement et relation (1968)

17
Martha Boto
Lumino-kinetic mobile (1967–71)

technological devices in order to create a variety of movements and light effects. At that moment electro-mechanical, electronic, thermal, hydraulic and magnetic movements appeared in the works of these artists, sometimes combined with light effects produced by arc lamps, spots, a variety of projectors, light bulbs filled with sodium or mercury vapour and white or coloured, straight or bent, neon or fluorescent tubes. Among these techniques the most influential for future development were those concerned with perceptual awareness, mathematical programming and environmental integration.

If Kinetic and Lumino-kinetic art in general can be regarded as a significant phase in the development of what was to be electronic art, the specific area of Neon Art is particularly revealing with respect to the continuity of aesthetic preoccupations and technological advance.

Although Georges Claude had invented the device of a vapour-tube filled with neon gas by 1910, it was not until the 1930s that neon tubes were widely used for decorative and advertising purposes. Only a few artists employed them during that period, and merely in an accessory way. Credit for the earliest attempt to use neon light as a principal material of a sculpture is usually given to Gyula Kosice, who produced his *Luminous Structures* in Buenos Aires in 1946. In their conception they were related to Lucio Fontana's *Manifiesto Blanco*, and in 1951, for the IXth Triennale in Milan, Fontana devised a memorable ceiling, *Spatial Concept*. From

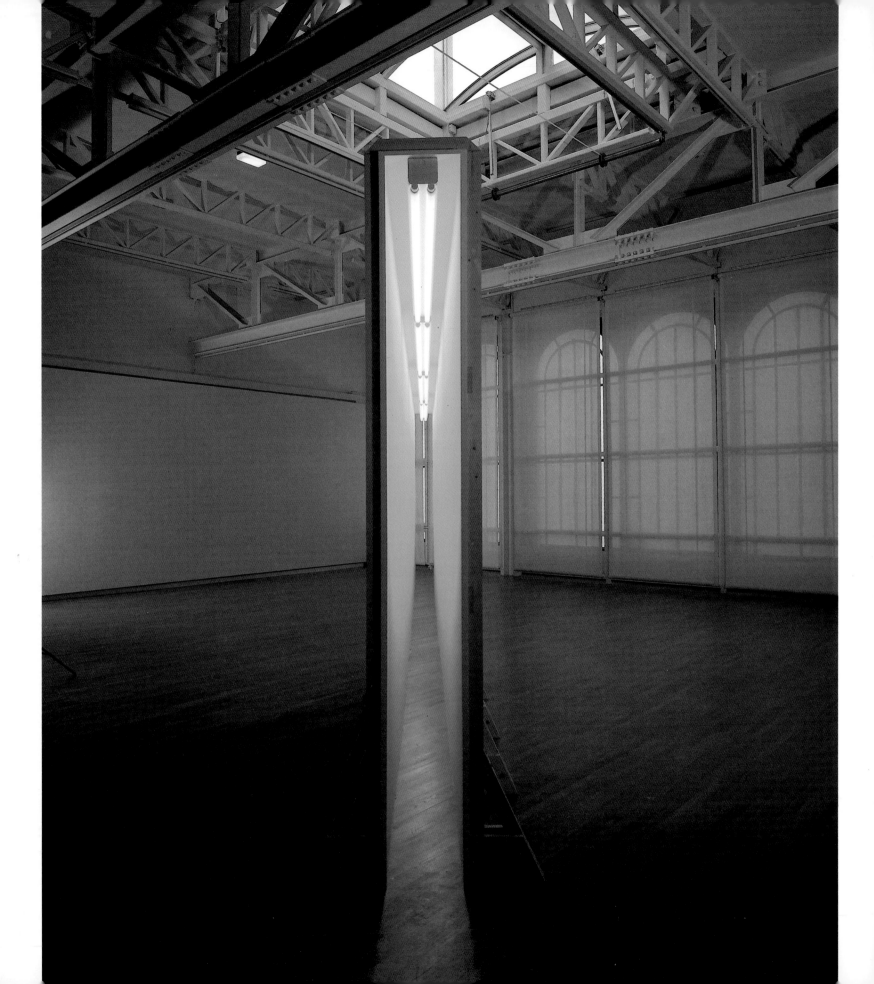

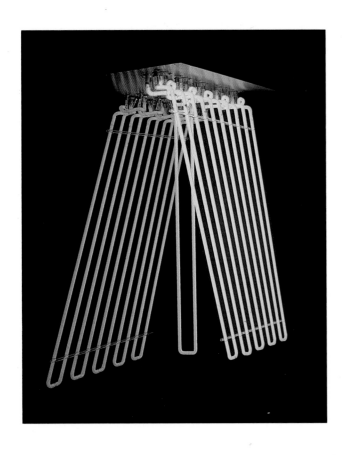

18
Bruce Nauman
Green Light Corridor (1970–71)
Panza collection, Milan
S. Guggenheim Museum, New York
photo Giorgio Colombo, Milan

19
Stephen Antonakos
Hanging Neon (1965)

20
Dan Flavin
Untitled: To a Man George McGovern (1972)

21
Piotr Kowalski
Mesures à prendre (1972)

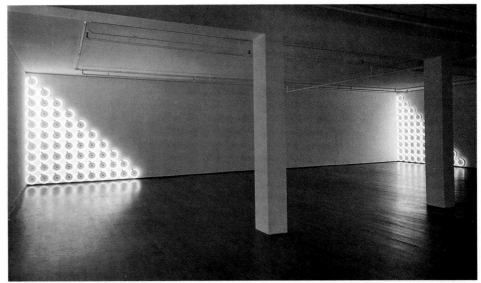

that time to the present day, artists of very different tendencies have employed neon light as a principal or at least important technical means of expression. In this respect one might mention Stephen Antonakos with his interior and exterior environmental pieces, Dan Flavin with his 'cool' installations, Joseph Kosuth and Bruce Nauman with their conceptual and critical approach in, respectively, works like *Five Words in Orange Neon* (1965) or *My Name as Written at the Surface of the Moon* (1968). Also worthy of mention are Martial Raysse's neon works, with their allusions to the artificiality of modern times along with the innocence of a new way of life made possible by technology; Chryssa's coloured neon tube works containing enigmatic symbols and alphabetical elements which attempt to bridge the gap between classical Greek and present-day civilization; and Piotr Kowalski and François Morellet's use of neon in order to test the spectator's spatial and architectural awareness.

22
Jean Dupuy
Heart Beats Dust (1968)

23
Jean-Pierre Yvaral
Interférence (1966)
relief, vinyl threads

24
Nicolas Schöffer
Cybernetic Light Tower (1972)
project for the Rond-Point
at La Défense in Paris

Although these various uses of neon technology were determined by different objectives, such as creating a luminous writing or dynamic light effects, manipulating interior and exterior space, or modifying existing architecture, it can be maintained that due to the specific technique or technology employed, all these works also contain a common specific aesthetic quality that covers a wide range, stretching from an invitation to contemplation and meditation to an awareness of the energy and vitality of contemporary life.[7]

A significant early moment in the passage from the mechanical to the electronic age in art occurred in 1968 when Pontus Hulten assembled a number of technological-based works at The Museum of Modern Art in New York under the title 'The Machine as Seen at the End of the Mechanical Age'.[8] This exhibition also contained a competition organized by EAT (Experiments in Art and Technology) and won by Jean Dupuy's *Heart Beats Dust* (1968), in which a number of artists showed some highly advanced technological work.

Important among the artists who, through their practical and theoretical researches, established the passage from the mechanical to the electronic in art were Yvaral, Yaacov Agam, Nicolas Schöffer, Liliane Lijn, Piotr Kowalski, Wen-Ying Tsai and Stephen Antonakos.

Yvaral created a link from his early optical research and his interest in science as a model for artistic creation with a subtle use of the computer for the programming of a pictorial surface. Agam moved from aural-optical-kinetic relief structures and interactive objects to arrangements transforming invisible acoustic objects to arrangements transforming invisible acoustic wave formations into visible electro-magnetic waves and to computer-aided murals of visual orchestration on several electronic screens. Nicolas Schöffer developed his early functional spatio-dynamic sculptures provided with electric motors in the direction of cybernetic lumino-dynamic towers on a vast scale, the most ambitious of which are awaiting realization. Liliane Lijn transformed her preoccupations with echo lights and liquid reflections into complex kinetic works known as

Dream Structures and beautiful and mysterious objects made of steel, optical glass, synthetic fibres and a micro-computer system designed to make a sculpture light-responsive to sound.

Kowalski's interest in scientific phenomena, expressed in his early work through simple neon signs and installations or through elementary electronic features, has evolved into sophisticated statements in which time is treated electronically as a zone directly accessible to the senses and not as an inert record or memory. Kowalski has also created such environmental works as *Field of Interaction* in which the physical interactions of the spectators modify the structure of luminous elements in a simulation of urban space. His research is now moving towards the use of holography.

Wen-Ying Tsai began his artistic career with dynamically integrated multiple kinetic constructions

25
Piotr Kowalski
Field of Interaction
at the Electra exhibition in
Paris, 1983

26
Liliane Lijn
Woman of War and *Lady of
the Wild Things* (1986), a
Conjunction of Opposites.
'The two sculptures enact
a ritual between two
female archetypes who
personify the divided
aspects of the female
psyche.' (L.L.) *Photo Helge
Mundt*

27, 28
Wen-Ying Tsai's studio in New York, 1989; and his
cybernetic sculpture of 1979

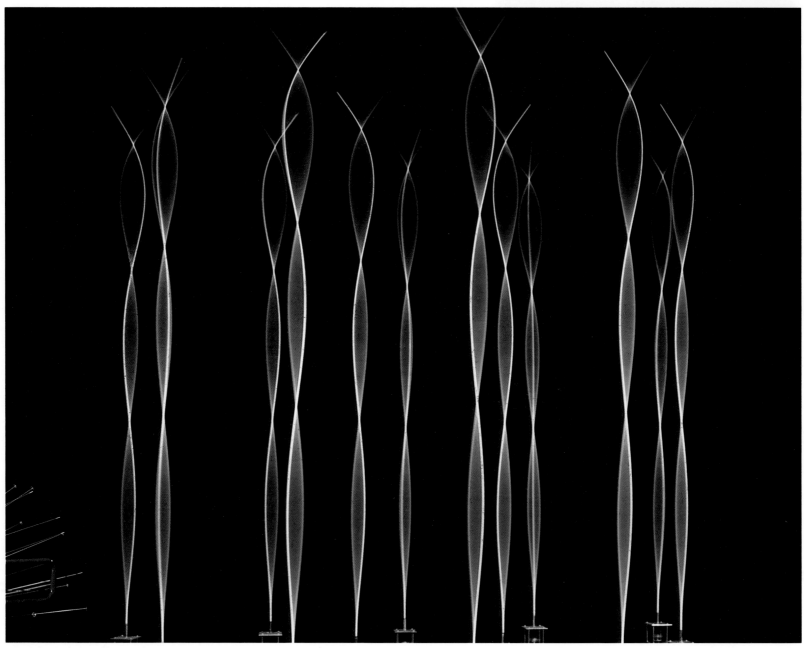

and cybernetic sculptures of stainless steel vibrating in an electronically activated environment filled with high frequency lighting. He then went on to interactive pieces, such as his *Upward Falling Fountain*, which manifest the artist's ambition to come to terms with both the natural and artificial environments.

Stephen Antonakos transposed his early neon research to his interest in architectural and environmen-

tal sites, using a formal chromatic neon language of circles and squares and their segmentable elements – arcs and right angles – in an evocative, expressive manner.

Other artists, such as Joël Stein, Otto Piene, Carl Fredrik Reuterswärd, Rockne Krebs and Dani Karavan, developed their early kinetic or environmental research with light in a still more technically advanced way by using the laser beam in three main directions: combined visual and aural productions, long-distance environmental plastic displays, and holography.

One of the most impressive and consistent involvements in the passage from the mechanical to the electronic in art can be found in the work of Roy Ascott. In the 1960s he was producing pedagogical sculptures that required the simple participation of the spectator-pupil in a localized physical space. In a series of methodical stages Ascott proceeded, on both the practical and theoretical levels, to research in the use of cybernetics and finally to a number of projects arriving, with the aid of technologies of interactive communication, at superconnectivity in deep dataspace. (We shall return to Ascott's work in the communication arts in more detail in Chapter V.)

Purely in typological terms, one might summarize the progression towards technological art in the last half-century by adopting the classification of Dario del Bufalo in the catalogue of the 42nd Venice Biennale in 1986. He consisered that the 1940s deserved the title of Electronic art, the '50s of Data art, the '60s of Random art, the '70s of Computer Graphic art and the '80s of Synthetic Image art.[9] However, this view, which rightly assumes that the technical innovations described by these categories were in place by the dates mentioned, neglects the fact that the isolated artistic achievements corresponding to those dates were generally insufficient to make a real impact on the art world. It is only through the committed theoretical and practical research of a number of creative artists in these areas that technological art has been able to establish itself as a valid aesthetic expression of our times in competition with, or rather in complement to, other hegemonic 'Postmodern' artistic

29
Wen-Ying Tsai
Upward Falling Fountain (1979)

developments such as the eclectic painting and multi-media object-based works exhibited at the state-of-the-art 'Metropolis' exhibition in Berlin in 1991.

These artists, in seeking a way of reconciling technological, aesthetic and artistic factors, have progressively placed increased emphasis on such global problems as the relationship between the artist and the art work, on the one hand, and technology, the environment and the general public and culture of mass society on the other.

To this end artists have drawn their inspiration from several different sources already mentioned, principally Futurism, Dadaism, Constructivism, Kineticism and Lumino-kineticism, as well as Environmental and Conceptual art, technological developments beginning with photography and cinematography, and different branches of science.[10]

As regards photography, in an issue of *Art Journal* devoted to the subject of art and the computer, Margot Lovejoy, Terry Gips and Georges Legrady make a powerful plea for the importance of photography as the basis of computer art. Lovejoy argues that photography's role in the development of both Modernism and Postmodernism has provided a paradigm for gauging the function of electronic media in relation to art. She reiterates the viewpoint of Walter Benjamin,

which places photography in a pivotal position in the collapse of the aura of the original and unique art object, and demonstrates how the suppressed critical ramifications of photography as a reproductive technology were developed forcefully in the 1960s by the work of Andy Warhol and Robert Rauschenberg.[11]

As several of the articles in this issue of *Art Journal* indicate, electronic technologies – first video and now digital imaging – have accelerated the changes initiated by photography, causing the occurrence of additional changes. In these technologies, much of the history of photography is being replayed with greater speed and fewer detours. The photographic paradigm, in conjunction with the further dissolution of rigid distinctions between art and non-art communication systems, 'has dumped computers right on the artist's doorstep.'[12] According to Gips it is the complex intertwining of photography, video and older techniques of visual representation – drawing, painting, sculpture – with the new digital technologies that has changed communication and opened the door onto a new definition of art that includes an ecological awareness.[13]

On the other hand, Georges Legrady observes that in digital processing, as in other forms of communication, the technological components of hardware and software are structures that shape and impose a form on the information they process, even though these mediating structures are usually understood as transparent or 'value-free'.[14] As with his previous work in photography, Legrady's computer-generated works engage the viewer in consideration of the ambiguity inherent in an image that looks natural on the surface but is in fact mediated and is therefore a challenge to conventional notions of visual representation as a simple reflection of pre-existent real objects.

Another route from environmental art to the ecologically concerned art of the electronic era can be traced from the architectural and environmental works of such artists as Victor Vasarely, Carlos Cruz-Diez and Bernard Lassus to those of Wen-Ying Tsai, Jürgen Claus and Otto Piene,[15] which will be analyzed in later chapters.

31
François Morellet
mural painting in the Plateau Beaubourg, Paris (1971).
Now destroyed

32
Victor Vasarely
Entrance gate of the Faculté des Lettres et sciences humaines,
Montpellier, France, 1966

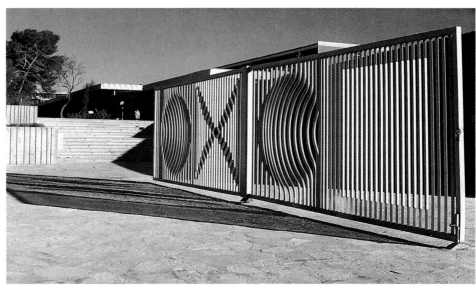

33
Carlos Cruz-Diez
Radial Chromostructure
(1983–88)
Barquisimeto, Venezuela

34
Yaacov Agam
Tactile Painting (1963)

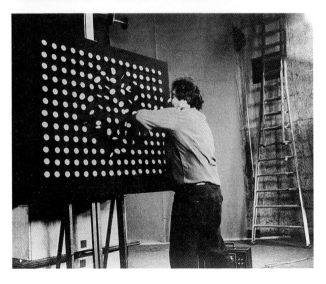

Parallel to this development, the concept and practice of spectator participation came to be replaced by that of interactivity. Active participation by the spectator had been inaugurated by artists like Agam, Soto, Tinguely and Pol Bury at the beginning of the 1950s. These artists, who had been experimenting with geometric forms, introduced the third dimension into their works, in order to give a choice to (and sometimes even to create an obligation for) the spectator to intervene in the creative process so that their art works could become fully operational. Thus Agam's polyphonic and contrapuntal pictures revealed their structure only if the spectator moved in front of them. Similarly, his transformable works using a different technique were constructed in such a way that the mobile elements of the picture could be rearranged freely by the spectator-participant.

If Soto's works of that period were governed by the slightest movement of the spectator in front of them, especially through the moiré effect, his later environments often needed a much greater degree of participation, both optical and tactile.

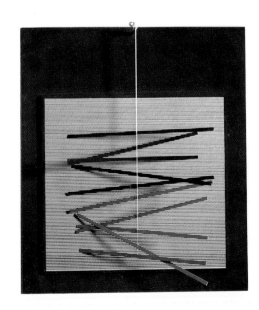

35
Jesus Raphael Soto
*Small Red and White
Horizontals* (1965)

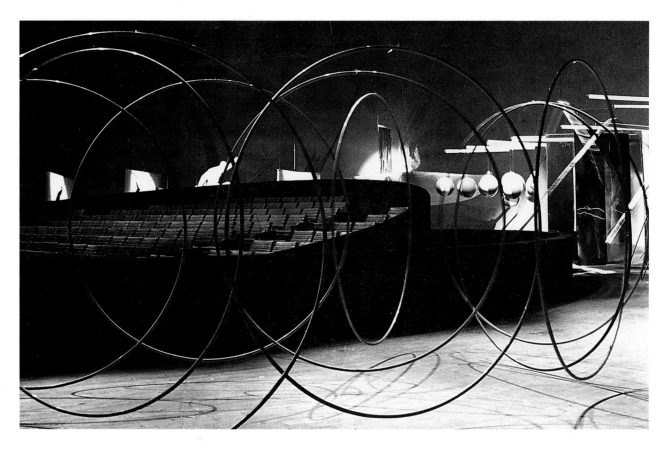

The *Metamatics* of Tinguely in the 1950s, although intended mainly as an ironic challenge to technology, sometimes required the participation of the spectator, especially in his drawing and painting machines.

In the case of Pol Bury, the passage from his two-dimensional abstract geometric forms to his three-dimensional transformable *Mobile Planes* must be considered both as a revolt against the constraints of the easel picture and as an invitation to the spectator, if dissatisfied with the arrangement of forms and colours proposed by the artist, to alter the composition.

A little later, other Op and Kinetic artists such as Cruz-Diez or the members of the 'Nouvelle Tendance' – especially the Groupe de Recherche d'Art Visuel of Paris and the Group T of Milan – tried to implicate spectators still more and in such a way that they became conscious of using their freedom constructively. Thus Cruz-Diez appealed to perceptual capacities with regard to colour perception, and the French and Italian groups, which included Morellet, Le Parc, Colombo and Boriani, tested the spectator's creative faculties in unusual environments such as labyrinths or planned walks teeming with optical, stroboscopic, magnetic, mobile and luminous effects.

The problem of spectator participation was also evident in the works of artists who created 'happenings', 'actions', 'events' and 'performances' in the 1960s and '70s. If in these types of works a critical stance towards society was often apparent, the phenomenon of graffiti, which had its modern inception in the U.S.A. in the '60s and which became a topic of increasing attention in the '70s, must be considered as an emphatic challenge to the established social order. Yet it involved, in a quite unexpected way, new strata of the population in an aesthetically creative, if by everyday standards destructive, occupation.

37
Julio Le Parc
Colour Box (1965)

sents both a technical and an aesthetic transformation in the realm of spectator participation. It is prominent in the works of artists such as Jeffrey Shaw, Edmond Couchot, Roy Ascott, Jean-Louis Boissier, Myron Krueger and Stephen Wilson.

As for the influence of Conceptual Art on electronic art, a good example in the area of Computer Art is provided by Christine Tamblyn.[16] In her recent theoretical writing, she opposes the traditionalist attitude to art media (as represented by paint programmes for microcomputers that allow artists to draw with an electric pen or a mouse as well as more sophisticated image-mapping or map-tracing programmes which are used to simulate aspects of Modernist painting, drawing, printmaking or photography), to the Postmodern attitude represented by computer artists who extend the purview of Conceptual Art. She argues that computers were designed to augment mental processes as opposed to being visual or manual aids.

One may conclude that there are at least seven different sources from which contemporary technological art has drawn its inspiration. These are, first of all, photography and cinematography with their interplay between technical and aesthetic factors; then Conceptual Art with its intellectual and informational aspects as well as its environmental dimension, Land Art. The environmental dimension was also arrived at early by the third principal source, Light Art, with its electrical and later electronic characteristics. A fourth source is that in which the physical movement of the machine plays an important role and is best represented by Kinetic Art. Calculated programmed art has been a significant factor in the establishment first of early Cybernetic, then electronic art. As for the arts predominantly concerned with the specificities of environment and spectator participation, they can be also considered as two separate areas of influence on technological art: the first taking the form of environments or installations, both optical and conceptual, sometimes attaining architectural or urbanistic scale; the second in the form of ludic and more or less creative participation leading to interactivity.

Another popular form of aesthetic expression with a strong community and social orientation, mural painting, was inaugurated with the *Wall of Respect* painted by William Walker and a group of helpers in a South Chicago street in 1967. It must be said that the mural movement in the U.S.A. has had a double social impact. It not only brought home to inhabitants of a district their immediate everyday problems, but the organization of the groups also permitted a collective activity, an effective physical and mental participation in the elaboration of aesthetic, artistic and socio-political statements.

The notion of interactivity, introduced as a consequence of social and technological changes, repre-

2

Laser and Holographic Art

38
Rockne Krebs
Aleph 2 (1969)
an early small-scale interior installation piece

39
Rockne Krebs
Miami Line (1983–88)
Downtown Miami; neon 1/4 mile long on both sides of an
elevated railway bridge; conceptually based on Krebs's
urban-scale laser pieces

As mentioned before, one of the most spectacular developments of contemporary Light Art involves the use of *laser* (an acronym for *l*ight *a*mplification by *s*timulated *e*mission of *r*adiation), a device that significantly increases an input of light and produces a narrow and intense monochromatic beam. This has a widely known application in the field of sophisticated weaponry; but for artists the attraction has been the narrow concentration and directability of the laser beam.

The first practical laser was not produced until 1960, though it was based on calculations made by Albert Einstein as early as 1917. It was first used as an art medium in 1965, and from then on it has appeared in a) long-distance environmental productions, b) combined visual-aural installations, and c) the special field of holography.

The technical qualities of the laser have been used by many artists in holography, whereas its graphic characteristics found their aesthetic application in the work of a few specific artists, either on an environmental urban scale or in theatrical or other spectacular performances. Outstanding achievements in environmental realizations have been the work of Rockne Krebs, Dani Karavan and Horst H. Baumann; in the area of multimedia performances, such musicians and artists as Lowell Cross, Paul Earls, Iannis Xenakis, Joël Stein and Carl Fredrik Reuterswärd have been most significant.

Along with other American artists like Robert Whitman and James Turrell, Rockne Krebs was among the first to create laser light displays in art galleries in the U.S.A. His *Aleph 2* (1969), shown at the Corcoran Gallery in Washington, D.C., was made up of six helium neon lasers and four co-planar mirrors. These slightly bent mirrors gave the reflected images a curved effect.

It was also in 1969 that Krebs participated in the first exhibition devoted entirely to the artistic use of the laser, *Laser Light – A New Visual Art*, at the Cincinnati Art Museum. Among his co-exhibitors were Michael Campbell (*Laser Beam: Fantasia*), Barron Krody (*Search*) and Donovan Coppock (*Alpha Chamber*). All

four artists constructed rooms filled with mirrors and varying degrees of smoke that intensified the laser's inherently pencil-like form; as the beams crisscrossed these rooms, they created complicated linear networks of radiant light.

In 1970 Krebs collaborated in the ambitious artist-in-residence project organized by Maurice Tuchman at the Los Angeles County Museum of Art in conjunction with a group of industrial corporations; this resulted in a city-wide laser project by Krebs, and his participation at the Osaka World Fair, where he constructed a helium and argon laser room.

In 1971 Krebs mounted a work at the Los Angeles County Museum of Art which consisted of two corridors in the shape of an L; within these areas an illusory space was created through the use of lasers in different colours. But Krebs's main achievement in Laser Art is the fact that he was probably the first artist to install full-scale outdoor night displays on the environmental scale in Minneapolis, Buffalo, New Orleans, Philadelphia and many other towns from the early 1970s onwards, and that, even in his most recent works, he has remained true to his pioneering vision.

The Israeli sculptor Dani Karavan was introduced to the laser beam's aesthetic possibilities through his work with the Czech stage designer, Josef Svoboda, and later at the Massachusetts Institute of Technology in the U.S.A. and the Weizmann Institute in Israel. His first personal experience in this medium was with a laser table in Florence from which he projected laser-created forms in inner space. It was also in Florence, in 1978, that he created his first outdoor display linking historical or other representative buildings in a symbolic way, by using an 8-watt argon laser beam to connect Sangallo's Forte del Belvedere with Brunelleschi's cupola on the Duomo; this work was entitled *Environment for Peace* and is also referred to as an Homage to Galileo Galilei. In 1983, he produced a work entitled *Bridge*, which linked the Kunstverein and the Palace in Heidelberg, following the Philosopher's Path. Later the same year, he participated in the 'Electra' exhibition in Paris with two argon green beams that connected the Musée d'Art Moderne de la Ville de Paris with the Eiffel Tower and the new Défence quarter, in an attempt to symbolize the close relationship between historic and contemporary artistic, architectural and technological achievements,

40
Rockne Krebs
Inclined Planes (1989)
Johnstown, PA; urban-scale
laser installation

41
Dani Karavan
laser equipment projecting a
beam in his laser display in
Florence, 1978

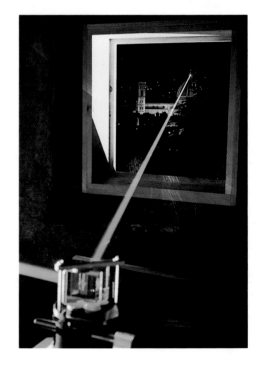

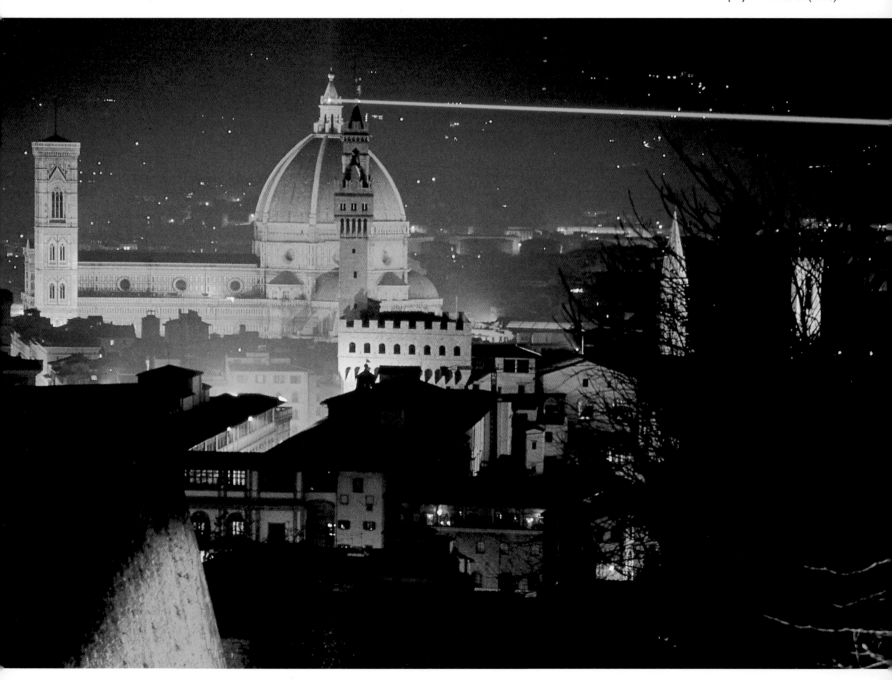

43
Dani Karavan
Axe Majeure, Cergy-Pontoise (1986). First attempt to install the permanent laser linking the Belvedere Tower to the Carrefour de Ham

44
Horst H. Baumann
Laserscape
produced with the LASCAN system for the Philips Corporation during the International Telecommunications exhibition in Berlin in 1985

as well as the passage from the mechanical to the electronic era.

Karavan is currently developing his monumental urbanistic intervention with the laser beam at the new town of Cergy-Pontoise. This 8-watt argon beam, following the major axis of the town, is to be a permanent feature; it was first conceived in 1980, an installation attempt was made in 1986, and the finished work should be ready by 1992.[1] Karavan also conducted an interesting laser experience at a kibbutz in Israel at the beginning of the 1990s in memory of the early pioneers, whose only form of communication among each other was the sending of Morse signals by means of sunlight reflected by mirrors.

The German designer and photographer Horst H. Baumann started his artistic laser research at the beginning of the '70s. In 1976 he realized an environmental project in Düsseldorf with an argon laser that inscribed the letter N (for Neighbourhood) across the Rhine. In the following year, he linked the principal exhibition sites at the Documenta 6 in Kassel with the aid of an argon and a krypton laser; two years later, this work became a permanent municipal feature, with the additional function of indicating the time of day. Baumann has also created the so-called LASCAN System, with which he staged many laser displays. All the components of the 'system' – the argon and krypton lasers as well as the scanner and microcomputer that facilitate the projection of mobile images, texts and symbols over long distances – are collected in a container that can be easily transported. With Nam June Paik, Baumann has also staged laser-video displays in Düsseldorf, Linz, New York and other locations.

The combination of laser visual displays with musical and theatrical performances makes an appreciable contribution to artistic production in this field. Four outstanding musicians, composers and musicologists – Lowell Cross, David Tudor, Paul Earls and Iannis Xenakis – have been involved in such laser displays.

The American Lowell Cross can be regarded as a pioneer in this particular area. After studying electronic

music in Toronto from 1964 to 1968, he collaborated with David Tudor and the scientist and sculptor Carson Jeffries in 1969–70 to produce the mixed-media works *Video-Laser I* and *II*, shown in Oakland, California, and at the World Fair in Osaka, Japan. It was on the latter occasion that a highly constructive cooperation between artists of different disciplines was established. Lowell Cross's contribution was an important one: with the aid of a krypton laser he produced graphic beams in blue, red, green and yellow which, by way of a vibrating mirror system, oscillated in harmony with the intensity and the variations of the sound.

The American composer and Light artist Paul Earls treats the laser as a musically responsive visual medium. Among his numerous laser works and events, we can single out *The Laser Circus*, produced with Otto Piene in 1980; the Sky Opera *Icarus*, with text by Ian Strasfogel and visual designs by Otto Piene and Günther Schneider-Siemssen, which was performed in Linz (1982), Munich (1983) and Cambridge, Mass.

45, 46
Paul Earls in his M.I.T. studio, and one of his 1988 laser images

47
Otto Piene/Paul Earls the sky opera *Icarus* (1983)

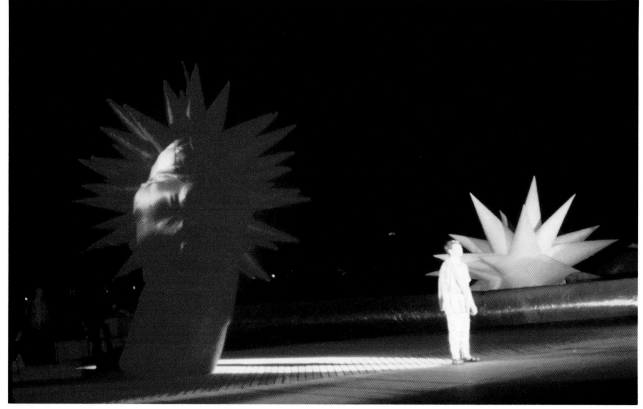

(1984); the laser projections on water screens entitled *Aqua Mirage* (with Joan Brigham) at Washington, D.C. and Cambridge, Mass.; and the piece *Augenmusik* (Eye Music) for chamber orchestra and lasers at Cambridge the same year.

Paul Earls's artistic aims can be gathered from a statement published in the exhibition catalogue *Otto Piene und das CAVS* at the Badischer Kunstverein in Karlsruhe in 1988: 'Beauty, power, mystery, poetry, wit, eloquence, evocative, evolutional, unique, derivative, virtuosic, subtle, direct, playful, transparent, abstract, enigmatic, complex, multi-layered, effortless, sophisticated, simple, distinct personality – all [these] qualities [can be] found in the best music, such as a Mozart opera. It is my ambition also.'

In another statement of aims he says, 'To create new work that neither I nor anyone else has ever experienced before which integrates the senses and celebrates life.' That was printed in the catalogue of the LightsOROT exhibition in 1988 at the Yeshiva University Museum in New York, where Earls showed, among other works and again in collaboration with Otto Piene, *Firmament*, a series of laser projections and laser images

combined with an environmental sound composition. The visual component of this work had two parts, both sharing the same argon laser beam: a computer-generated series of images related to the graphic and verbal tradition of Judaism and a diffracted colour play with green, blue and purple patterns and dots.

Earls uses the laser beam for its unique physical characteristics. It travels across space without spreading; it retains its power at a distance; it has a single wavelength composition; it embodies power and heat in the form of light; and 'its sensed character is of a living, vibrant, life-in-light'. Laser images are created within the eye and the brain, which interprets fast movements of light as lines rather than as movement. These two-dimensional images can take on three-dimensionality through animation and modulation, which Earls achieves by the use of music and sound to expand, contrast and rotate the images.

In the extensive body of work by the composer, architect and artist Iannis Xenakis, the laser plays only a secondary role. Yet he has produced some impressive combined displays, such as the *Polytopes* and the *Diatope*, involving programmed electronic flares, elec-

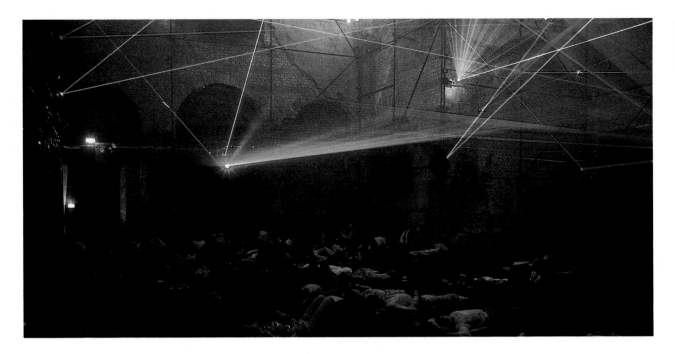

50
Iannis Xenakis
Polytope II (1972)
Paris

tronic music and reflected laser beams in large interior spaces. His Polytope research had already begun in the 1960s and culminated first in the large and long manifestation, *Polytope II*, at the Roman baths off the Boulevard Saint-Michel (Cluny) in Paris in 1972. This was a strong audio-visual spectacle in a vast and complex interior space, somehow imitating the cosmos. As for the *Diatope*, first shown in 1978 in front of the Centre Pompidou, Paris, its aural elements were based on instrumental music and on noises from natural and other materials (stones, paper, etc.), as well as computer-generated sound. The visual elements were made up of 1,600 electronic flares, four laser beams and 400 mirrors and various other light-reflecting materials. Light and sound combined in a computer-controlled composition of spectacular dimensions. The cosmic connotation was stressed by the fact that all sorts of 'galaxies' were created by the use of electronic flares.

In the theatrical area, artistic intervention has been attempted by Joël Stein and Carl Fredrik Reuterswärd. Stein, true to his erstwhile allegiance to the Groupe de Recherche d'Art Visuel de Paris, used the laser with an environmental purpose as well as to implicate the

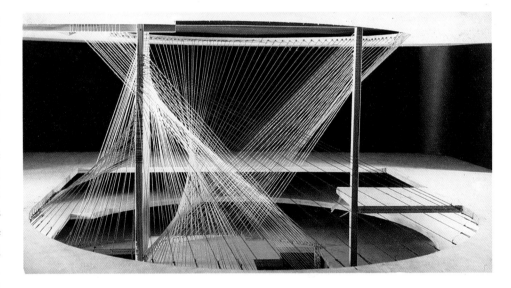

51
Iannis Xenakis
Polytope (1967)
shown in the French Pavilion
at the Montreal World's Fair

spectator entirely in the creative process. On the subject of a luminous environment realized with a laser and pulsation mirrors, he wrote in the journal *Leonardo* (vol. 3, 1970),

> The beam is reflected in one or several mirrors which are either fixed or cut out in spirals enlivened by regular pulses. This beam is multiplied according to the acceleration of a mobile reflector and describes a variable circuit – wall, floor, ceiling. Manipulable mirrors, kinds of light castanets, have been arranged and these allow the direct intervention of the spectator, who works upon a beam that has been recovered.

Carl Fredrik Reuterswärd, an early pioneer and all-round artist in the medium, uses the laser in the spirit of Pop Art and the Fluxus Group. His attitude reveals a desire to surprise and trap the spectator. From 1962, he kept a 'laser diary' for ten years. In 1969 he combined laser beams and laser/video images for theatrical productions in Stockholm. His earliest projects for laser environmental displays in urban surroundings were never actually realized, although they probably played a certain role in the practical research of other artists. Reuterswärd, however, produced what he calls 'lazy lasers', i.e., soft, eccentric laser beams reflected by metal foil, and a certain number of laser images, laser diffractions, three-dimensional laser designs and also some holograms.

Holography is a two-step image-forming process in which an intermediate record is made of the complex optical field associated with an object. The wave-front reconstruction process (now called holography) was first described by Dennis Gabor, a Hungarian physicist, with a specific application in mind – improvement of the resolution of images formed with electron beams.

To produce a hologram, a single beam emitted from a laser is split in two by a thin, semi-transparent plate, producing a reference beam and a light beam. The direction of the beams is controlled by mirrors. Because the beams are narrow, a system of lenses and pinholes along their path spreads them out. The light beam is directed to, then reflected by, the selected object. When the light beam is reunited with the reference beam, the two sets of light waves interact and form a pattern of interference fringes, which is recorded on a photographic film. This becomes the hologram, which under ordinary conditions appears to be an unrecognizable pattern of strips and whorls, but which, when illuminated by a coherent light source such as a laser, organizes the light into a three-dimensional representation of the original object.

The invention of the hologram by Gabor in 1948 was followed in 1961 by Yuri N. Denisyuk's production of a white-light monochromatic hologram and by Emmett Leith's and Juris Upatnieks's discovery of laser transmission, which permitted the first holograms of three-dimensional objects to be shown. An invention in the field of white light transmission by Stephen A. Benton in 1968 allowed the image to be viewed in a succession of spectral colours in 'rainbow holograms'.

A hologram can be thought of as an active optical element and as both a part of, and the consequence of, the totality of optical elements involved in its making.

In order to build an historically legitimate aesthetic of holography one has to detach oneself from dependence upon the photographic paradigm so important in understanding computer art. The persistence of this paradigm reveals itself especially in the overemphasized 'third' dimension of holography. Taking a different viewpoint, one can postulate the 'self-creating power of light' as the creative foundation of the holographic medium. Certain theorists, in identifying the role of light in the history of art (here especially the symbolic significance and material presence and effects of light), tend to dismiss the pertinence of holography's relationship to one-point perspective image construction in the Renaissance, and relate it more to pyrotechnics than to painting.

Unlike a normal picture, a hologram manifests itself as something that first appeals to the tactile and motor senses. Only through the skilful interaction of the tactile and the visual does it release its holographic

54
Carl Fredrik Reuterswärd
Kilroy (1962–71)
hologram at the Musée
national d'art moderne,
Centre Pompidou, Paris

image. Only when we hold it in our hands like a mirror and move it back and forth, or when we look at it from various angles, is it possible to discover something similar to a picture.

Just as holographic optics brings about a rupture with geometric optics, holographic space is no longer explainable in the sense of classical Euclidean geometry. Unlike perspective space, which left its imprint on three-dimensional visualization and our conceptualizations in general, holographic space is not imaginable as a purely functional mathematical construction but is experienced as an indefinite phenomenon, which corresponds, according to Zec, to the everyday experience of Postmodern culture.

The holograph is not only a product or a tool, but a statement of specific effects based on an autonomous structure of its medium, light. Zec maintains that holographic space cannot copy reality, and that the aesthetic effect of holographic space as well as its substantial existence derive solely from the self-creating energy of light to which holography gives absolute priority.

As light is not only a generative principle but a subject and the basic substance of the holographic image as well, the self-reference of light represents an essential form for the articulation of the holographic message. Independent of colour pigments and the referential relation to material reality, holography opens up a wide spectrum for aesthetic realization in its original Greek meaning of 'sensation'. It is the barely observable, minute differences between the object beam and the reference beam which produce the aesthetic message of holography. Moreover, holographic space creates the actual contents of the aesthetic message in which physiological seeing 'interferes' with the psychological way in which the aesthetic effect of holography is received.[2]

The most prominent artists in the area of laser and holographic art are Margaret Benyon, Harriet Casdin-Silver, Dieter Jung, Paula Dawson, Michael Wenyon and Susan Gamble, Rudie Berkhout, Georges Dyens, Douglas Tyler and Shunsike Mitamura.

We may wonder about the relationship between the technical and aesthetic in the work of a pioneer in holographic art like Margaret Benyon. Benyon has certainly used the various techniques described above, such as light-monochromatic holograms, three-dimensional object holograms, white-light transmission holograms and 'rainbow holograms' for a multiplicity of purposes, with the special aim of bridging the gap between high technology and ordinary human perception. She has used holograms as a reminder of the immaterial dimensions of the material world as well as a mass-communication medium for questioning and subverting stereotyped thinking before making pulsed laser holograms of human beings themselves.

At the beginning, the sole technique available to her as a female hologrammatic artist working alone in Britain was the laser transmission hologram, which could only be exhibited with specialized light sources and in darkened conditions. Her early pieces continued her preoccupations as a painter within holography, before she used unique aspects of the medium which allowed her to introduce unfamiliar notions about space, time-reversed imagery and double exposures in which

two solids seemed to share the same space. She made 'non-holograms' that showed motion invisible to the naked eye, 'solid-holes' and 'three-dimensional silhouettes'. In 1972 she began to make holograms addressing themselves to the dangers for society which she saw arising from the increasing sophistication of holography and of technology generally.

In the phase that followed from the mid-'70s, Benyon adopted an associative, cross-cultural, even holistic approach catalysed by holography. Her *Cosmetic Series* (1986–87) stems from the idea that the use of our bodies, painted for the ritual of dance, is likely to have preceded cave painting as the first expression of human culture. The images of the *Cosmetic Series* adopt a form appropriate to the present day in making use of the pulsed hologram. The pulsed laser 'freezes' moving subjects for the duration of the holographic exposure and enables the artist to make three-dimensional images of real people. Sometimes the laser beam has been used in the double-pulse mode. The images of the *Cosmetic Series* show faces of young women, painted to make themselves beautiful. A carefully registered painting is placed underneath the hologram, so that both become fused into one image. The ideas underlying these portraits are cultural, socio-political, art-historical, documentary, psychological and personal.[3]

Harriet Casdin-Silver is an artist who has collaborated with an engineer, Stephen Benton, in making her holographic images. Before 1968, she had been constructing stainless steel environments that incorporated sound, lighting effects and participation from the spectators, who entered her installations draped in mylar clothing of their own design, thereby blending, in both texture and colour value, with the steel. In searching for lighting that was more sophisticated, Casdin-Silver discovered holography and its luminous and spatial possibilities. She finally opted for holography as her principal artistic medium in 1968 and began using laser lights alone to form the initial configurations, eliminating the object altogether. For a while she deviated from her original aim of communicating feminist and socio-political ideas to concentrate on the phantasmagoria she could create in a laboratory with her laser light configurations and the freedom they generated to expand holographic techniques. Casdin-Silver's holograms fully materialized when she started to work

56
Margaret Benyon
Cosmetic Series, Richard Hamilton (1991)

57
Margaret Benyon
Cosmetic Series and others (1987–88) shown at Artec '89, Nagoya, Japan

with Stephen Benton in 1972. Their first collaboration was *Cobweb Space*, containing both a laser transmission hologram and a white-light transmission hologram, each measuring 11 × 14 in. In this work the artist's first concern was the composition. For numerous reasons, she chose a rectangular glass fishbowl through which to beam the object light against ground glass. A problem existed in that the chosen pattern of light on the ground glass was, of course, two-dimensional, whereas the intended aim was three-dimensionality. The second-generation factor of the white-light transmission system solved this problem. With diverging beams and no collimating lens, the second-generation process can round and expand the image. The further the image is projected in front of the plate, the more it will enlarge and distort.

After having created (in collaboration with Benton) a number of multi-coloured white-light transmission holograms (*Hologram IX*, 1972, for example)

and some laser transmission holograms (*Holos 17*, 1973, for example), Casdin-Silver joined Brown University where she produced the *Sphere* series, entirely composed of laser light (there was no real object in the optical system). Here the illusory form projecting through the plate and back again seems to curve the flatness of the plate; the glass and sphere attain a symbiotic relationship.

From this point onwards, and in part because of her feminist position, Casdin-Silver has undertaken the conceptualization and technical production of her holograms alone. From 1975, after having used the laser light in many forms, she realized her socio-political commitment through holographic art, for example, in *Phalli* (1975), in which white-light transmission imagery is frontally projected to a depth of 3 ft.

After having moved to the Center for Advanced Visual Studies at the Massachusetts Institute of Technology in 1976, her interest in environmental art

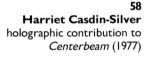

58
Harriet Casdin-Silver
holographic contribution to
Centerbeam (1977)

received a new impetus resulting in the *Equivocal Forks, Series I and II*. Made with spectral colours, these formed part of the Center's collective 144 ft environmental outdoor sculpture, *Centerbeam*, first presented in 1977 at Documenta 6 in Kassel. A year later it was exhibited near the Smithsonian Institution's Air and Space Museum in Washington. The project included the manipulation of holographic images by the mirror trackers (most of the holograms were using a solar tracking system). To reconstruct images by themselves, spectator-participants could manually manipulate two additional trackers.

Following this installation, Casdin-Silver engaged herself more closely with feminist issues in pieces such as *A Woman*, *Compton I and II*, *Beth Dara* and *Karen Stefani*, and the development of interactive environments whose prototype was her stainless steel work, *Exhaust* (1968).[4] Her latest works are the holograms created at the Ukrainian Institute of Physics in Kiev in 1989 and shown at the Museum of Holography in New York in 1991, as well as her collaboration with the United States and Hologram Industries in Paris, resulting in a hologram entitled *The Venus of Willendorf*, which replaced the Paleolithic fertility figure by a live model. *Ikony 1989*, one of the three installations at the Museum of Holography, can be interpreted as symbolic of the relationship between religion and mass media; it also comments on the fear that the collapsed authoritarianism of the USSR will be assumed by the Church.

The German artist Dieter Jung started painting in 1972 a cycle of portraits on canvas in vertically and horizontally oscillating lines whose patterns reiterated the warp and weft of the support itself.

Jung's first holograms in 1977 were off-axis transmission holograms, which projected laser-light viewable images of feathers. The fine translucent structures within the real feathers refracted and reflected the light, scattering their own iridescent optical illusions and fractal beauty.

These experiences were the basis for Jung's holographic art production. One of his first projects was done in collaboration with a scientist, Donald White. It

59
Harriet Casdin-Silver
Venus of Willendorf (1991)

was the transfiguration of two poems by Hans Magnus Enzensberger, both entitled 'Hologram' and written specifically for Jung's works. One in German begins with: 'Dieser Satz hier liegt in der Luft' (This sentence lies here in the air . . .), the one in English with 'It is easy to build a poem in the air'.[5]

The first poem was mounted in a diaphanous tube in which the letters were projected as both real and virtual images. The second poem became a 360–degree

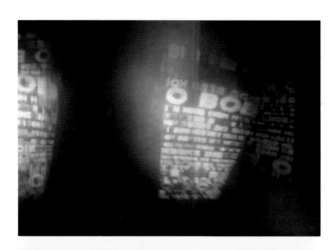

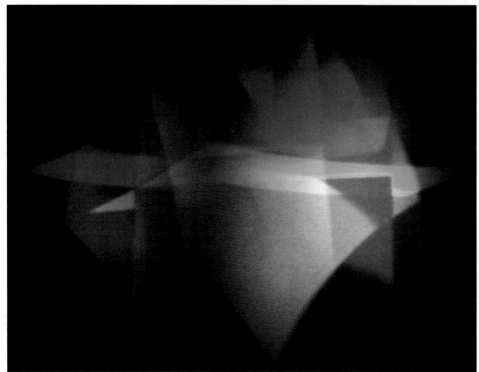

integral hologram, with the poem hovering as a spiral in a cylinder and its title serving as the vertical axis. This was a way to get words off the page and into space.

Jung was particularly fascinated by the rainbow and used Benton's rainbow holographic techniques to produce several holographic cycles: the multi-slit full-colour hologram *Butterfly* (1982), *Feather Shadows* and *Into the Rainbow* (1983), and the multi-exposure holograms *Present Space* (1984), *Different Space* (1985), *Illuminations* and *Sun Dial* (both 1986). These project their colour fields in wide vertical bands in front of, and behind, the image plane. They can only be experienced as a spatially indefinable artistic effect of changing colourful shadows of light which melt into air in the absence of a viewer.

The multi-slit and one-step rainbow techniques offer a unique light palette for subtle additive colour mixing in the air. 'Real' animation can be achieved through extra lenses, light traps, obstacles and manipulation of the slits, reference and object beams. The Venezuelan holographic artist Ruben Nuñez has called this 'holo-kinetics'.

Also at the end of 1985, Jung transposed another poem/text by Enzensberger, organizing the horizontal and symmetrically arranged letters 'BIBI BEI BOB' with computer-generated and animated integral techniques. Jung tries to incorporate the visual knowledge learnt from his work in traditional media with the delicate technology of holography in order to explore the aesthetic and artistic potential of various holographic techniques, to stimulate spatial imagination and orientation, to generate new mental images, to experience different dimensions, to visualize the sensation of spatial fusion and finally to reflect and redefine his old media through these explorations.[6]

A particular specialization of the Australian artist Paula Dawson are her large-scale holograms. In 1980 she made an installation incorporating a laser transmission hologram simulating a whole room, entitled *There Is No Place Like Home* (plate size 1500 × 950 mm, image size 3000 × 3000 × 2800 mm). This work, which necessitated a hologram of a much larger scale than had

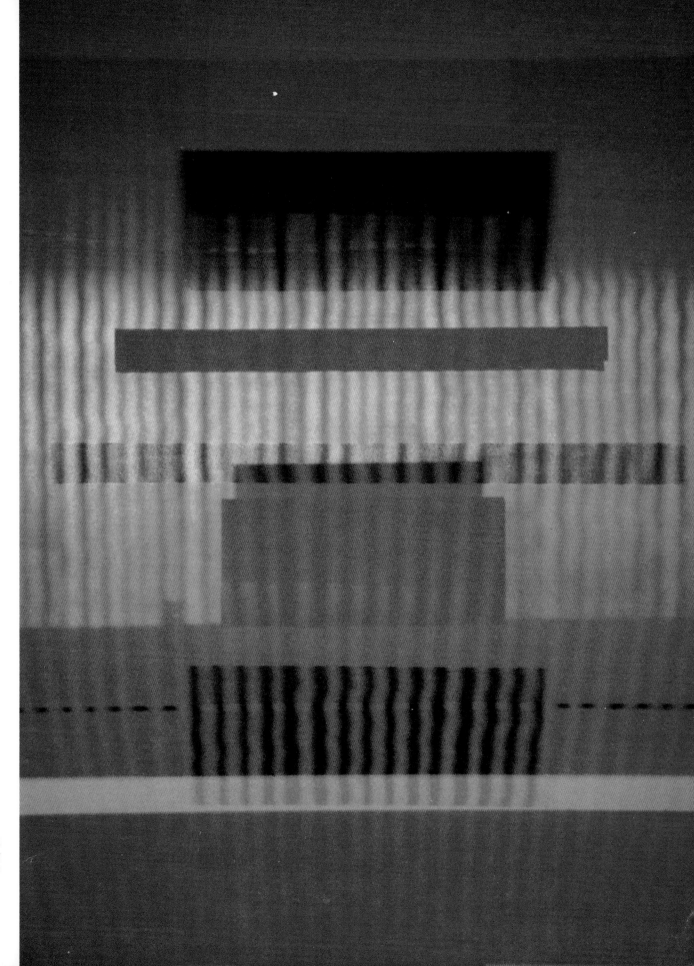

62
Dieter Jung
Different Space (1985)

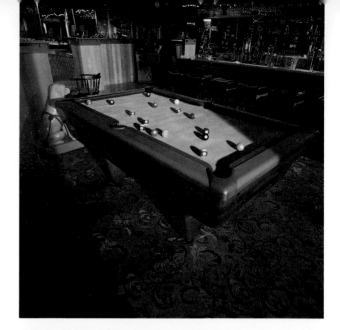

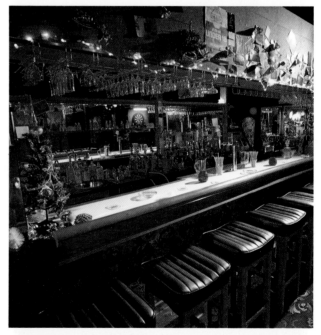

63–65
Paula Dawson
To Absent Friends (1989)

previously been attempted anywhere in the world, was finally realized at the O.B.E. laboratories in Besançon, France.

In *Eidola Suite* (1985), an installation incorporating three laser transmission holograms (plate size 1500 × 950 mm, image size 3000 × 3000 × 5000 mm), Dawson represented different 'moments' of a suburban house, the present moment of the empty central structure, and, through windows on each side of it, the past life of the site as a treed landscape on the right, and to the left a backyard scene representing its future. In the first instance, in presenting an experience not usually encountered in a gallery, *Eidola Suite* may be regarded as pure spectacle. Its sophisticated construction inspires a 'technological wonder' which can recreate the world before the eyes of the spectator. This is the form of 'enframing' which Heidegger saw as the dominant mode of presencing in the technological era.[7] Dawson also dealt in this tri-partite structure with the

66
Paula Dawson
Eidola Suite (1985)

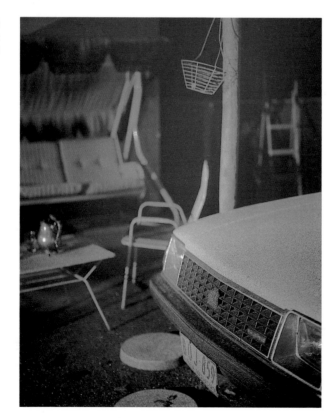

partial desiccation of the material world through time.[8] *Eidola Suite* calls for an alternative awareness of time as being formed out of the familiar objects of the lived environment and enduring in a way such as is experienced in performances and stories.

In more recent work such as *To Absent Friends* (1989), the central theme of which is memory, Dawson has created a complex installation involving performance and film, and incorporating holographic images recorded by a variety of techniques. Three large laser transmission holograms represent the reflective surfaces of furnishings in a typical Australian 'pub' bar (plate size 1500 × 950 mm, image size ranges up to 8000 × 30,000 × 3000 mm). Its theme is explored by using an ancient Greek mnemonic technique in which students walked through a well-known building or architectural structure, being careful to remember the path they took. Having memorized the place, they were able to use it on a wax writing tablet, placing informational data on each part of the building as they encountered it on their walk. To recall a piece of information, they had simply to visualize themselves returning to that part of the building. The holographic images of *To Absent Friends* reproduce various points in time during a New Year's Eve celebration as metaphors of the processes of memory. The holograms behind the bar define the same object, e.g., the juke box, in a number of locations, as though the image were remembered through the perspective of many lives. The picture plane of the hologram, like midnight on New Year's Eve, symbolically separates past and future. The main purpose of *To Absent Friends* is a plea to use contemporary architecture as a memory repository, not of factual information, but of emotional states.[9]

In 1980, the optical engineer Michael Wenyon and the artist Susan Gamble created the holography facility at Goldsmith's College in London, the first workshop in Europe dedicated to exploring the artistic applications of holography. In 1983 they began their active artistic partnership and produced a number of long horizontal double-plate holograms presented on an easel, often with speckled effects. The colours in these holograms,

67
The studio of **Michael Wenyon** and **Susan Gamble** at the Royal Greenwich Observatory, London, 1987

coming from chemicals, swell or shrink the emulsion. Otherwise all the colours would be red, the colour of the laser. The works with speckle effects use reticulated patterns of coloured light based on this particular side-effect of laser light called 'laser speckle'. This occurs more or less naturally whenever a laser beam lights up an object, but the artist can change the size of the pattern, use a combination of speckle patterns and pure spectral colours in order to mimic natural and biological processes, or create a new synthetic patterning. In a work called *Coal Seam*, stretched-out speckles appear to be flames; and in another, entitled *Water Stretch*, they emulate the flowing of water.

After a residency as artists at the Royal Greenwich Observatory in 1986 and 1988, Wenyon and Gamble produced some remarkable holographic installations in line with their aim of presenting an image of a universe of their own making. For example, *Zodiac* is a thin strip of clear glass through which the viewer sees an infinite field of red 'stars'. They want the viewer's experience to be like looking through a narrow 'letter-box' aperture; a larger space appears behind, up, and beyond the edges of the glass. This work is completed by an electric

68–70
Michael Wenyon and
Susan Gamble
Stella Maris (1989); *The
Fringes at the Shadows of the
Knives* (1987); *Zone One*
(1989)

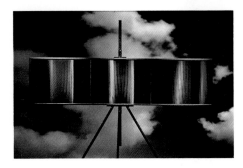

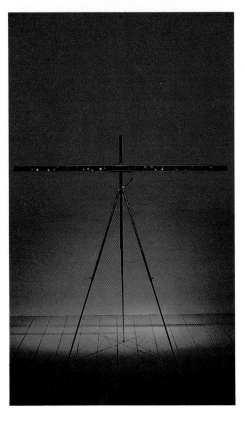

dimmer system alternating slowly to fade the lights between the red hologram and the blue background, mimicking the effects of stars appearing in a twilight sky.

This piece is the first part of a larger installation incorporating many thin horizontal holographic elements, shown under the title of *The Heavens* at the Karlsruhe Media Festival in Germany in 1989. Wenyon and Gamble's purpose is to explore, as in an actual living theatrical performance, the properties of the hologram, since it seems to be a moving image of light with a kind of life of its own, and not a static pictorial image. They look on the history of astronomy as a model for interpreting the secrets of the cosmos. They wish to imitate this fact on an artistic level by creating their own abstract patterns of light, to be decoded through an 'optical reading'.

Two recent series of large-scale holograms, *Stella Maris* and *Radii* (both 1989), are based on these artistic intentions. In *Stella Maris* Wenyon and Gamble create a simple receding space made out of optical caustics – an

inherent property of light that can be seen, for example, as a pattern under water. *Radii* presents the experience of light at the end of a tunnel and recalls looking at a distant light through a telescope.

Although Wenyon and Gamble are, in the first place, interested in capturing light as a concrete phenomenon presented through the hologram in its original optical state, on a more poetic level they see the optical devices and the space they create as a visual expression of the current interest of science in the chaotic qualities of the universe.[10]

The work of Rudie Berkhout, a Dutch fashion designer and expert in stage lighting, who discovered holography while in the U.S.A., is diverse in form. It runs from single black-and-white transmission holograms that can be seen in white light, using a large lens system and focusing the image on the holographic plate, via the Benton white-light transmission holograms with an extra reference beam to arrange and line up the different colours that produce white light, to a new use of Holographic Optical Elements (HOEs) in the image-making process that results in animated imagery. These technical changes have also involved an aesthetic transition from geometric abstracts to organically based compositions.

Berkhout set out in 1978 to develop his image and colour multiplication techniques by using a cube and two spheres, which were recorded in three master holograms. With the help of a holographic optical element that he designed especially for this task, he made many cubes and spheres from the original masters. The HOE 1 was basically a lens containing many focal points arranged in a three-dimensional grid, through which the masters were multiplied.

Holographic image-making is for Berkhout a fascinating experience since it is the result of pure optical processing, which is not possible in any other medium. The result seems to him to be related to sub-atomic interactivity. What he finds unique about holography is the fact that the image is simultaneously present and absent, depending on the viewer's position. Being able to see the work from the sides and from

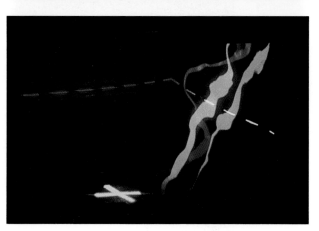

71–73
Rudie Berkhout
Deltawork; Delta II; Delta IV
(all 1982)

74
Rudie Berkhout
Overland (1987)

behind allows the viewer to examine and consider all angles of the image. The holographic animation process developed by Berkhout after 1980 enabled him to 'draw' with light – as exemplified in *Event Horizon* and *Vasarely Space*. In the latter, he played with the three-dimensional possibilities of the optical effects that Vasarely had achieved in a two-dimensional format.

In 1982 Berkhout constructed a holographic viewfinder that helps during the process of composing the image and colours of the finished plate. It forms a dotted rectangular outline that represents the transfer plate in the image space of the maker and was the inspiration for works like *Deltawerk*, *Delta II* and *Delta IV*, all incorporating dotted outlines of curved surfaces that interact with each other.

From 1989 Berkhout's main goal has been to render the image-making process more organic, immediate and direct so that he could express more personal thoughts. With this aim in mind, he produced many works that oscillated between landscape and abstract painting in order to create a feeling of expansiveness and

75
Georges Dyens
Big Bang II (1987)
exhibited at Rheims in 1991

to challenge the viewer's perceptual presuppositions. His hope is to reach subtle levels of perception with the aid of both nature and technology while mirroring the 'magic' world in which we live.[11]

Georges Dyens discovered holography at the beginning of the '80s when he was searching for a way to show his works as floating freely in space, to create spatial landscapes devoid of vertical and horizontal dimensions, weightless environments in which the viewers are able to face their existential anxieties. In Dyens's work, both sculpture and holography are conceived of as organic tools of communication. Because of its diaphanous, ethereal and luminous nature, holography provides a striking and poetic contrast to the solid sculpture with which it is combined in his works. Suspended in time and space, these 'Holosculptures' evolve within intermediate realms between the dynamic and the static, unity and disunity, life and death. They are meant to be symbols of a philosophical perspective, lying outside the ephemeral nature of schools and movements. They represent an inner world concerned with the nature and meaning of existence, the fragility of life and the human quest for balance within the universe.

To Dyens, holography is both real and immaterial, illusionistic and magical; it is about light and light *is* colour. Holography offers him the creation of an infinite, constantly moving space in which shapes move in a close relationship made visible by external light.

Light, symbolic of spirituality, plays an essential part in his work. He now creates his sculpture with a laser beam rather than a chisel and he paints with dimmers and spotlights rather than brushes. His mingling of tangible sculpture with intangible holography is close to nature where tangible and intangible elements (earth-water/air-fire) combine to create a whole universe.

In *Big Bang II* (a multi-media installation 36 to 50 ft in diameter, constituting a sculptural environment), 24 bleached, rainbow transmission holograms (12 × 22 in. each), 30,000 ft of fibre optics (the most economical lighting tool), electroacoustic music, a programmed electronic system and a high fidelity stereo system were used to create an infinite starry space with a multitude of varied shapes in an attempt to comment not only on the short-sightedness of our technological civilization, but also on the role everyone is playing in a universal drama represented by this astrophysical mythos.[12]

Douglas Tyler's stained-glass holographic installations entitled *Light Dreams*, shown at the 'Light Art' exhibition in Rheims in 1991, form part of his *Dream Passage* series. Tyler, born in 1949 in Detroit, Michigan, first achieved notoriety as a muralist. He began working with holography in the later 1970s and has since advocated the expressive use of the medium by writing and lecturing on holography as well as organizing exhibitions and teaching holography courses. Tyler's installations enable him to explore the interaction between artist, public and artwork. He writes:

> There is something inherently exciting for me in the medium of holography. On the one hand, there is the uniqueness and on the other hand, there is the mysterious illusion of dimensionality. More importantly, however, for my work, holography is an interactive medium, one in which artist, artwork and viewer share in a dynamic and symbolic relationship. Although all artwork involves some type of exchange between artist and audience, the medium of holography escalates the activity level of the key players in such an exchange, and the exchange, in turn, becomes a highly dynamic dialogue. As we travel through the diaphanous spaces of a hologram, we converse with our mutual existences.[13]

The kinds of spiritual and metaphysical implications and aspirations associated with Dyens's work are also important to the Japanese artist, Shunsike Mitamura. His rainbow hologram, *Apple in the Eye* (1982), which consists of a wire mesh used to form the shape of the human eye, creates a moiré effect, as in his *Heliostat in Aqua*, a mixed-media installation which puts the stress on colour. In the latter, colour is captured in a rather small hologram that is exposed under water on a mirrored surface. With the hologram acting as an optical lens, the water is put in motion by an electric motor and a rippling pattern of waves reflects on the walls and ceiling. He has claimed that with this 'luminous meditation' he would 'develop a spiritual space which has never been seen.'[14]

Of the work of the new generation of holographic artists, one could mention the researches into colour manipulation in holography by Pascal Gauchet with his *Mirage, Moirage* (1988), and his holographic and sonorous environments, such as *The Colours of Time* (1991), a luminous reconstruction of a pebble beach, framed by clouds projected onto screens of translucent mesh and with the rhythmic sound of the waves breaking on the seashore. A line of reflection holograms cuts across the horizon: the image of the textured painted surface progressively cracks and peels off in

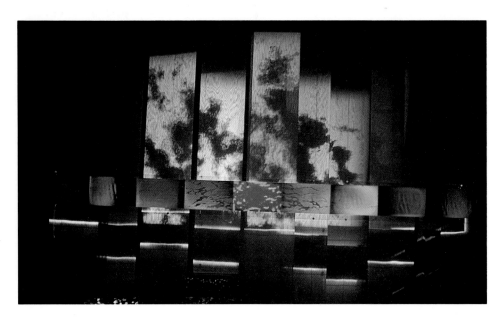

colourful splinters, gradually revealing the image of a cloudy sky. The installation is an invitation to a journey into an imaginary world, a door in time between the tangible and the intangible.

Another artist of the new generation is Brigitte Burgmer, who, when working on her first pulsed white-light reflection hologram, *Cartesian Portrait of a Young Painter* (1982), came across the phenomenon of anamorphosis. This assumed an important place in her subsequent holographic production. She discovered that under certain circumstances holographic anamorphosis based on the geometric theory of optical imaging shows that there is not only a hidden but an obvious relationship between the two phenomena, anamorphosis and holography. While a photograph records a subject point to point, in a hologram the information is spread across the film. An anamorphosis can be represented in a drawing constructed on a two-dimensional surface or in a hologram of a three-dimensional subject.[15]

The hidden relationship between the totally invisible storage mechanism of holograms and the visible code of anamorphosis can be shown up by pseudoscopic

holographic reconstruction, where optical distortion alters the abstract form. It is difficult, however, to calculate the distortion needed in the model. Burgmer experimented with an anamorphic drawing by Leonardo, *Anamorphic Sketches of a Child's Head and an Eye* (1985), in order to produce a white-light reflection hologram in a plexiglass frame, entitled *Leonardo's Baby*, in which the anamorphic effect is caused more by the model than by the holographic technique.

Burgmer bases her research on the union of holography and anamorphosis, but she also takes into account that there is a fundamental difference between holographic anamorphosis and anamorphic drawings since, unlike the latter, holograms can be considered as a

'lens system', for the laws of optics as well as the rules of central projection have an effect on the hologram.

However, in her 1987 book *Holographic Art – Perception, Evolution, Future*,[16] she explains that a completely different relationship comes about through the real pseudoscopic reconstruction of a subject. For example, in a hologrammatic portrait-collage produced in the same year, entitled *Holographic Anamorphosis for L. d. V.*, she exhibited a white-light reflection hologram in which, when viewed from the right side, the right face turns into a pure profile while the left face stretches to two or three times the original size. This effect is reversed when the piece is viewed from the left side.

Philippe Boissonnet has explored some of the formal characteristics of the hologram in terms of its conceptual implications, these being in particular the ideas of simulation (of the natural by the artificial) and of cloning (from the unique to the multiple).

The group of works he produced in 1987 and 1988, consisting of nine pieces bearing the title *L'Ombre d'un Doute* (*The Shadow of a Doubt*), explores the equivocal relationship between presence and absence, one of the principal characteristics of holography. The kinship that holograms have with hallucination and mirage led Boissonnet both to a theoretical reflection on the philosophical and literary tradition of the imaginary Double as related to the image of the body, and to its application in a pulsed holography installation.[17] Thus in *The Shadow of a Doubt* he was interested more in the classical representation of a torso as an emblematic model of Western classical culture than in the representation of a particular body. His research also relates to Postmodernist concerns with borrowing, quotation and hybridization of types, styles and materials.

John Kaufman can be considered a specialist in multi-coloured reflection holography. This particularly delicate technique involves exposing the holographic plate several times, having previously treated the emulsion chemically.

Kaufman's home is situated on the San Andreas fault in California and his work reflects this precariousness. Inspired by the natural forces which surround

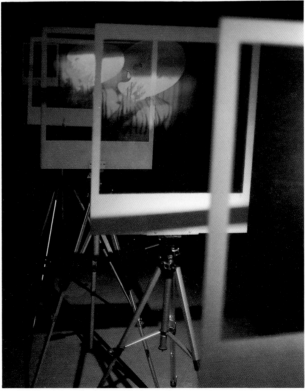

80, 81
Philippe Boissonnet
De Profundis (1989)

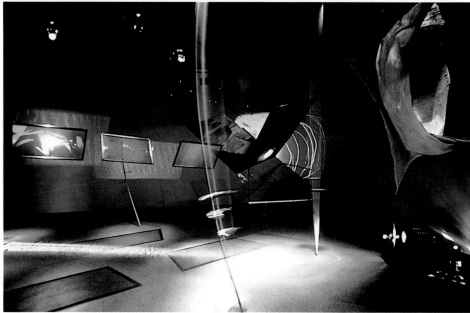

82
John Kaufman
#76 (1988)

83
Doris Vila
Heaven, Home and Weightlessness (1989)

him, the choice of colours in his holograms of volcanic rocks reflects the tension of the internal geologic forces.

Kaufman states that 'The greatest potential of holography lies in its position mid-way between reality as we can see it and a version of reality that we are able to record.'[18]

The young artist Doris Vila has based her holographic works on the compelling fascination of images of light floating weightlessly in air. Technically, holography presents the opportunity to develop a working language of light and space by coupling transparencies of colour volume with textual information. That the objects defy gravity suggests metaphorically that the medium can reach beyond the physical world into a realm where matter slips effortlessly into energy, where idea and emotion build the architecture of memory.

Thus a white-light transmission hologram by Vila entitled *Every Time You'd See an Extra Guy* (1985) provokes multiple readings in layered transparent colour, while in another work, *Late Evening, Early Summer* (1986), a spiral of three-dimensional objects is created. In *Chart: Space-Time-Sex-Money Continuum*, and *Diagrams of an Existential Headache* (both 1987), and *Blueprint for a Meta-natural Power Plant* (1988), all belonging to the *Explication* series, the extension of narrative metaphors is attempted as they point beyond the visible to render a web of ideas and emotions, caught in large volumes of colour.

By working with simplified rainbow geometries, Vila is in fact trying to go beyond holography's technical constraints. She was thus able to produce a series of monotype works, including large-scale pieces, with rainbow holograms formed from spectrally pure colours to pastel tones. The imagery, combining shadowgram, photogram, found object and text, creates a non-linear narrative emphasizing the privacy of the act of perception.[19]

Let us add that Guy Fihman and Claudine Eizykman, members of the University of Paris-VIII, have formed a team that has produced a number of interesting experiments in laser holographic films, one

of them (in memory of Etienne-Jules Marey, a forerunner in cinema who has used this theme for his experiments) creating a very striking, three-dimensional illusion of the flight of sea gulls; and that the Hungarian artist Attila Csaji has produced an extensive series of works in the laser and holographic sphere: laser photos, laser animation films and laser environments, reflection and transmission holograms and shadowgrams. As Lóránd Hegyi remarks in the catalogue to Csaji's one-person show at Budapest-Mücsarnok (9 December 1988 to 17 January 1989): 'It seems that . . . [Csaji] . . . was successful in unifying the activities of the inventor-artist, the informed painter, the conceptual artist, the researcher of technical mediums, the post avant-garde constructors and those who produced newer and newer mediums.' The artist himself, however, puts a poetic accent on his use of light when he states that 'reality is evoked by its transient image and the reality of this image is light.'[20]

Among the artists who have only occasionally ventured into the holographic area, the most prominent are Carl Fredrik Reuterswärd, Salvador Dali, Bruce Nauman, Lowry Burgess, Simone Forti, Amy Greenfeld, Yaacov Agam, Nancy Gorglione, Sam Moree and Dan Schweitzer, some of them using the highly saturated brilliant colour of white-light transmission holograms to make colour structures, delicate scenes and landscapes, or, as in the case of Reuterswärd, a facetious commentary on laser holography. Reuterswärd's *Cross-Reference*, which was shown at the 'Electra' exhibition in Paris in 1983, consisted of a hologram lit by a halogen lamp and represented the artist imitating the appearance and pose of Dali.[21]

The fact that holographic research can be carried out not only with the aid of lasers, but also with other light sources, was already illustrated in the exhibition 'Alice in the Light World', held in Tokyo in 1978.

The variety of the uses of light with an aesthetic purpose, as well as the diversity of the 'universes' to which this phenomenon metaphorically alludes, had already in the 1950s and '60s posed the question of whether the artists do not actually aim at a more

comprehensive meaning involved in the art of light than a purely formal exploration of its effects.

The search for an answer to this question, heralded in the catalogue to the 'Kunst-Licht-Kunst' exhibition in Eindhoven in 1966, has ranged from technically oriented commentaries on optical laws and physiological and psychological responses, to historical and sociological contextualizations and semantic and metaphysical speculations. Due to recent developments in Light Art this discourse has gained in precision as well as conquering new areas. The qualities of light and its generating of colour, its self-creating power and the special effects based on an autonomous structure of the medium itself have been stressed. We may conclude that from both a technical and an aesthetic point of view, laser and holographic art are an outcome of the principal characteristics of Light Art. New theatrical aspects of the laser and holography have been exploited, the quest for a new visual language has been continued and the interplay between perception and illusion, image and reality – issues that concern art in general – has received a new impetus.

84
Carl Fredrik Reuterswärd
Non-violence (1990)

3

Video Art

Video Art originated with the opposition to commercial television that appeared in the practice of certain artists in the early 1960s. Chronologically this can be regarded as beginning with the work of Nam June Paik and Wolf Vostell, first shown at the Gallery Parnasse in Wuppertal in 1963, and the first programme with an experimental treatment of the image, broadcast in 1964 by WGBH-TV of Boston in its 'Broadcast Jazz Workshop'.

From the outset, two different orientations could be observed in the work of video artists. On the one hand there was the use of video cameras as simple recording devices, and on the other there was experimental research conducted through the specifics of electronic systems. Examples of the former are tapes of 'actions' by Vito Acconci, Gilbert and George, Gina Pane and other representatives of Body Art who wished to broaden their documentation, limited until then to texts and still photographs.

The activities of Bruce Nauman, Peter Campus, Wolf Vostell, Joseph Beuys and Robert Rauschenberg stemmed from an analogous procedure, though using the flexibility of the system more fully. Nauman, for example, directed his camera towards his studio and let it run freely to capture each of his gestures. He then simply selected certain sequences for exhibition. Similarly, Peter Campus attached his video camera to the ceiling and recorded the spiral drawn by his body suspended at the end of a rope.

The approach of artists who carried out research on the characteristics of video technology was quite different. The electronic device was considered by them no longer as a simple recording tool, but as a complex artistic means that could be manipulated like pictorial or sculptural materials. Thus, for example, Nam June Paik, who has pursued his investigation through all forms of the medium, has been able to make black-and-white abstract tapes by modifying the disposition of the electronic components inside the video camera.

Four other categories of video work have played an important part in the development of this art form. One involves the use of cameras, monitors and tape recorders

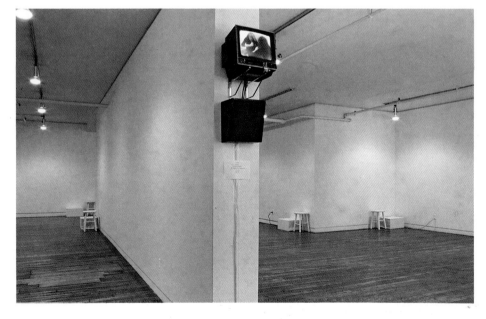

85
Vito Acconci
Airtime (1973)

to build up 'video sculptures', 'video environments' or 'video installations'. This is the category which has been most noticeably developed by artists in the last twenty years. A second category is 'guerilla video', which involves recording everyday street activity with a portable camera, and generally with a political or pedagogical purpose. Although guerilla video was neglected by artists after an initial period of being in fashion, it again attracted the attention of artists in the late 1980s and '90s.

A third category, that of theatrical video performances, has been used consistently by artists since the early 1970s and has been developed into more elaborate forms of video communication works. The fourth category consists of works which combine video equipment with other advanced technologies, particularly the computer in recent art work.

Thus there appear to be at least six different kinds of practice in Video Art: 1) the use of technological means in order to generate visual imagery, including formal research into plastic elements; 2) the considerable range of recording Conceptual Art actions or happenings, often concentrated on the artist's body itself; 3) 'guerilla video'; 4) the combination of video cameras and monitors in sculptures, environments and installations; 5) live performances and communication works involving the use of video; 6) and lastly, combinations of advanced technological research, most often of video with computer.

The most important areas into which the works of prominent artists have until now fallen are no doubt the production of video tapes (covering the first two categories described here) and the creation of three-dimensional works involving the combination of several cameras and monitors, sometimes with a distinct architectural arrangement, whether called video sculptures, video environments or video installations. Also important, but to a lesser extent, has been the area of video performances and other communication works.

One of the most striking characteristics of present-day Video Art is that artists not only create sequences of new images in their installations but also devise completely novel situations in order to view them. In this context, the Belgian artist Marie-Jo Lafontaine, for instance, uses her experience of multiple-source and multiple-screen programmes and time-lag and slow-motion effects in order to produce video installations such as *Round Around the Ring* (1981), a simulated boxing match, or *The Dream of Hephaistos* (1982), in which robot figures assume human roles. *Tears of Steel* (1985–86), shown on 27 monitors, concerns the opposition between the preparatory training of young men and their ultimate use in war, while *Victoria* (1987–88) is an installation in which two men dance a tango. All these installations are concerned with investigating the psychological and physical limits of extreme human situations.

Another artist working predominantly with video installations, Catherine Ikam, also refers to ritualized social behaviour (sport, politics, etc.), incorporating in her works television broadcasts, recorded and treated with video technology. *Fragments of an Archetype, a Tribute to Leonardo Da Vinci* (1980), is a video sculpture in which the famous Leonardo drawing *The Proportions of the Human Body* is reworked. Ikam's version, shown at ARTEC in Nagoya in 1989, added sound and was

86
Catherine Ikam
Fragments of an Archetype
(1980)

intended to modernize Leonardo's vision of humanity and at the same time celebrate the bicentenary of the Declaration of Human Rights in France.

Ikam's extremely varied practice has arrived at the beginning of the 1990s at research into the combined technologies of polaroid photography and scanachrome, which has made possible the production of works on large-format sheets of marouflé paper. According to Pierre Restany, this 'painting by computer' thanks to the procedure of scanner printing suggests relationships between Ikam's work and that of Yves Klein, particularly his monochromes and his *Fire Path*.[1]

Also characteristic of the later developments of Video Art are theoretical reflections on the factor of time and the relationships between time and space in this art, their practical applications in video sculptures, environments and installations, the re-adaptation of performances and other theatrical events in conjunction with video technology and, in the most recent examples, the combination of video and computer technologies.

The fundamental difference between cinema and video, even at the experimental level, lies in their respective treatment of the time factor. Video can, and does, represent real time, which, in cinematic projects such as those of Léger and Andy Warhol, emerges as a self-contradictory element. Hermine Freed, who has carried out a detailed study of concepts of time, memory and simultaneity in video, has rightly observed that the question of time is crucial to the importance and meaning of Video Art and that it reflects the change that has taken place during the last twenty years in our sense of time (and place). This change is so far-reaching that today visual sensation is inseparable from its temporal component. Early video tended to be an exploration of those aspects of time which are unique to the medium — an instantaneity resulting from the ability to play back a tape immediately without processing or time delay; and the simultaneity achieved through the use of several cameras or monitors, which makes it possible to record or play back several images in the same place, or several images from different places all at the same time. Indeed the possibilities are endless, and the methodologies vary

enormously. According to Freed, video has a great attraction for the artist precisely because of the spontaneity and simultaneity it makes possible.[2]

Outstanding examples of artists making prominent use of the time element in their works are Dan Graham, Bruce Nauman, John Baldessari and Bruce Wegman, Vito Acconci, and Joan Jonas among the video artists already active in the 1970s; and Thierry Kuentzel, Klaus vom Bruch, Jenny Holzer, Gretchen Bender, Mario Sasso, Nicola Sani and the Studio Azzurro among the more recent generation.

By its nature, video's most important characteristic is its potential for transformation, not its material identity. Bruce Kurtz, in an article entitled 'Present Tense', states that video artists will use the characteristics of Video Art, i.e., newness, intimacy, immediacy, involvement and, above all, a sense of the present tense, more or less deliberately. In Nam June Paik's work, immediacy and intimacy predominate, whereas Beryl Korot's four-channel video work, *Dachau 1974*, weaves very precisely timed, paired images back and forth. Here the time dimension of video is emphatically the present tense.

Space, always the province of the artist, is also shown in its experimental dimensions. Both the time and space dimensions of Video Art relate directly to the integrated sensory and mental responses required for each person to communicate successfully with the information-saturated environment.[3]

The difference between the cinema and video with respect to the spatial factor largely involves the field of projection. The confined two-dimensional nature of the cinema may be overcome in Video Art by several means: by increasing the number of screens in use (Carolee Schneemann and Michael Snow), by contrasting simultaneously the physical representation and the virtuality of the cinematographic image (Valie Export, Birgit and Wilhelm Hein), by dividing the screen into several areas in which images are re-grouped in a series of matching or contrasting combinations (Keith Sonnier), or, finally, by analyzing the mechanisms of the basic projection process (Anthony McCall).

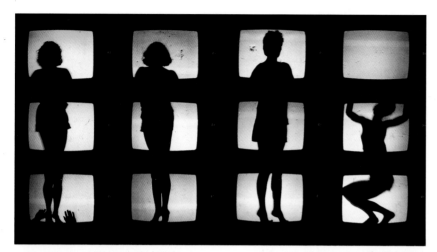

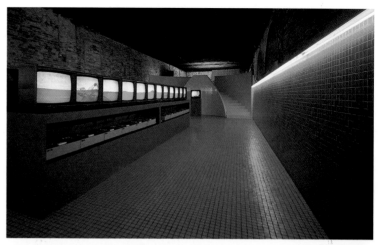

Other differences between cinema and video arise from the conditions in which the images are viewed, the size and shape of the screens, and the element of improvisation to which many artists resort in the process of narration. Through their personal narration, artists working with video try to get around reality, to give unreal colours to the images and force them towards disintegration by only occasionally contrasting observed and experienced time to the point of exhaustion.

The final difference between the cinema and Video Art involves visual presentation. In recent years, as a result of the possibilities which electronics now afford for using computers to analyze and recompose the image, video has been characterized by a specific visual presentation of the videographic image.

The basic difference between television and video lies in the fact that elements of TV's processes of world-wide communication are continually filtered and contradicted by video's different form of creative communication: sound and time of the conventional televised images are altered, distorted and intensified to form a new profile.

In addition to the profound differences between the television screen as a light source and the cinema screen as a field of projection, Video Art has made it possible to combine several images in the same space at the same time, thereby involving the spectator in a previously unknown spatio-temporal dimension. Thus the perceptual structures established by mass-media television are expanded in Video Art, in an approach which redefines the language of televisual communication.

Artistic research into video during the '60s was closely related to such developments as Environmental and Conceptual Art, taking advantage of the temporal dimension specific to the medium. It was during this period, in a climate favourable to the dematerialization of works of art and the rejection of their fetishistic accumulation and exchange in the art market, that Video Art came into being, not only as an expression of adaptation to the new possibilities offered by visual technologies (as had happened in photography and the cinema), but also as a means of producing original images governed by an internal aesthetic code.

We can recall Vittorio Fagone's observation that the term 'video art' refers to the original production of works created especially for video: the recording, often in real time, of acts, performances and events; the juxtaposition within the same space of several video structures, video sculptures and environments; the

cross-media combination of heterogeneous material – transparencies, films, plastic images and objects (installations); and the multi-media amalgamation of televised productions with other techniques and art forms (theatre, dance, etc.).[4]

It has often been suggested that the term Video Art should be applied exclusively to videographic work, but in practice it covers more complex areas. Today it embraces all uses of the medium in the context of artistic production.

Within the framework of Video Art, recordings of performances are not documentaries but representations of actions carried out in time. The creation of new images, in many cases through the use of synthesizers and with no external reference, represents the other intensely creative aspect of Video Art. The most recent works, however, involve contact with other media in addition to the spatial arrangement of the different sources of televised images (which was the original inspiration of video research).

In videographic productions, the video image takes on many different forms: the biographical image, the exploration in continuous time of visual details; the juxtaposition of expanding geometrical forms; differently angled distortions of a meaningful image; temporal narration and analysis. Each of these categories, corresponding to specific videograms, is profoundly marked by the personal intervention of the artist.

In video recordings, the search for dematerialized forms of art, the visual and social perception of the environment, the identification of primordial energies, forces and forms in natural space, and the body as the producer and vehicle of language are highlighted. Video recordings have fixed on tape an image of a living situation, one which is not only documentary but a part of the creative moment, implying a visual and temporal extension of the phenomenon observed. It is no coincidence that the artist (in many cases) directs and signs the video recording of his or her work.

In the case of video sculptures and environments, we can recall that Marshall McLuhan stressed the polysensorial quality of the video image and its tactility. These characteristics are highlighted in video sculptures, complex productions in which the video image is fed through several monitors creating a complex visual construction that reacts to the immediate surroundings. In video environments and installations the spectator is invited to move as if along a path to be explored, for the artist offers a series of comparisons between different points of view and images in an attempt to dislodge the spectator's habitual perceptions.

Video environments and installations also involve spectator participation and the use of different media. Films, slides, soundtracks and objects are used in conjunction with each other, creating a complex and polymorphic plastic image; the interplay between the separation and juxtaposition of images from different

92
Jacques-Louis Nyst and
Danièle Nyst
Saga Sachets (1989)

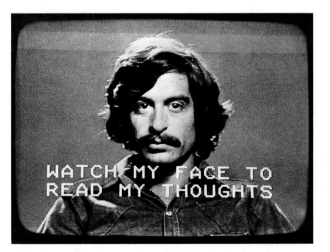

93
Roland Baladi
Telepathy (Watch My Face to Read My Thoughts) (1976)

media produces a series of positive divergences. Video installations currently represent one of the most productive developments in Video Art.

In video performances, the televised image of mass communication and that of video, which made its mark in the early '70s, has profoundly influenced the world of the visual arts, theatre and literature. Video has succeeded in asserting itself in the field of performance where the dividing line between the fine and the performing arts is blurred. A common practice among performing artists today is to turn attention to the television screen, which acts as a mirror, a signal, and above all as a time machine. The televised image also has its place on the stage as a point of reference, counterpoint, reflection or escape.

Many recent combined works of Video and Computer Art put the accent on programming and the treatment of information: these will be dealt with in the next chapter. Yet there are also a certain number of such works which remain, without any doubt, largely in the category of Video Art. These are generally created by artists who have had extensive experience with video tapes before introducing computer graphics and digital images into their works. They can be limited to tapes only or they can be instrumental in the elaboration of video environments and installations.

There are a number of outstanding instances which illustrate the work done in the categories of Video Art we have established, and also offer the opportunity to study the interplay between the technical and aesthetic factors in them. A unique achievement is that of Nam June Paik, the Korean-American artist and musician who was in at the origin of Video Art and who, more than twenty-five years later, continues to dominate the scene with his varied and elaborate video sculptures, environments and installations, while he remains true to his Fluxus-inspired critical position.

Although a case can be made for locating the origin of Video Art with that of television, for example, with Ernie Kovacs's 1952 experiments with disturbing the TV signal, it is generally agreed that it was Paik who really started the movement. Coming to video as an avant-garde musician influenced by John Cage and Karlheinz Stockhausen, he saw television, with its lowbrow reputation, as the perfect means by which to shock the Establishment.

He first used television sets as altered ready-mades, and in *The Moon is the Oldest TV* and other works as self-referential machines capable of generating images from their own mechanisms. His experiments with feedback paralleled the art world's interest in process and materials.

94
Nam June Paik
Moon Is the Oldest TV (1976)

95
Nam June Paik
Arc Double Face (1985)

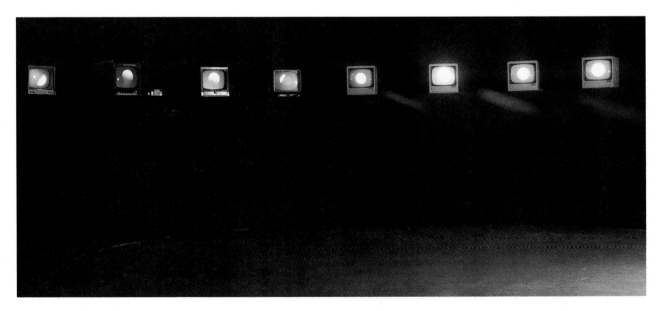

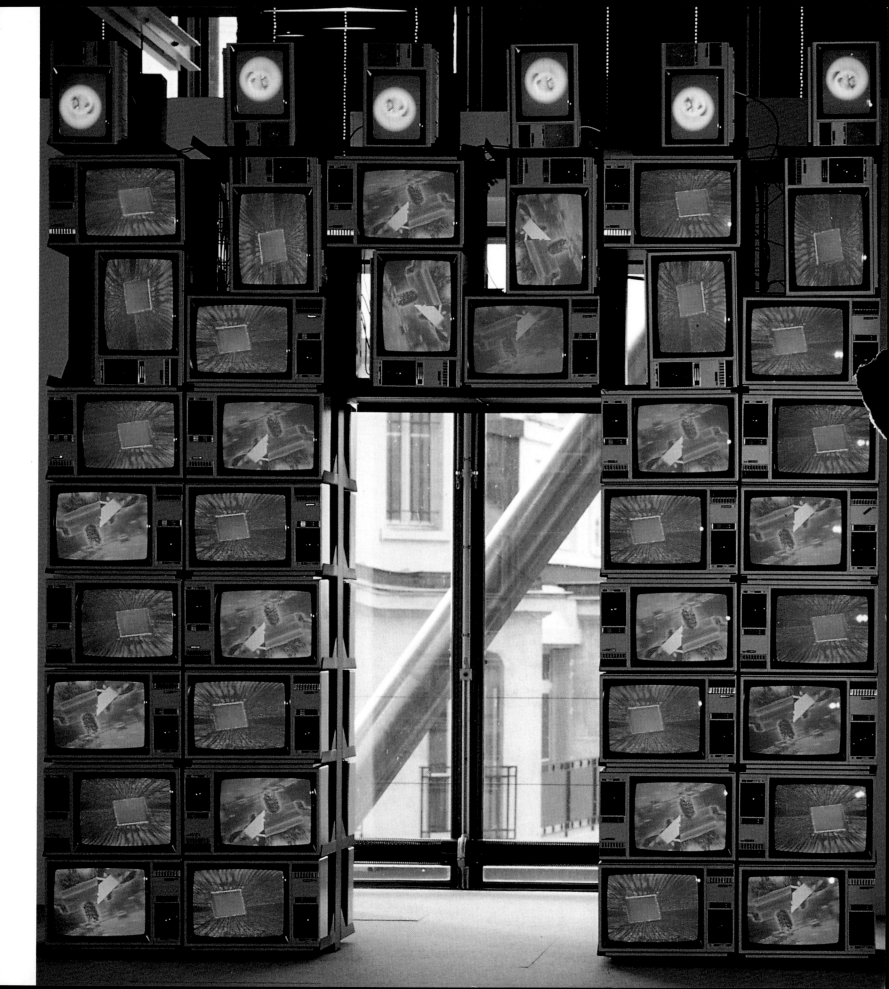

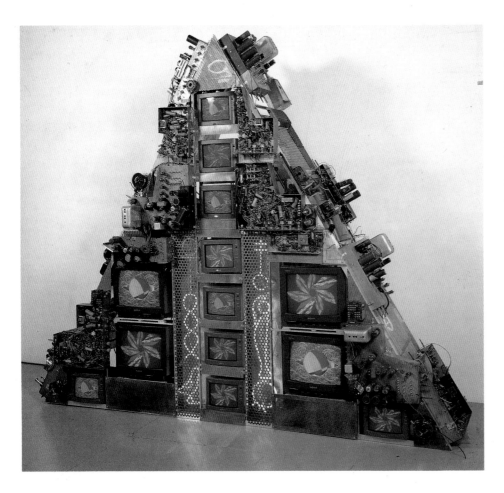

96
Nam June Paik
King Rameses (1991)

considered as his most influential tape of that period. From that time onwards, his outstanding video works were the closed-circuit and multi-monitor installations such as *Imagine There Are More Stars in the Sky than Chinese on the Earth* (1981), *V-yramid* (1982), *Beuys/ Voice* (1987), *One Candle* (1989), or the monumental installation, *The Electronic Fairy* (1989), which combined 200 television sets with video monitors in the room devoted to Dufy's *La Fée Electricité* at the Museé d'Art Moderne de la Ville de Paris in commemoration of the bicentenary of the French Revolution.

Steina and Woody Vasulka, the former originally a musician born in Reykjavik, Iceland, the latter a one-time jazz-music critic and artist born in Brno, Czechoslovakia, emigrated to the U.S.A. in 1965. In 1971, they founded in New York 'The Kitchen', a venue for theatrical performances, music, film and video works.

Already by 1969 the Vasulkas' interest had been in understanding the inner workings of video as an electronic phenomenon. As Woody Vasulka has said, 'There is a certain behaviour of the electronic image that is unique . . . It's liquid, it's shapeable, it's clay, it's an art material, it exists independently.'

Video's plasticity has been explored by many artists, but the Vasulkas have taken a mainly conceptual and educational approach. They were fascinated by the fact that the video image is constructed from electrical energy organized as voltages and frequencies in a temporal event, and many of their early tapes illustrate the relationship of sound and image – one type of signal determining the form of the other.

Another aspect of their work concerned the construction of the video frames or still images. Because timing impulses control the stability of the video raster in order to create the 'normal' screen images we are accustomed to see, viewers are rarely aware of the fact that the video image is actually a frameless continuum. Between 1971 and 1974 the Vasulkas produced numerous tapes based on that consideration: *Shapes* and *Black Sunrise* (both 1971), *Spaces I* and *II* (1972), *Golden Voyage* (1973) and *Soundgated Images* (1974). These were tapes of colourful swirls of imagery that resembled

This work led Paik to develop the colourizer, or colour synthesizer, in collaboration with Shuya Abe. With its capacity for producing Fauve colours and electronically induced osmotic forms, the Paik-Abe synthesizer, along with those concurrently invented by Stephen Beck, Peter Campus, Bill and Louise Etra, James Seawright, Eric Siegel, Aldo Tambellini, Stan VanDerBeek and Walter Wright, led to the separate genre of image-processed work. Paik's video sculptures *TV Bra for Living Sculpture* (1969), *Concerto for Cello and Video Tape* (1971) and *TV Buddha* (1974), and his performances with Charlotte Moorman, introduced video performance, video sculpture and video installations to the art world.[5]

Whereas *TV Buddha* is one of Paik's best-known closed-circuit installations, *Global Grove* (1973), which was incorporated in his *TV Garden* of 1974, can be

abstract painting. For the artists, however, they represented their research based on various manifestations of electromagnetic energy. They began to think of these manifestations as a kind of language, and to see their work as a dialogue with the equipment itself.

Throughout the 1970s the Vasulkas produced an enormous amount of work designed to reveal the inner workings of video, before embarking on a digital video system that would allow a computer to perform various operations on two video images by using mathematical logic functions. Depending on which logic function was operating, the numerical codes – and hence the images – can be combined in different, but absolutely predictable, ways. Such combinations revealed the system's inner structure and also constituted what Woody Vasulka called a 'syntax'.[6]

Ed Emshwiller, another pioneer in Video Art, studied painting and graphics at the University of Michigan, the Ecole des Beaux-Arts in Paris and the Art Students League in New York. He made experimental films and documentaries, and worked with multi-media performances before producing a number of innovative videotapes and completing his first digital computer-animated video tape, *Sunstone*, in 1979. His production since then includes computer animation (*Skin Matrix*), multi-media works (*Vertigo*, *Hungers*), and video installations (*Passes*, *The Blue Wall*). *The Blue Wall*, shown at ARTEC in Nagoya in 1989, is an interactive audience participation video installation. By means of video keying, it unites images of three different real locations with computer animation. Spectators see themselves on screens in a composite space depending on where they are, sometimes in the foreground, sometimes in the middle ground and sometimes behind the animation plane in the background.

Video provides Emshwiller with an exceptional flexibility for combining and transforming images, as well as a form of concretization of the imagination. In his view video is the most exciting art medium – like painting immediate, like film a collaborative art form, like dance a sensual pleasure – which is also a series of questions and a process of discovery.[7]

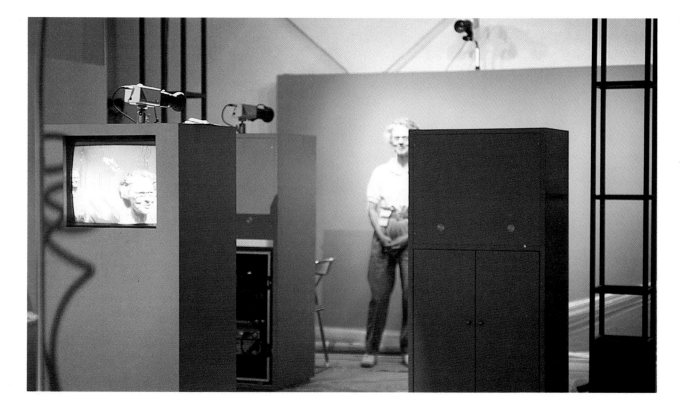

97
Ed Emshwiller
The Blue Wall (1988)

98
Tom Chandler
Three Graces (1990)

99
Tom Chandler
War and Birth (1990)

100
Artur Matuck
Alproksimigo (1990)

An interesting application of a process originating with video, then proceeding to photography before reverting to more sophisticated techniques, is represented by a work of Tom Chandler entitled *Videocy* (1990). The artist first photographed the images from video tape on a TV monitor using a 35 mm camera. Then he made laser colour copies from the snapshots and copied several at a time. The experimental videos were produced by using combinations of Chroma Key, Mat Key, Posterization and Feedback.

An artist who amalgamates different techniques and technologies in an original way is Artur Matuck. He has combined video, slow-scan television and audio in works like *Alproksimigo* (an Esperanto word for 'approximation'), which aspire to a consciousness-raising function. The printed video images or 'sonorigraphies', which are the final product of his installations, are a translation of audio signals altered by the slow-scan equipment into video prints.[8]

It is revealing of the dilemma of many video artists to note the hesitations between producing video tapes and video installations by a prominent pioneer of Video Art, Dan Graham. Benjamin Buchloh has pointed out that Graham's work, unlike that of Nauman and

Acconci, reflected from the very beginning the fact that all video practice, from a technical point of view, originated and is ultimately contained in the dominant mass-cultural discourse of television. This would be best illustrated in a work from 1971, *Project for Local Cable TV*, in which one of Graham's typical experiments to survey and record the dynamics and mechanics of an exchange between two individuals is linked to the community audience via the cable network.

The most complex and advanced work of this kind was produced by Graham in collaboration with Dara Birnbaum in 1978. *Local Television News Program Analysis for Public Access Television* was a work based on the belief that access to public broadcast television will only be a matter of time and proper organization, and that the instrument of television could then be turned from being the most powerful social institution of manipulation and control into an instrument of self-determination, two-way communication, exchange and learning.

In the 1980s, however, Graham changed his strategy and reverted to pre-produced video tapes. In a work such as *Rock My Religion* (1983), the phenomenon of mass culture is approached for the first time from a high-cultural vantage point that is radically different from the traditional attitude of appropriation and quotation.[9]

Since the beginning of the 1970s, Bill Viola has been producing video tapes and video installations simultaneously. He aims to create audio-visual temporal compositions which collect sounds and images on video tape in order to rearrange them and invest them with the structures of a representation of the world based on the artist's own perception, imagination, conscience, dreams and memory, free from the usual narrative and verbal structures of conventional film and television. His ultimate goal is to transmit his works, which he considers visual poems, into everyone's living room. Among Viola's early works conceived in this spirit are *Wild Horses* (1972), *Information* and *Cycles* (both 1973).

Already by 1972, Viola had produced a work, *Instant Replay*, which was made up of a 20-minute video

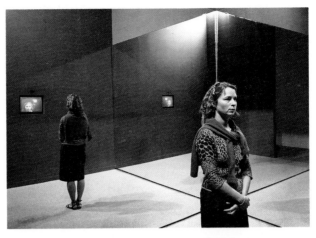

101
Dan Graham
Present Continuous Pasts
(1974)

102
Bill Viola
The Passage (1987)

103
Les Levine
Still from videotape *Game
Room: A Tribute to the
Great American Loser* (1976)

tape and a closed-circuit installation in which a camera, two monitors and two recording devices were arranged in such a way that the time-lag is perceptible to the spectator. Other works, such as *Vapour* (1975) and *He Weeps for You* (1976), combine similar arrangements of technology with the natural element of water in visual essays on themes from Sufi philosophy.[10]

In *Hatsu Yume (First Dream)* (1981), a 56-minute coloured video tape with stereo sound, Viola presented what appeared to be a high-tech travelogue of modern Japan, contrasting city and country life. Woven throughout are partially buried symbolic references to his constant themes of the opposition and essential unity of fire and water, light and dark, life and death. As he observes, 'Video treats light like water – it becomes fluid on the video tube. I thought water supports the fish as light supports man. Land is the death of fish – Darkness is the death of man.'[11]

Viola's impressive installations *Room for St. John of the Cross* (1983) and *The Theatre of Memory* (1985) both make an appeal to the human imagination to overcome physical sufferings and limitations.

Les Levine can also be regarded as a pioneer of Video Art, since he started working with the first Portapak equipment in 1965 at the same time as Nam June Paik. In that year he produced his first videotape, *Bum*. Levine calls himself a video sculptor, and his works use not only video technology but also film, telephone, recordings and photography. His first video installation, the first ever closed-circuit installation with time lag, *Slipcover*, dates from as early as 1966. Exhibited at the Art Gallery of Toronto, it allowed spectators to view themselves with a time lag of five seconds. In 1968 Levine created the video sculpture *Iris*, using three cameras and six monitors, with the aim of producing a cybernetic sculpture which was not only viewed by the spectator but which could also 'see' itself and thereby influence the behaviour of the viewer. In subsequent video installations, like *Chain of Command* (1977) and *Deep Gossip* (1979), or *Visions from the Godworld* (1981), in which five tapes play simultaneously, Levine explored his theological-technical fan-

tasy, a fictional environment in which any possible earthly wishes and needs can be satisfied.

In Levine's view, video artists do not produce tapes that can be conflated with conventional television productions. Rather, they use television technology in order to express artistic ideas and feelings. The function of the videotape is to create a direct channel from artist to spectator.

In Japan, after the first period of Video Art productions that were somewhat dependent on TV, many artists lost interest in the medium. They were unable to see how it could be used except for 'talking back to the media'. During the early '70s, video was mainly used as a device for recording artistic events. Aside from this use, the application of video technology in the years that followed can hardly be included with Video Art, since there was little interest in the technology itself or in its specific formal characteristics. Artists tended to remain attached to traditional means of art-making – painting and sculpture – and to consider video from that perspective. But for Katsuhiro Yamagushi, as for Nam June Paik, electronics has a creative power that can extend the abilities and intelligence of

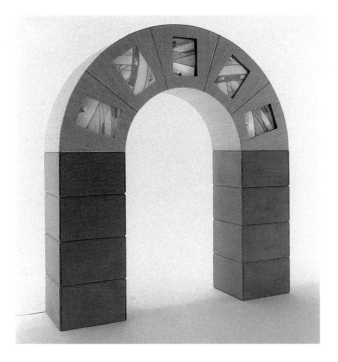

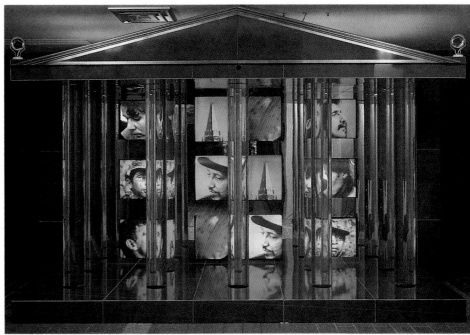

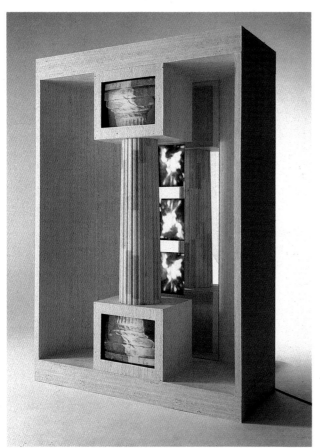

the user. His vision, which he calls an 'imaginarium', sets out a network of media in real space. With the use of adequate software and a video camera, anyone can make images and transfer them to the network. These images can be transmitted in real time to any monitor connected to the network.

Yamagushi was one of the leading lumino-kinetic artists in the 1950s and '60s, as well as a sculptor and experimental designer. He constructed his first video installation, the *Image Modulator*, in 1969. Many of his video installations are elaborate constructions involving sculptural and design elements, often on an environmental scale. They tend to be either closed-circuit installations which involve the spectator, or multi-monitor arrangements in which the artist obtains a kaleidoscopic effect through the spatial and temporal arrangement of the images. Since 1981, Yamagushi has taken the Japanese garden as his central subject, thus transforming a traditional theme into an electronic one, as in *Future Garden* (1984). Another important element in his work is architecture. In such works as *Arch* and *Column* (both 1988), he juxtaposes classical architecture in its three-dimensional form with images on monitors

104–06
Katsuhiro Yamagushi
Arch (1988); *The Invention of Morel* (1991) and *Column* (1988)

displaying graphic developments of the same elements, alluding to Postmodern citational art while at the same time inaugurating new vistas in video sculpture in general.

For Douglas Davis, Video Art is not a movement sharing a common group of ideas, since the only factor common to all video artists is a disposition to work in the medium. He perceives it, rather, as the first step in a major structural transformation of art. The video art that interests him is anti-television and anti-populist. In his view, Video Art can be high art, when thought and medium come clearly together; and in this respect it will act slowly and subtly on the television system. Video, he believes, has incalculable power not only to communi-cate directly, eye to eye, mind to mind, but also to do so in real time, in which the time of the sender and the receiver is identical. This is the 'live' dimension of video. According to Davis, video artists play exactly the same role artists have always played, elevating and provoking the mind that is watching, listening and thinking. Only in this sense is Video Art linked to the past. A thought laid upon video tape is a thought that has the potential of being broadcast everywhere at once in 'naked communication'.[12]

Davis qualifies as a communication artist in the fullest sense. He is a critical theorist and a wide-ranging artist in the areas of both video and performance art. Ever since his first video tape, *Look Out* (1970), documenting one of his performances, he combined the techniques of video with those of communication art. *Images from the Present Tense I* (1971), a manifesto against commercial television, consisted of nothing more than a television set turned to a wall, functioning solely as a source of lighting. In his video productions and performances, such as *Electronic Hokkadim* (1971) and *Talk Out!* (1972), in which the spectators could comment on the images being shown during the three-and-a-half-hour event, Davis adopted an informal and personal approach to the medium of video and invited the spectator to do the same. In doing this, he was interested in subverting the usual structures and conventions in broadcast television, and in the establishment of a direct, live and strongly subjective communication. It is a technique and an aesthetic philosophy which he developed subsequently with the aid of satellites.[13]

Another artist who uses video to attack TV as a mass medium is Richard Kriesche, an Austrian pioneer in Video Art and a well-known theorist on the subject. His activities combining video tape and video performance are numerous and not limited to the context of art. Kriesche's main preoccupation, as in the early 'actions' such as *TV Death* (1975), is with the problem of television as a mass medium and creator of fictional realities. He sees video as an instrument for communicating real issues. His usual procedure is to juxtapose

107
Richard Kriesche
Eternal Light (1983)
Kurfürstendamm, Berlin.
Kriesche is trying 'to resolve artistic contradictions through a technical symbiosis'.

the object and its image in order to demonstrate the differences and similarities between physical reality and electronic 'reality'.

On the other hand, Shigeko Kubota works with pure video sculptures. Her series on Marcel Duchamp was developed in the mid-'70s after she met Duchamp just before his death in 1968. *Marcel Duchamp's Grave* is a column consisting of eleven monitors which show views of Kubota's visit to the cemetery where Duchamp is buried. Two other video installations are directly connected with Duchamp's works, *Nude Descending a Staircase* and *Meta-Marcel: Window*. In the former, Kubota created a real three-dimensional segment of a staircase, which contains on each step a monitor showing a nude in the act of walking down some steps. *Meta-Marcel* shows a window with electronic 'snow', which Kubota uses as a symbol of the video as the 'outlook of tomorrow'. Her numerous other video installations are generally connected with natural phenomena and are often combined with images from Buddhist art.

Gary Hill, who began his career as a sculptor, turned to Video Art at the beginning of the 1970s. He has created both video tapes and video installations, but he distinguishes clearly between these two forms. His familiarity with electronic devices, whose mechanisms closely resemble those of the human brain and nervous system, led him to the production of works which involved the transformation of not technical but mental processes.

Hill's basic theme, the relationship between speech and image, is exemplified in *Primarily Speaking* (1981–83). On the other hand, he also creates what he calls 'systems performances', such as *In Situ* (1986) and *Media Rite* (1987). In the former, a seated spectator watches a video tape on a monitor while photocopies of images that have just been seen by him descend from above. In the latter, images of excavations are produced which communicate to the spectator a metaphor for the creative process that leads from searching to finding.

Hill's video installation *Between Cinema and a Hard Place* (1991) won a prize in the International Competition at ARTEC in Nagoya in 1991. This work consists of 23 variable-sized monitors positioned so as to suggest a crumbling stone wall, typically seen dividing parcels of land. Images and sounds from three sources are routed to 32 outputs on a frame by a computer-controlled switching matrix. The images are composed around a spoken text, an adaptation of Heidegger's *The Nature of Language*, which questions a strictly parametrical view of space and time, posing the possibility of a 'neighbouring nearness' that does not depend on a

108
Gary Hill
Beacon (1990)

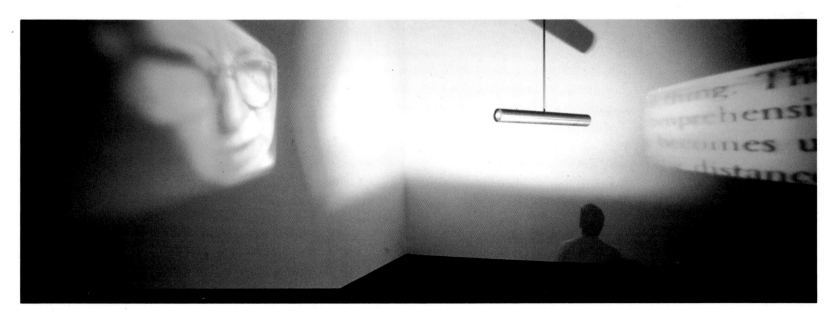

spatio-temporal relation. By interpreting the text within a cinematic context that uses the same parameters being thrown into question – time-sharing images as well as spatial and proportional placement of images – the work attempts to carve out the structural apparatus of cinema as it measures philosophical issues against the visceral nagging presence of the everyday.

Nil Yalter, an artist of Turkish origin living in Paris, who often uses video to create animation works with socio-cultural themes, has been described as an 'ethnocritical' artist. Her video sculptures, installations and performances, such as *The Rituals* (1980), realized in collaboration with Nicole Croiset, *Tele-totem* (1987), and *Pyramis or the Voyage of Eudora* (1988), testify to her interest in ethnology as a scientific method for understanding human communities, their relationships with the material world, their practices, rituals and beliefs. Video is given the role of signifying magical correspondences through its ability to establish immediate communication at great distances and through the apparent immateriality of its images, which can be transmitted without a permanent form of transcription.

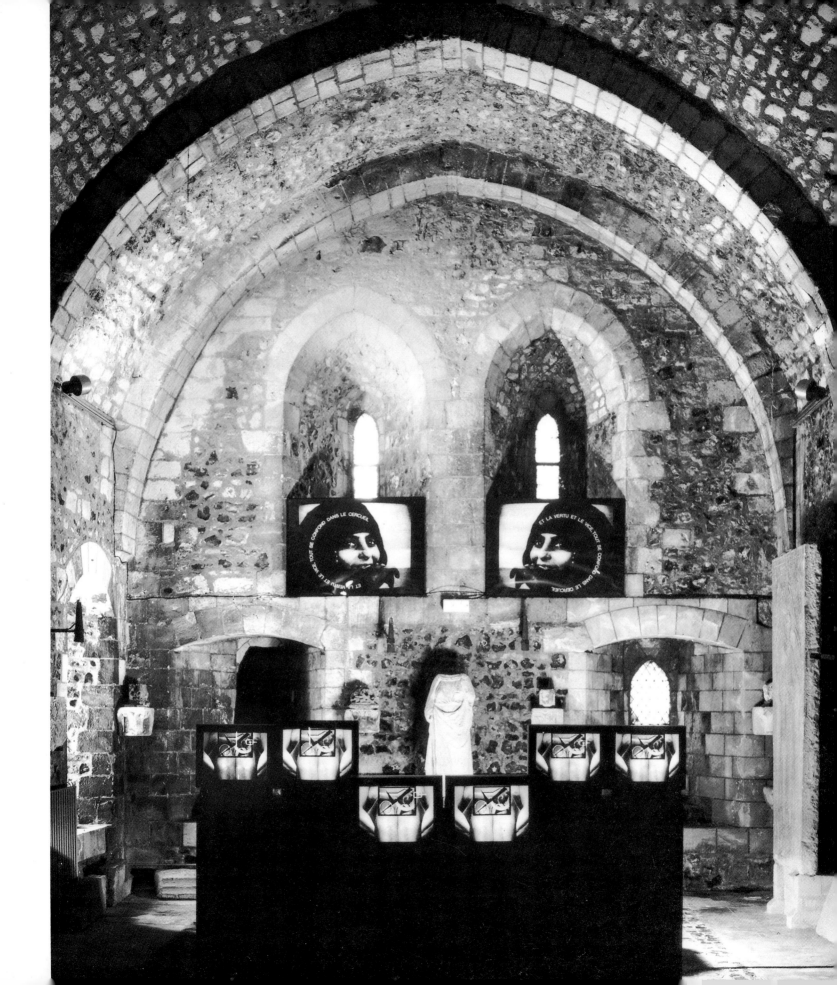

113, 114
Michel Jaffrenou
Two stills from *Vidéoperette TV* (1989)
© Philippe Bresson

The Frenchman Michel Jaffrenou was one of the first artists to employ multi-sources and multi-screens for his video works, as well as for his video theatre sketches: e.g., *The Sweet Babble of Electrons in the Video Wall*, shown at the 'Electra' exhibition in 1983. In a joint work with Patrick Bousquet, *Full of Feathers*, a precise synchronization in the simultaneous running of four video tape recorders allowed an object or person to appear to be freely circulating behind screens.

Jaffrenou discovered the artistic possibilities of electronics while looking for a circuit breaker. Coincidentally, he found instead a portable half-inch black-and-white video recorder whose battery was prone to go flat. As a result, his first video tapes were saturated with interferences. He was so enthusiastic about the results that he took up syncopated video – i.e., video which functions with syncopated rhythms. He plays with the video equipment to create such works as *Video Circus* (1984) and *Video-Operetta* (1989). The latter, cut into short segments, was able to play with the diffusion system of a television network. Concerning these works and their dissemination, Jaffrenou speaks of fluidity, but also of mental suppleness, the possibility of continual transformation even in the interior of the software itself.

After *Video-Operetta*, Jaffrenou wanted to make something other than a work which simply confronted a passive, seated audience. He conceived *Kaleidoscope*, a project in which the body of the spectator plays an important role. Initially, *Kaleidoscope* would invent a fictional world on the video screen, whose inhabitants were taken from tales, legends, myths. The spectator could interact with these characters and affect their evolution. Later, Jaffrenou hopes to create virtual worlds beyond the confines of the video screen that may emulate the events of our natural world or that may be purely imaginary or artificial, the creation of free electrons.[14] The spectator will embark in teleguided vehicles and will be introduced to another world.

Three other artists prominently involved with video performances are Jochen Gerz, Friederike Pezold and Ulrike Rosenbach. Gerz integrates video in his performances in a poetic manner without sacrificing the

technical potentiality of the medium. In *Calling until Exhaustion* (1972), the artist stood 60 metres from the video camera and microphone and called as long and as loud as possible until his voice became hoarse and finally inaudible. In *Prometheus. Greek Piece No. 3* (1975), a performance lasting 20 minutes, Gerz reflects sunlight with a mirror into the lens of a video camera placed at a distance of 50 metres, thereby damaging the viewing system of the camera. The interference thus created makes his own image gradually disappear.

Friederike Pezold's main preoccupation from 1969 onwards has been the female body. She conceives of it as architecture. Just as the proportions of the male body have served to determine architectural elements, Pezold tries to establish the female body as the measure of all things. Since 1971 she has used the video camera to record her performances. In a series of videotapes entitled *The New Living Body Language of Signs According to the Laws of Anatomy, Geometry and Kinetics* (1973–76), she abstracted her body through black-and-white painting and developed a language of signs through the graphic action of parts of her body. In 1975 she created a video sculpture, *Madame Cucumatz 1*, with five superimposed monitors whose images, when added to one other, while maintaining a certain autonomy, formed a single female figure.

Ulrike Rosenbach began in 1972 to make video tapes which were shown in the same year at the Video Gallery Gerry Schum in Düsseldorf, at the Venice Biennale, and at Documenta in Kassel. She started a series of performances with the video camera a year later. To begin with, she worked entirely with a live situation: the audience could watch her acting live while at the same time being able to follow the performance from a different perspective on a monitor. Later she took to using pre-prepared tapes. Until the beginning of the 1980s an active feminist, Rosenbach concentrated on themes based on her personal experience as a woman. Her numerous performances include *The Enchanted Sea* and *Don't Think That I Am an Amazon* (both 1975), *Reflections on the Birth of Venus* (1976), *My Transformation is My Liberation* (1978) and *Psyche and Eros* (1981).

115
Jochen Gerz
Der malende Mund (The painting mouth, 1978)
Kunstverein, Bonn; photo Roland Fischer

116
Ulrike Rosenbach
Reflections on the Birth of Venus (1975–76)

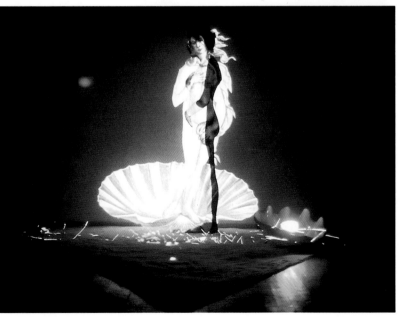

117, 118
Two photographs of **Orlan**
on the operating table; a
chirurgical performance

Rosenbach stresses the difference between pre-produced works and those that are created during the performance. In most of her performances, which she calls 'live video performances' or 'not actions', the video tapes are created during the performance with a closed-circuit procedure. The spectator is aware that the artist is producing a video tape, since the camera is visible in the artist's hand or fixed onto her body in such a way that it registers and projects the objects from the artist's own point of view rather than the spectator's.

Rosenbach is particularly concerned in these performances with the passing of time in everyday life. Her goal is to appeal to the spectator's capacity to follow from beginning to end the whole of this temporal process in order to discover subtle details that could kindle a sudden interest and create a revelation.[15]

A very different type of video performance is that of the French multi-media performance artist Orlan who, since 1974, has developed a critical feminist stance with reference to religious iconography, particularly that of the Baroque. She has now begun work, such as *The Re-Incarnation of Saint-Orlan* or *Image(s)/New Image(s)*, that combines the new technologies with techniques of surgery, micro-surgery and psychoanalysis in an attempt to create a 'psychological' self-portrait.

Using video digitalization and actual surgical operations recorded by video cameras, she employs

plastic surgeons to change her chin into the chin of Botticelli's Venus (from *The Birth of Venus*), her nose into Psyche's nose (inspired by Gérard's *Le Premier Baiser de l'Amour à Psyché*), her lips to those of Europa in Moreau's *L'Enlèvement d'Europe*, her eyes to those of Diana in the painting of *Diane Chasseresse* by the School of Fontainebleau and her forehead to resemble that of Leonardo da Vinci's *Mona Lisa*.

Each step of this monstrous performance is organized, filmed in video and photographed under Orlan's direction (who is administered only local anaesthetic during the operations). She thus supervises the operating room with its specific decoration, the surgical team, dressed by a fashion-designer, and the video and photography teams, while reading literary, philosophical and psychoanalytical texts during the operation.

Orlan's purpose in this elaborate video performance is to create a 'Carnal Art' as a 1990s equivalent of the Body Art of the 1970s, while at the same time changing her identity. The new face that she will present to the outside world, the new name she will adopt, the new existence she will lead, are meant to symbolize and indeed incarnate a blend of historically varying images of European femininity, a truly Postmodern undertaking with the aid of modern technology.

An excellent example of a video artist who arrived at the use of computer techniques through a logical

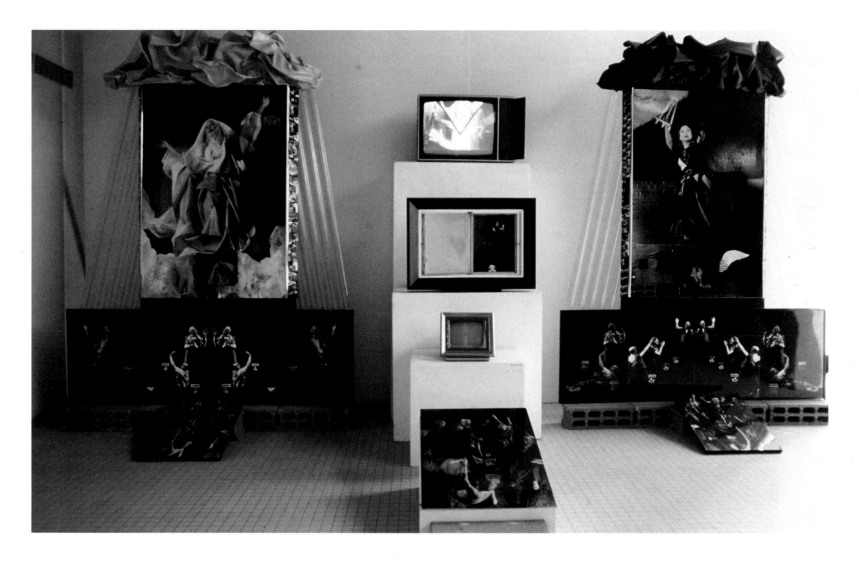

progression of work is the Austrian writer, film-maker, action and conceptual artist Peter Weibel, who as early as 1969 had begun to work with video. Apart from numerous video sculptures and video installations which analyze the structures of perception and communication, he has produced a series of video tapes which at first tried to deconstruct the language of television. In the 1980s he concentrated on developing an autonomous language of the electronic image with the aid of complex digital devices in such works as *Songs of the Pluriversum* (1986–88).[16]

Video Art began in the U.S.A., then spread to Europe along with the motifs of the '70s: anti-militarism, love and peace, the road to India and the pop and drug cultures. This mixture manifested itself in the aesthetics of Video Art as psychedelic effects of unrestrained electronic feedback. The TV screens were now literally and symbolically freed from the formal stereotypes that had applied in conventional use. The pioneering video-artists discovered an infinite range of new patterns as they challenged the formal and technological impediments that had existed since the beginning of television.

The American tapes which appeared for the first time in France in 1974 displayed hitherto unknown energies, attributable in most cases to a strong symbiosis between image and music. Apart from a few programmes that did not go beyond the 'psychedelic' stage,

119
Orlan
Saint Orlan and the Old Men
(1984)
multi-media installation
(laser, holograms, video,
photos, Minitel), shown at
the Galerie Donguy, Paris

where the video technique seemed to serve as an almost hallucinogenic device, the vast majority of the sequences already showed strong discipline in the treatment of rhythms and colours (in particular, the work of the Vasulkas, the Etras, VanDerBeek, etc.). Even if the effects remained limited and highly experimental (colourizing, superimposition, keying), everything was attempted in this golden age of the history of video. It is difficult not to feel a certain nostalgia for that era, when freedom of exploration was 'in', when the video served as an outlet for psychological drives and people played the video synthesizer as an instrument in search of hallucinated visions of reality.

As pointed out by the video artist Dominique Belloir, the first explorers to be freed from the shackles of television did not imagine that fifteen years later new and far more insidiously restricting criteria would appear and bring with them censorship or, even worse, self-censorship among creators of electronic images.

Nowadays, video creation has become a profession with the scope of a complex structure, but still rather poorly defined and halfway between television and the museums. This is the result of a repeated cross-breeding with all other art forms (painting, fashion, photography, literature, theatre, dance, etc.). Video-makers who have turned professional take on more and more diversified commitments, for which specifications and formats are imposed. This in turn gives rise to new kinds of documentaries, video catalogues and video clips, whose layout is invigorated by new graphic techniques.

Simultaneously with the development of the short 'applied video' productions, frantic 'programme-zapping' at home, and when video screens have become the new form of advertising poster, fewer and fewer original creations appear by independent video-makers exercising artistic control over their productions. They are all too often influenced by the criteria set by television in its role as both entertainment and sales device.[17]

Anne-Marie Duguet believes that it is precisely in regard to the domination of cinema and television production standards that certain video works have proved to be original. She considers that the develop-ment of video creation has, until now, taken place in a variety of activities that use more or less effectively the specific features of this medium but that above all are defined by their experimental character. Far from being reduced to mere technical exploration, the results have converged in ways that take account of both production conditions and creative expression. Moreover, experimentation is by definition constantly being reassessed and it is always in a precise context that the unexpected appears and leads to the asking of different questions.

In Duguet's view, what constitutes the interest of video work is that it is, on the one hand, an essentially hybrid practice in which different techniques and elements of expression are combined, and on the other, one which is open-ended. The performance (of the actor/director or of the machine), as well as the technical set-up (the design of the space or of the system), are thus the basis of numerous videos.

In order to comprehend how the new technologies fit into the context of Video Art, one should keep in mind that certain notions, like hybridization, metamorphosis, immediacy or interactivity, have already been dealt with in other contexts in terms of the techniques of the 1960s and '70s. The concept of the 'open' work that can constantly be modified as far as the script and the image are concerned, the stress placed on the working process, on the mode of perception that invites the viewer to join in, confronting him or her with a large range of points of view, are all attitudes and concepts that contemporary art has made us familiar with, and which, in particular, Video Art, with its diverse techniques, its possibilities for feedback and special effects, captures.

Although digital processing is more than a mere improvement in the treatment of the image, and although computer editing may dramatically change the traditional concepts of image-making, the main breakthrough in this area takes place in the synthetic generation of the image. Being a virtual image produced by mathematical formulae, the video image, unlike the traditional pictorial image, can only be considered as proof of the model that it simulates, not as a copy of a

pre-existing object or model in the real world. More-over, a three-dimensional synthesis enables the artist to intervene not only on the image, but inside the image. Image has become architecture, a space to visit, to explore in various ways. Editing, often highly sophisticated, has been replaced by a scenographic concept.[18]

To these reflections on the character of Video Art can be added Jean-Paul Fargier's argument that video creation knows no limits of duration, subject or stylistic treatment, and that video cannot be reduced to giving television a new look.[19]

Benjamin Buchloh states that the image of video technology in artistic practice since the mid-'60s has undergone rapid and drastic changes. This makes it particularly representative of the shifts to which art in general has been subjected since the end of Minimal and Conceptual Art, the context in which video production was established as a valid artistic practice. According to Buchloh, it is clear that these changes concern the application of art practice with other discourses (film, television, advertising), the conditions of its institutional containment and its audience relationship as well. Buchloh posits a post-avant-garde practice that is reflective of the critical authority in images themselves, recognizing that there is no neutral information or technology, and insisting on an artistic procedure that informs its audience about the ease with which cultural authority is moulded into the form of objective authority.[20]

Katherine Dieckmann, in a brilliant critical assessment of the 'Electra' exhibition in 1985, contends that video combines the paradoxes of Postmodern pluralism with the Modernist trope and tools of technological progress.

However, the institutions of the art world have never known quite what to do with video. After twenty years, it still lacks a solidly independent body of criticism, a situation largely attributable to its dearth of those qualities required for art-historical appraisal (materiality, established aesthetic criteria, and a history). Dieckmann calls video a medium in suspension, bridging Modernism and Postmodernism.[21]

Deirdre Boyle promotes a resuscitation of the somewhat neglected guerilla video. She writes that today, in an era of creeping conservatism, the ideals of guerilla television are more in need of champions than in its heyday when it was easier to defend experimental media. Few have come along to take up the challenge of guerilla television's more radical and innovative past, although many notable pioneers continue to keep their ideals alive.[22]

Let us finish this chapter by recognizing that there are two parallel movements in current video research. One is centred on a more detailed analysis of the image in its temporal dimension, and provides the most original line in video research. The other uses video technology with greater flexibility in order directly to grasp everyday reality in its smallest, most fleeting, details.

There is a tendency now to reconcile video and television and to renounce the artist's preoccupation with the self, characteristic of much of Video Art, at a time when the videodisk replaces the video cassette and new cable transmission techniques open up new possibilities of research and dissemination.

On the whole, Video Art has progressed from an early anti-television attitude to a new outlook of considerable social significance, just as it has developed with a certain continuity and coherence from experimental film techniques and aesthetics to new visual research. Video Art has introduced specific time factors, instantaneity, spontaneity and simultaneity, and a new potential for transformation in the creative process of image-making. It has also created a link between the temporal aspects and spatial factors in producing a great variety of sculptures, environments and installations, and has added important social and psychological factors with its incorporation in performances, often involving intense audience participation. Its future is certainly bound up with its potential for combination with communication (satellite) and computer technology and their aesthetic exploitation.

4

Computer Art

The origins of Computer Art can be traced back to 1952 when Ben F. Laposky, in the U.S.A., used an analogic computer and a cathode tube oscillograph for the composition of his *Electronic Abstractions*. He followed this up in 1956 with the creation of a coloured electronic image. The same year Herbert W. Franke created his oscillograms in Vienna; and the first computer graphics were realized in 1960 by K. Alsleben and W. Fetter in Germany. It was in 1965 that the first works produced with the digital computer appeared. They were executed independently yet almost simultaneously by several artists: Frieder Nake and Georg Nees in Germany, A. Michael Noll, K.C. Knowlton, B. Julesz and others in the U.S.A.

Technically speaking, a digital computer consists of four main sections: an arithmetic unit which performs simple operations on data; a memory system for storing data; input-output equipment; and a unit for controlling the flow of information in the system.

On the aesthetic level, computers in general can intervene in at least five different areas: in the production of plastic, film, or video images; in cybernetic sculptures; in environmental art works; in optical or video discs; and in telecommunication events.

In the first part of this chapter we shall consider the production of images by artists with the aid of the computer, images that can take the form of graphic designs or pictorial works in different media including film or video.

For some artists the computer is only a design tool. For others it is a means of fabrication; and for yet others, the computer is used because it possesses capabilities analogous to human intellectual processes and may even be considered as a creative entity in its own right.

In computer graphic terms, we have to distinguish between two- and three-dimensional imagery, although of course both these terms refer to screen images. The former refers to an image that is not plastically modelled and whose description exists only in two dimensions, whereas the latter, like fractal images, refers to pictures based on algorithms for modelling different three-dimensional effects.

120
Susan Ressler
Earth I (1989)
Using a video camera, Ressler created images of her hand holding a stone and a Native American
traditional basket. These photographic fragments were then collaged and manipulated by
computer in order to produce a constellation of symbols in praise of the earth.

Among the artists of the first category, using computers as a design tool in the area of two-dimensional images, is Jack Youngerman. Youngerman discovered that many of the time-consuming studies he did by hand before beginning a composition could easily be carried out by using a computer. For an artist of his type, who often puts a single theme through many variations, the computer functions as a sketchpad that can electronically alter colours and compositions, offering him multiple options from which to work.[1]

On the other hand, David Em is an artist who uses the computer as a design tool for the production of illusionary three-dimensional imagery. In 1986 Em created a group of digital landscapes inspired by methods of topographical illustration.[2] To many observers, Em's cosmic fantasies epitomize the aesthetics and subject matter of computer-generated imagery. Yet, as fantastic as his visions may appear, and as high-tech as his artistic implements may be, Em thinks of his works as paintings in the traditional sense.

Both these artists use the computer only as a tool, as a canvas or a very elaborate palette with which to 'paint', using a variety of methods. At most, in their case, the computer is regarded as an assistant.

Artists like Harold Cohen develop programmes to be followed by the computer, without themselves necessarily having any idea of what the final result will be. Such a use of the computer changes the strategy of image-making and opens up questions of the extent to which the computer actually creates art itself. From this perspective, the computer is no longer simply a tool but becomes a creator or perhaps a simulator of memory, of reasoning and of the brain itself.[3]

Cohen began by considering the computer as analogous to human intellectual processes and exhibited computer-controlled drawing machines that continuously executed a series of drawings. He now develops programmes which, in addition to their repertoire of abstract forms with tentative figurative references, are capable of creating convincingly realistic drawings of plant life and the human body.[4] Cohen selects certain drawings and enhances them with watercolour, each of the drawings generated by his programme 'Aaron' (his name in Hebrew) being unique. Like many other artists who work with computers, Cohen, who is now at the University of California at San Diego, sometimes translates his computer-generated imagery into traditional paintings on canvas. His goal is shaped by the historically long-standing dream of a 'thinking machine' and he looks forward to a time when computers will be able to surprise him, not only by drawing something he did not anticipate but by producing a drawing only possible through the computer's own modification of the programme.[5]

Taking a position between those artists who see the computer as a tool and those who see it as an autonomous creator, Vera Molnar, a pioneer of Computer Art, holds that, at least for her, the computer can serve four purposes. The first concerns its technical promise – it widens the area of the possible with its infinite array of forms and colours, and particularly with the development of virtual space. Secondly, the computer can satisfy the desire for artistic innovation and thus lighten the burden of traditional cultural forms. It can make the accidental or random subversive in order to create an aesthetic shock and to rupture the systematic and the symmetrical. For this purpose, a visual data-bank can be assembled. Thirdly, the computer can encourage the mind to work in new ways. Molnar considers that artists often pass far too quickly from the idea to the realization of the work. The computer could create images that can be stored for longer, not only in the data-bank but also in the artist's imagination. Finally, Molnar thinks that the computer can help the artist by measuring the physiological reactions of the audience, their eye movements for example, thus bringing the creative process into closer accordance with its products and their effects.

Molnar has applied these considerations to the images she makes. Thus, for example, in *Transformations* she uses arrangements of simple geometric elements, due both to her aesthetic preference for simple geometric patterns like squares, circles and triangles, and to her interest in creating works of art in a much

more consciously controlled and systematic way. Her exploration of the way in which intuitive knowledge may be reinforced by conceptual processes depends upon a strict methodology. By using simple geometric patterns and stepwise transformations to alter their dimensions, proportion and number, she controls the formal modification which brings about changes in the viewer's perceptions. In order to obtain a sufficient choice and precision in developing a series of similar images with only infinitesimal transformations, she has made use of a computer with terminals like a plotter and/or a Cathode Ray Tube screen.

One can speak here of a global computer graphics method, that is, one where the image is conceived and treated for the computer which almost creates it. Other artists using this means of producing fixed graphic works are Dominic Boreham, and Holger Backstrom and Bo Ljungberg, two Swedes who have worked together since 1965 under the names of Beck and Jung.

Such graphic works as Beck and Jung's designs exhibited at the 'Electra' exhibition in 1983 or Boreham's *Interference Matrix* on perspex and aluminium are objects to be contemplated and not modified by the audience, and express the artists' view that technology is only a means and cannot replace the content of their works. Yet since 1974 Boreham has made use of electronic media in creating synthesized sound for his electro-acoustic compositions, as well as computer technology in his graphic work, in such a way that the audience is stimulated to go beyond the simple results exhibited and imagine new possibilities, both technical and artistic.

Beck and Jung were among the first artists who looked for creative inspiration from the computer. Although they have primarily worked as infographic artists with a predilection for line and geometry, as early as 1972 they were also interested in problems concerning colour in data-processing. The *Chromo Cube*, where primary and secondary colours are developed and altered on the surface of 4913 small cubes, was shown at the 'Ars & Machina II' exhibition at Rennes in 1983. In the same year, Beck and Jung realized *Dragon Triptych*, a lithograph produced by a computer ink plot.

The work of artists like Roger Coquart, Jeremy Gardiner, Kammerer-Luka, Joan Truckenbrod, Margot Lovejoy, Jean-Pierre Yvaral and John Pearson also fits into this category of fixed computer works on traditional supports.

The paintings of Coquart and Gardiner, which are computer-generated, not only exist as images that have been made with the help of computer programmes but also attempt to illustrate how computers assist mental images to evolve and to be altered, flexibly and dynamically, by the artist. For these artists, science no

121
Vera Molnar
Comment faire sortir le carré de ses gonds (1988), shown at the Festival des arts électroniques, Rennes

122
Vera Molnar
Parcours (detail, 1976)

longer acts as an authority but as a creative catalyst. Coquart tries in his 'poetico-conceptual' panels to establish a universal language based on computer-generated signs, whereas Jeremy Gardiner intends to express his concern with the landscape and 'inscape' of modern technology, both as a science of the industrial arts and as an ethnological study of the development of the arts.

Kammerer-Luka's modular frescoes and Joan Truckenbrod's tapestries create fluid, layered images which reflect a sensitive integration of visual and conceptual aspects of the way in which we view the natural world and the innovative potential of high-tech art for combining them. In reality, there are many layers of information in images which are imperceptible because of the limits of our visual faculties. These 'invisible' layers of natural phenomena are abstracted into mathematical formulae by scientists. Truckenbrod has created a 'conceptual lens' with which she visualizes these phenomena and weaves the visual layers into amorphous networks.

Margot Lovejoy incorporates different kinds of computer output in her art rather than working directly with technology. She culls images from meteorological data and other computer printouts that are aesthetically appealing to her. She then transforms them into lyrical visions in mixed media in works such as *Flux II* (1982). Up to 1984 Lovejoy was totally involved in conceptual explorations for measuring the relationship between illusion and reality. These investigations led her from the tonal grains of photography to her first encounter with the computer pixels of digitally based imagery. At the same time she began her first installation work using sound, movement, multiple images and aspects of sculpture instead of media which she has formerly used in producing prints, books, photographs and mixed media constructions. *Azimuth XX: The Logic Stage* (1986), *Cloud Stage V* (1987), *Labyrinth* (1988) and *Presence* (1990) are all multimedia projection installations, the first contrasting logical systems of order and belief with their chaotic opposites, the second being a metaphor for the illusory and the baroque, the third

123
Joan Truckenbrod
Sociotecture (1991)
'In this invisible social landscape undulating with magnetic attractions and dynamic tensions we act out the mythology of male/female romance that constantly assaults us in advertising, fashions and toys.' (J.T.)

124
Margot Lovejoy
Black Box (1992)
a projection installation. The artist uses the flight recorder as a metaphor for the collection of data on a disaster that has yet to happen.

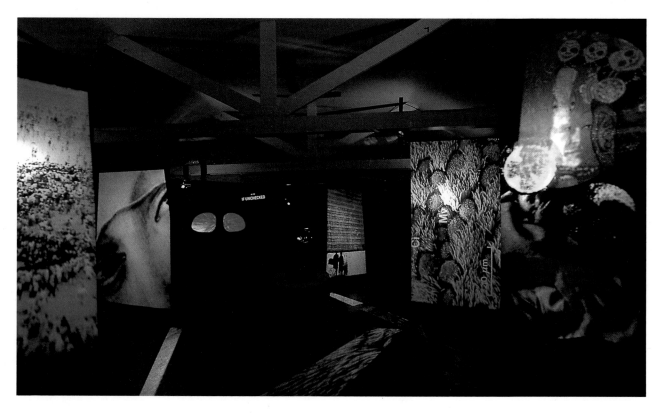

exploring the power of the media to create false beliefs and to control cultural identity, and the last, through texts by Plato, evoking the way the personal and private must be understood as political and public.[6]

Jean-Pierre Yvaral has shifted from his early optical research and interest in science as a model for artists' creation to a subtle use of the computer for the mathematical programming of a pictorial surface. His series of computer graphic paintings entitled *Synthetized Mona Lisa* (1989) comprises 12 visual studies based on a numerical analysis, which breaks down an image of Leonardo's *Mona Lisa* into measurable elements. Their strictly geometrical structure makes possible not only the reconstitution of the original image but also the construction of a different image, a different face, with the same elements. Any whole form can be

considered as a geometric combination of elementary units available for reconstruction. It is in the systematic exploitation of this field that the artist hopes to create visual phenomena in which figuration and abstraction are no longer in opposition.

A comparable strategy is that of Richard W. Maile, whose work *Birth of Elvis* was shown at the 'Siggraph '90' exhibition in Dallas in August 1990. This was a digital image based on a reproduction of Botticelli's *The Birth of Venus*, the digitally integrated image of Elvis Presley being substituted for the figure of Venus.

John Pearson's works, such as his *Fresnel Proposition: UNM Series No. 8.* (1985), an electronic (digital) image and slide, or his *Finale No. 3* (1988), pastel on paper, are based on either software that allows for the generation of all possible permutations of a set of simple

geometric shapes related according to the Golden Mean (simple image generation and plotting) or digitalized (using filters to achieve pseudo-colour), and manipulated in order to alter structure and, above all, colours. Finally pastel, pencil, and charcoal drawings were hand-executed using the slides of the digitalized images as models and points of departure.

Pearson sees Computer Art as the union of traditional and computer techniques. He regards the computer as principally a tool, but does not exclude the possibility that it is in the creative development of software that the essence of artistic value for the computer lies.[7]

As regards animated paintings, we may examine the work of artists like Lillian F. Schwartz, Edward Zajec, Tom De Witt, and Yoichiro Kawagushi.

For Lillian Schwartz, the computer is a far superior tool to photography for an art of appropriation and the control of images. In 1985, she digitalized photographs of paintings, sculptures, drawings, and prints from the collection of The Museum of Modern Art, New York. She stored them in a computer memory bank and produced by collage processes a poster for the opening of the newly renovated museum. Afterwards she began painting again on a Symbolics computer system, which she is testing for artificial intelligence capacities.

In 1987, Schwartz was juxtaposing images on the computer screen in order to produce a slide that demonstrated the physiognomic similarities between a self-portrait by Leonardo and his Mona Lisa. A still more recent computer-aided project by Schwartz deals with the question of perspective posed by Leonardo's *Last Supper* in the refectory of Santa Maria delle Grazie at Milan. A three-dimensional space was built within the computer to explore the idea that Leonardo used the 'trickery' of the theatre in constructing the non-traditional perspective of this fresco. The model produced by Schwartz shows the position from the point of view of the monks sitting along the side wall of the refectory. The tops of the tapestries in the depicted space line up with the design Leonardo painted in the

127, 128
Lillian Schwartz
Mona-Leo (1986) and *Last Supper* (1988)

real room to give the illusion that the painted room of the fresco is an extension of the refectory wall.[8]

Edward Zajec sees his work not only in the narrow perspective of exploring the computer as an image generator, but also in the wider context of the expanded communication possibilities deriving from the intersection of art and technology. His ideas and techniques are concerned with the fluid articulation of colour and form in time. The focus is not on the choreography of forms in motion (animation), but rather on those transitional states where dimensions interpenetrate, motifs dissolve into patterns and the geometric blends with the organic. Zajec aims beyond even this in trying to formulate some codes for a hypothetical language of light and sound (Orphics).

In a work called *Chromas*, crossed rays dissolve into one of several possible derivations while modulating from a siena/cobalt to an ultramarine/green tonality. The actual unfolding of the images is based on the rhythms and sounds of a composition for piano by the contemporary Italian composer Giampaolo Coral. *Chromos* is an attempt to develop and manipulate an aural theme in terms of colour and form. Thus the formative principle behind this development is not shape animation but thematic transformation.

In a more recent work by Zajec entitled *Composition in Red and Green*, the artist did not design the theme, but simply used a mathematical cymaton (a higher degree algebraic curve) as a source of thematic material. The colour modulation going from green to red starts by displaying a curve which gradually dissolves its graphic form as it turns to red.

Tom De Witt can be considered a pioneer in what was to be called 'virtual space' or 'cyberspace'. His technique (called Pantomation) involves computer analysis of photographically recorded images. The process permits the recording of the surface coordinates of three-dimensional objects and three-dimensional drawings. The derived images are manipulated by following the movement of a person.

For De Witt an important feature of Computer Art is its non-materiality since its 'works' are abstract

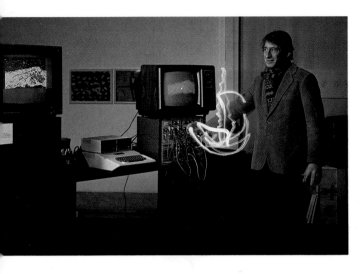

132
Tom De Witt and his *Pantomation System* (1982)
at the Electra exhibition in 1983

algorithms or databases. He regards it above all as 'Dataism' – a term and an art opposed to the iconoclasm of Modernism in general and Dadaism in particular. Dataism restates traditional aesthetics through formal practices. Dataist works are not singular art objects but algorithmic procedures and digital databases that have a symbolic description. Dataist artworks can appear to exist in three dimensions and move in the time dimension, but they may be entirely synthesized, that is, become purely imaginary products.

Among other animated images may be mentioned Mario Sasso's *Footprint*, Philippe Andrevon's *Star Life*, Robert Lurye's *Dirty Power*, all shown at the 'Ars Electronica 90' exhibition, and above all the fractal images of Benoît Mandelbrot, Brian Evans and Richard Voss. Fractal geometry was developed by Mandelbrot, a mathematician at IBM from 1975 to 1980. It is based on self-similarity: i.e., every large form is composed of smaller, virtually identical units, themselves composed of progressively smaller replications of the same units.

One of the artists typifying the area of animated computer graphics is Yoichiro Kawagushi. In a work entitled *Float*, the floating movement of marine animals has been closely observed and depicted by computer graphics. In this work an assemblage of metallic balls is used to form a curved surface, whose texture expresses the skin colour of organisms living in the subtropical islands, such as marine plants and sea cucumbers.

133
Michel Perreau
Aleatory Fractal in 3 Dimensions

In *Embryo* (1988) the initial world of life development is programmed with a parallel processing multi-macro computer system – 'Metaball' – which combines ray-tracing transparency effects with a dynamic flow of images. The rhythm of the pulse is likened to the rocking of the waves and the movement of sea anemone feelers and calculated by derivative composite functions. In describing *Embryo*, Kawagushi says:

> This piece presents flexible transparent textured objects which are concerned with birth and growth from the artistic point of view. My boyhood was spent primarily diving into the sea to catch fish, digging for the shellfish hidden away among rocks, and feasting my eyes on beautiful coral clusters. The images and colour-tones I experienced in those days have a deep-rooted source and form the basis of my mental pictures and imagery today. The shapes in my works are of sea plants and molluscs which do not look at all like organisms living above ground. The colours also reflect the hues of fish and radiant coral found in southern waters around my native tropical island.[9]

In these filmic and high-definition synthetic video images as well as in *Flora* (1989), Kawagushi creates a visual world inspired by the sea world, its light and its movements. The creatures that live in it are in evolution, hybrids situated between the vegetal and the animal, in constant growth and mutation. In Kawagushi's works their flesh is reduced to a simple luminous envelope which reflects partly the world in which they are immersed and partly the body to which they belong, in a fascinating mirror game where the object merges with its reflection. The light, aided by the sophisticated technology of ray tracing, recalls the art of Japanese lacquer or porcelain.

Up to now we have generally dealt with fixed or animated images produced with the aid of computers on traditional supports such as paper, canvas, textiles or in the more recently developed media of photography, film and video. We have encountered fixed works or animated paintings and images, images produced by the electronic 'paint-box' palette and other digitalized images, as well as logical, mathematically calculated images (synthetic images) produced from a model, sometimes only with two-dimensional but more often with three-dimensional effects.

Before describing, as well as trying to detach the specific aesthetic intention and results of, works in the

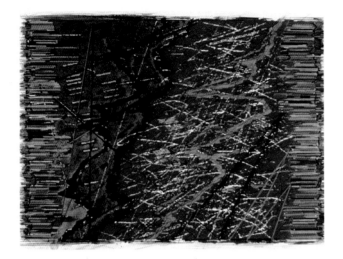

real third dimension, principally sculptures and installations, let us try to define a stricter division or classification of Computer Art works by making it clear that the two main divisions, technically speaking, are between those works on more traditional supports (including film and video) and those that have the computer itself as support.

Within these two main divisions we again find two subdivisions: from the 'traditional' division, 1) digitalized images, including those produced by an electronic palette; and 2) three-dimensional calculated images, fixed or animated. From the division in which the computer itself is support, we can distinguish between those works in which 3) the computer handles a collection of digitized images and allows an interactive access and modification of them; and 4) calculated interactive images or interactive robot installations functioning in real time and sometimes allowing the creation of 'virtual worlds'. We thus have four categories.[10]

Let us add a number of examples in each of these categories. In the first can be included works by Karen Guzak, Miguel Chevalier, Rainer Ganahl, Michaël Gaumnitz, Lea Lublin, Yaacov Agam, Thomas Porett, Gudrun von Maltzan, John Dunn and Duane Pulka.

Karen Guzak believes that 'Geometry always needs chaos, disorder, the organic end of the spectrum.'

After having produced hundreds of computer drawings stimulated by the context of group experimentation and the 'hard copy' opportunities of the ink jet printer, Guzak created a suite of computer-oriented lithographs, using hand-drawn images layered with images on the computer. Her lithograph *Double Crisscross* sets up a balancing act of two X-shaped images that are similar but not identical. There are meeting points, but each X is doing its own 'dance' with its own centre of energy. The lithograph *Range Finder* is an abstract view of the earth from space, superimposed with images from scanners and plotters acting as a guide to finding a possible home.

For Guzak, the integration of traditional hand methods, photographic techniques, printing processes and the use of the computer as a drawing instrument are especially satisfying and complete. She uses her visual and manual skills with the computer to explore microscopic and macroscopic worlds, to integrate accident and order, to combine the old and the new, and to link science and art.

136
Karen Guzak
Red Ridge (1987)

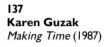

137
Karen Guzak
Making Time (1987)

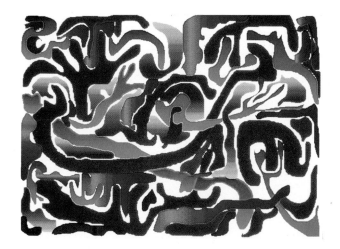

138
Roger Guillemin
Paradise Lost (1990)

139
Gillian Wise
Cercle Syncopé (1991)
acrylic on canvas; a colour
study generated on a
computer

140
Miguel Chevalier
Anthropometry (1990)

It is of interest that Roger Guillemin, Nobel Prize winner in Physiology and Medicine (1977), has recently produced computer images with an artistic purpose, bearing such titles as *Paradise Lost*, *Flat Fields*, *Globes*, *Vale!* and *Schizolines* – free compositions for which he has chosen the traditional support of lithographs. On the other hand, a confirmed artist like Gillian Wise, a former member of the British Constructivists, is currently creating coloured computerized images with quite rigorous symmetrical forms, available as collages or on discs.

The computer plays an important role in the Cibachrome works of Miguel Chevalier. His installations, which are generally made up of several components telescoped together, are adapted to a given context – which could be the maritime atmosphere or a viticultural establishment.[11]

Chevalier considers that his computer variations and his digital images are built on implicit information encountered in the work of Malevich and Yves Klein with respect to the notion of infinite space. But they relate most of all to the work of Piet Mondrian and its geometric principle, of which Chevalier became progressively aware and which he adopted in most of his interventions. Chevalier thinks that Andy Warhol and Nam June Paik should also be considered as contributing to the context of his work, the former for the colour variations through light in his stereotype images of the consumer society, the latter for his musical and chromatic video installations.

Chevalier is an artist who is aware of the importance of the interplay between technical and aesthetic factors in Computer Art. His aim is not only to reproduce the technological characteristics of this tool, but also to reflect on the relationship of art to reality. For him the computer is not a simple substitute for the materials of the painter. Its unlimited repertoire of forms and colours provides the opportunity for the perpetual metamorphosis of its elements. All these qualities allow Chevalier to realize his sequentially ordered work, close to the preoccupations and activities of definite professional groups inside society, and testify

to his interest in communication and the media. With the computer, which is situated at the crossroads of painting, photography and video, we enter into what could be called 'data culture'; and thus, with the aid of what seems to be a purely technical tool, Chevalier is trying to comprehend and exemplify a particular stage of human expression.[12]

In the 'Artistic Installation' of PIXIM 88 at La Villette, Paris, Rainer Ganahl showed his *Still Life* (1988), consisting of 10 xeroxed Laser-prints. Of his work he states:

> With sophisticated tools reduced to their most basic functions, without colours, without digitizing, I investigated an underestimated but very semiotic, anti-theatrical and anti-baroque subject of [art] history seen through the intellectual enquiries of self-conscious contemporary art-thinking. I try to use the conceptual and text-oriented abilities of the computer by renouncing all the myriad of fancy possibilities. Also I reject simple screen reproductions by exploring alternative forms of presentation.[13]

Between 1985 and 1989, Michaël Gaumnitz produced a series of video montage works entitled *Sketches, Portraits and Homages*. These were short works of 'electronic animation' developed with the use of an electronic palette and involving some free improvisations around themes of personal memory. To transcribe these interior images in their stage of perpetual transformation, Gaumnitz tried to profit from the limits of a basic graphic palette: the three primary colours and their complementaries, and some elementary techniques (pasting and erasing, displacement, multiplication). Sometimes funny, sometimes nostalgic, but endlessly imaginative, these video works incorporate the new technology in the range of artistic means of expression. While revitalizing traditional animated film they also open up new dimensions of space, time, rhythm, and movement to painting.

In his own words, Gaumnitz likes to

> explore the world of traditional painting with the new image technology, linking a new means of plastic

expression to our cultural heritage: references, myths, quotations, improvisations, appropriations, glimpses, new combinations. With the new electronic tools the image has radically changed its status: from being a fixed, eternal image in traditional painting, it has become changeable, revealing the processes of its genesis and as quickly disappearing. It exists only for the length of a glance. The unique image multiplies itself infinitely, insinuating itself in millions of living-rooms through the small screen. Quietly in museums it begins to speak, to sing, to dance, to remonstrate. For the coloured pigment of the painter's tubes is substituted an image of the mobile architecture of light growing from the depths of the cathode tube to fascinate our eyes as once did church stained-glass. The electronic image is impatient with slow and measured elaboration. It is very quick, its speed of appearance and reappearance is itself a plastic means. To the notion of space in painting is added duration. Perception, once considered a finality, has today become a way of living.[14]

Lea Lublin, an Argentinian artist living in Paris, has used the computer to re-present masterpieces from the history of art in such a way as to draw attention to their often hidden intentions. For example, in a series entitled *The Memory of History Meets the Memory of the Computer*, Lublin investigates the traditional theme of the Madonna with Child to reveal its sexual connotations. She generally exhibits the results on traditional supports such as canvas or paper.

144
Franco Summa
Imagines (1992)

145, 146
Lea Lublin
The Memory of History Meets the Memory of the Computer (1985), a detail and a view of the whole installation

In the 1980s, Yaacov Agam, with the aid of electric and electronic devices, developed a new independent style, 'multidimensionality'. The idea was already present in some of his earlier works, such as the model for the *Multi-Stage Theatre in Counterpoint* (1962), or in his tactile paintings, but it was elaborated gradually until it became his central theme, especially in his multi-cylindrical painting-sculptures turning simultaneously backwards and forwards at different speeds. Agam's main contribution to Computer Art, however, consists of his series of multi-screen computer-generated works, *Visual Music*, exhibited at the Tel Aviv Museum, the Denise René Gallery in Paris, the International Contemporary Art Fair in the Grand Palais, Paris, in 1987, and at the 1st Biennale of Nagoya in 1989 where it was awarded the Grand Prix. This line of research is the crowning of Agam's efforts to obtain an effect of immateriality, making apparent the invisible in the visible and the spiritual in the corporeal.

Thomas Porett's *Victims* (1985–88), exhibited at PIXIM 88, is a computer slide show of video-digitized images accompanied by synthesized voice. The piece was created on the Mackintosh Plus computer, using the Magic and Macvision video digitizers with the software provided with these units. The speech portion of the piece uses Macintalk software from the Apple computer company. The original piece was constructed with the Slide Show Magician package and has most recently been reprogrammed in the Hypercard format.

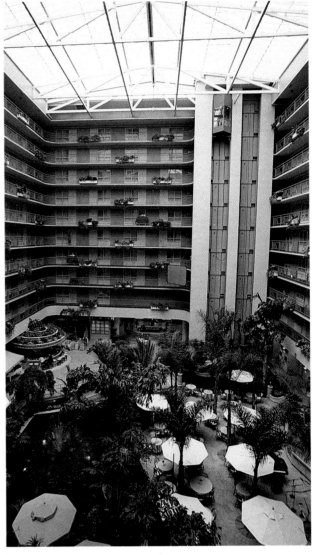

147, 148
Yaacov Agam
Visual Music (1988)
computer-generated artwork installed in the lounge of the Embassy Suites Hotel, San Francisco; and as seen from the terraces of the hotel

149
Thomas Porett
Victims (1985–88)

150
Thomas Porett
Deceptions (1988)

151
Gudrun von Maltzan
Natural stories (second series, 1988)

Victims is a continuous computer/video image work about the complete loss and impossibility of revenge suffered by victims of tyranny, and is intended to address the ever-present danger of any absolutist ideology that so easily sacrifices life in pursuing its self-appointed goals.[15]

At the 'Artifices' exhibition held at Saint-Denis in 1990, Gudrun von Maltzan showed video works obtained with an electronic palette. In *Natural Stories*, the 19th-century Romantic writer E.T.A. Hoffmann and the actor L. Devrient empty several bottles in the course of their grotesque discussion. In a drunken state, each sees the other metamorphose into figures which finally devour each other. Using an antique image in which the figures are progressively modified, Von Maltzan poses with exemplary brevity the question of the transformation of the constituents of the image in the art history of the 19th and 20th centuries. In *The Goddess Europe*, an image on paper of an old woman, representing Europe, is enclosed in a bottle and thrown into the sea. It is fished out by natives on the African coast who celebrate with a dance which culminates in an abstract colour composition. Finally the Goddess Europe becomes an amulet worn round the neck.

Von Maltzan explains that

Drawing, printing, photography, like the electronic palette, contribute by the concrete relations of their elements or their reciprocal destruction to the constitution of my plastic and imaginary universe. It is in constant relationship with daily life, daily images and objects in a world of perpetual exchanges between our common vision and the voluntary intervention of poetic desire that I construct these works. I visually tell many stories which mix the true and the false. I do the same thing with technique. I use found images and also those made by myself. I rework them, paint them, scratch them. Then I record the product of this hybridization, this mixture. My work could be said to be concerned with a staging of the myths of painting and photography.[16]

The work of both John Dunn and Duane Pulka illustrates the merging of Video and Computer Art and the introduction of the temporal dimension into this type of art. John Dunn has produced a Video Art Computer programme that allows 16 viewer-drawn images to be transformed, moved about and made to interact. Pulka, another American artist, has produced a programme that transforms one depicted object into another, for instance, a leopard into an automobile, and a programme that permits the transformation of objects as they move in a hypothetical gravitational field with properties quite different from the gravity that exists in the universe.

In the second category of our classificatory scheme, that of works operating on more or less traditional supports of fixed or animated calculated images, generally with a three-dimensional effect, the leading artists include William Latham, Herbert W. Franke, Hervé Huitric and Monique Nahas, Michel Bret, Nelson L. Max, Nicole Stenger, Manfred Mohr, Darcy Gerbarg, N. Magnenat-Thalmann and D. Thalmann.

In his computer animations, William Latham wants to add a new dimension to computer graphics, or 'computer sculpture'. He often develops three-dimensional shapes influenced by such surrealists as Salvador Dali and Yves Tanguy, which a sculptor could carve, deform or reshape on the screen. He has stated that he 'needed a computer technology which could carry out a large number of sequential operations which the normal mind cannot do.' In fact, he is trying to develop an interactive computer graphics system for designing complex forms. He uses three-dimensional modelling as well as advanced graphics techniques, such as texturing, blending and multiple light sources.

At the 'Artifices' exhibition he showed *The Conquest of Form* (1988) and *The Evolution of Form* (1990), films of synthetic three-dimensional images presented on video. *The Conquest of Form* presents imaginary forms, numerically generated sculptures carved into volumetric textures, floating in space and transforming themselves. These are 'phantom sculptures' that exist only in the form of data and are able to be 'touched' only with a look. The sequence *The Evolution of Forms* shows the continuous metamorphosis of a complex form in three dimensions: from a cloud of egg shapes swirling in a random manner, it takes the form of a starfish, then of palms. The key images of these animated works have been created with the new 'Evolutionary' interface which combines chance mutations and artistic choices. Their realistic aspects are due to the use of three-dimensional textures, ray-tracing, and multiple light sources. This film is the result of a collaboration with the scientist Stephen Todd and Peter Quarendon. According to Latham, they

developed a new Art Evolution Programme called Mutator. Thanks to this programme artists decide from an aesthetic point of view which forms to retain and which to destroy. It's a sort of natural selection controlled by the artist. The forms produced with this programme have an extremely organic aspect, and with this technique the artist can explore a multi-dimensional space of millions of sculptural forms. These images are then photographed or filmed. The works are the photographs of objects which do not exist and which have been produced by a computerized process of evolution.[17]

153
Masaki Fujihata
Geometric Love (1988)
sculpture conceived with the aid of
the computer

154
Pierre Friloux
Hybrid Venus (1988)
computer-generated images of
crystalline 'water' that electronically
'flows' through six video monitors;
shown at 'Images du futur',
Montreal, in 1989, New York and
Strasbourg

We have already alluded to the fact that Herbert W. Franke used a cathode-ray oscillograph in 1953 in order to provide free images; he was one of the first to be interested in Computer Art (which was then called analog design). Later, when there were graphic systems connected to digital installations, he first worked with plotter design and later with video design; it was the possibility of making images move which particularly interested him. According to Franke, the evolution of Video and Computer Art illustrates the fact that electronic systems have their own principles, which can be explored, understood and elaborated in aesthetic programmes that enable the discovery of new avenues of creation while also offering a visual technical means comparable to that available for music.

In the graphic games *Butterfly* and *Mikado*, exhibited at the 'Electra' exhibition in 1983, Franke based his work on an analysis of computer applications from the viewpoint of both graphic arts and colour combinations. According to him, two trends led directly to Computer Art: one in which mathematics allowed the description of projects and results, which include a number of artistic styles from Constructivism to Op Art; and the other, what he calls 'Apparative Kunst' (Complex Machine Art) – leading from the kaleidoscope or the chequering machine to works based on photo-mechanical transformation, 'diaphragm structures', scientific photography and picture processing. For Franke, drawings generated by computer make the study of the creative process, its principles and its laws indirectly possible, but they also encourage an interactivity between the work and the spectator. This has been one of Franke's concerns for a considerable time.

The three-dimensional digital film images of Hervé Huitric and Monique Nahas, e.g., *9600 Bands* (1983) or *Masques and Bergamasques* (1990), are based on work from a physical model and not a graphic design, although they refer to the traditions of painting and sculpture. In the latter case the digital images of human faces are produced with exceptional realism due to the reproduction of the traits and texture of the skin obtained by organizing data based on a real face with the

aid of an original laser system. The artists are hoping to develop this system so as to capture real colours and movements in order to create in the future a camera for making three-dimensional films and still photographs.

Huitric, not only a trained artist but a researcher in computer science, and Nahas, trained in theoretical physics, began their combined projects in 1970 at the University of Paris with only a small computer and a line printer. Their wish was to work on the variation of colour as a continuous fluid spatial medium.

In 1975 the first colour screen became available to them which made it possible to abandon their initial pointilliste approach and to focus only on colour variations. Since a picture could be easily stored and modified, the way was opened to develop a series of pictorial transformations. Huitric and Nahas's computations were based on straight lines and circles, and in 1979 they began to introduce figurative elements into their pictures, by programming in Fortran with real numbers and by drawing B-Spline curves and surfaces.

In 1981 they began to extend their two-dimensional programme to three dimensions, and started to model objects with bi-cubic B-Spline surfaces. By using the 'Oslo algorithm', they could insert new control points into a given area without changing the surface. This technique, together with the locality properties of B-Splines, makes it possible to shape the objects just as a sculptor works material.

157
Hervé Huitric, Monique Nahas, Marie-Hélène Tramus and **Michel Santourens** still from the film *Pygmalion* (1988)

159
CIMA
(Centre informatique et de
méthodologie en
architecture), Architectural
image obtained by Ikograph
computer graphic system,
software by Michel Bret,
image design by Sabine
Porada, 1986

Finally, Huitric and Nahas produced film sequences of three-dimensional shapes interacting together in space and time with the possibility to change colours, texture, shapes, observer and projector parameters from one scene to another. They also implemented a ray-tracing algorithm on B-Splines, in order to use reflections and refraction in their images.

The interest in realism found in this work is absent from that of their colleague at the Paris University Research Laboratory, Michel Bret, who has opted for an abstract and semi-abstract language in his subtle computerized animations of the one-million pixel surface with the aid of the 16-million chromatic choices at his disposal.

Bret's 'Anyflo' system of three-dimensional animation and synthesis uses his own concept of Procedural Art. The computer is more than just a tool for him, it is a 'meta-tool' which is used to manufacture tools. With such an apparatus, visual artists no longer produce a work, but the process which generates it. And they are no longer interested in the physical characteristics of the object, but in the laws which enable the object to appear and exist. By stimulating the creative act, i.e., manipulating a model, the visual artist can explore all its potentialities and change them at will.

Bret also proposes a palette programme built around a technical component called an interpreter, which is at the heart of the 'Anyflo' system. This programme is procedural and no longer simply gestural; the artist has produced with it some remarkable designs, such as the computer-generated image *Recursive Dragon* (1979).[18]

Nelson L. Max created between 1982 and 1983 *Carla's Island*, a three-dimensional digital image in motion, generated in real time by computer, some of whose parameters can be modified by the audience during its appearance on the screen. A trained mathematician, Max began in 1969 to use computer animation to produce films for mathematical education and from 1981 onwards for artistic purposes. In addition to visual pleasure, the primary goal of his work has been to approach photographic realism in his computer simulations and to teach concepts in science and mathematics.

In *Carla's Island*, which existed first as a film, Max introduced the factor of spectator interactivity. Thanks to a simple analog system, the spectator can interact with a moving three-dimensional image of islands surrounded by water and modify at will the colour of the sea and sky and the position of the sun and moon above the horizon.

Nicole Stenger has to her credit a large number of exhibitions in Europe and the U.S.A. Her *Gallia* video (1988), exhibited at PIXIM '88 and made with an 'Ikograph' programme, showed the hexagonal map of France initially made from traditional symbols (such as the tricolour cockades, streamers and torches), then mutating to those representing more heterogeneous forms (involving the mixture of ethnic emblems and individual figures) in order to represent the transformation of France from an old-fashioned national entity into a modern multi-faceted democratic state.[19]

In the laboratories of the Massachusetts Institute of Technology at Cambridge, Massachusetts, then at the University of Washington at Seattle, Stenger has developed *Angelic Meetings*, a project for an installation employing synthetic image devices which makes use of the specific interface between eyephones and data-

**161
Karl Sims**
Panspermia (1991)

**162
Nicole Stenger**
Angelic Meetings (1991)

gloves. With guidance, the spectator can create a meeting in the virtual space of several simulated gardens. This event can be recorded in the computer memory and in turn re-enacted for other spectators.

Manfred Mohr has developed a computer programme based on his research in fractured symmetry. His work begins with an algorithm, not with visual ideas. He starts by setting up a programme, which he translates into a coded language and feeds into the computer. The machine transforms the programme into signs, which Mohr samples, checks, improves and changes until he is satisfied with the final results. As soon as the development of the algorithm is finished, the plotter, a mechanical drawing device, takes over the technical realization of the programmme on drawing paper or canvas.

Since 1969, Mohr's research has evolved, but not in a linear progression. No one phase leads to or replaces another. Each work phase, whose development does not result in a single work but rather culminates in a series, is founded on a single idea and a common problem. So, for instance, the paintings, drawings and wall structures from the 'work phase' *Divisibility* (1980–86) show a common structure: the division of the cube into four

165
Vivid Effects, Inc.,
Willowdale, Ontario, Canada, *The Mandala* (1988).
A video camera views the performer on a stage area. The signal is digitized and brought into a matrix of software. Thus the performer's image is transposed into a world of video animation and he can experience real-time interactive control over animated events.

parts with a horizontal and vertical cut through the centre point. Four independent rotations of a cube are projected onto corresponding quadrants created by the cuts. In order to stabilize the structure visually, two diagonally opposite quadrants contain the same rotation. In the third part of this work phase (1984–86), the cubes no longer appear as the principal elements. The contours of the 'four cuts' are seen as a 'shadow-form' or two-dimensional visual history of the cube's growth. The connecting point between the centre-point of one 'four cut' and the centre-point of the next becomes a black growth line. Similar to the spine in a body, the growth-line is here embedded in the shadow-form.

In a work of 1987, belonging to the *Dimensions* work phase, a four-dimensional hyper-cube is the structure whose four-dimensional rotation becomes the generator of new sizes and shapes.

Mohr sees himself as an artist who uses mathematics only as a vehicle to realize a vital philosophy. He leaves it to the observer to find an approach to his work, whether as pure aesthetic experience or as a cognitive experiment in discovering and deciphering certain processes and structures.[20]

166–68
Rebecca Allen
Modélisation d'un visage
stills from a video clip produced in collaboration with the
German music ensemble Kraftwerk (1986)

Darcy Gerbarg works in many media, each with its own set of formal concerns, and considers her creative processes to be both conscious and intuitive. For ten years she has explored techniques for transforming images created in the immaterial medium of coloured light on computers into physical media such as paintings on canvas – for instance, *Cynth*.[21] Gerbarg also tried at a certain point to create a series of portraits by sitting at the computer and talking on the telephone with the subject for three or four hours.

Nadia Magnenat-Thalmann and Daniel Thalmann have been concerned with the creation of films, using 'synthetic actors' in their work *Rendez-vous at Montreal*, an animated film that uses advanced computer techniques to achieve such effects as 'reincarnating' Humphrey Bogart and Marilyn Monroe. In an article in *Leonardo*, Magnenat-Thalmann explains the processes involved in the construction of this film and discusses in detail the problems connected with animating the bodily movements, gestures and facial expressions of the actors.[22]

Among the third category in the scheme mentioned earlier, the one in which the computer is the support of the work itself, no longer only a representa-

tional or interactive intermediary, and handles a collection of images or controls their manipulation, as with the videodisk (digitized by the computer), the work of Brian Reffin Smith, Philippe Jeantet, Jim Pallas, Hillary Kapan, Jean-Louis Boissier, Sonia Sheridan, Vladimir Bonačić, Edward Ihnatowicz, Nicholas Negroponte, Jean-François Lacalmontie and Marc Denjean deserves mention.

Brian Reffin Smith seeks to introduce critical discourse and contextual and productive reference into the artwork itself as a means of avoiding misrepresentation. It is also his wish to create – and for other artists to create – artworks that interact and provoke communication, or that stimulate new ways of perception. For example, one of his works, *That Other Evil* (1988), a photographic reproduction of a plotter drawing, is an attempt to combine several levels of representation and discourse in one piece with advertising slogans and facetious allusions to Thatcherism.[23]

Off the Rails: Visual Anti-simulation of an East German Restaurant Car (1990) seeks to engage in critical discourse via the art of computer simulation while including a feeling for movement and power as well as for an impending catastrophe. Through its ability to simulate reality, the computer exposes the falsity of the quality-claims for food sold in the restaurant car, a falsity which persists even after the end of the Cold War or perhaps more so.

When Philippe Jeantet works with a computer he uses its capabilities as material characteristics which are modifiable at will. He is interested in the luminescent beauty of cathode images and the pleasure of assembling them in immaterial, constantly changing abstract paintings through the introduction of real time.

The first of his sculptures, such as *No. 1, The Egg* (1988), were the result of these interests, rendering perceptible the numerized gestation of the image by stripping the computer and the video monitor of their cladding. It is the coupling of these two pieces of equipment that structures the sculpture. Describing his work, *The Obelisk of the Rights of Man* (1989), the artist writes that it

> evokes the new alliance between Man, Technology and the Earth: and thus the triumph of the rights of man. . . . The ochre-red base, in a classical design but with a crudely executed surface seems familiar. Soft to the touch, its skins surprises, is it earth? The obelisk, with reflecting screens which mirror buried civilizations, extends from the base like a crystal. The column, full of metallic arrogance and electronic pride, springs from the earth and troubles us by the strange life which seems to inhabit it. Abstract paintings of light evoke the course of the sun, the caress of a breeze or the fury of towns. The silence which accompanies them is a golden accomplice to our meditations. Accidentals violently disturb our quietude. Their music breaks the silence, their colours are random and they surprise us with their chance rhythms.
>
> (Leaflet, Paris, 29 March 1991)

Cable News Nature, presented by Jeantet at the Parc Floral in Vincennes in June 1991, was a controversial work which coincided with the Gulf War. By freely staging their censoring, the media actively participated in the war, making evident the role of television as an institution for the control of dreams and the urgent necessity to retrieve it, by means of art, as a space for freedom. According to Jeantet, *Cable News Nature* was an artistic arrangement constituted as a sculpture, installed on an outdoors site and using a chain

171
Philippe Jeantet
The Obelisk of the Rights of Man (1989)

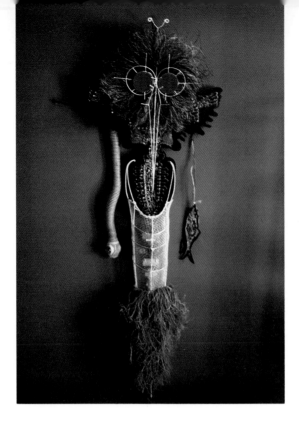

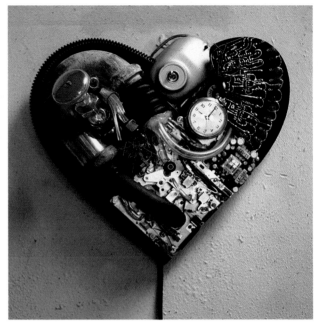

172
Jim Pallas
Mosquito, Fish, Snake (1984)

173
Jim Pallas
Electromechanical Heart (1985)
electronic circuitry pocket watch,
Janet Pallas Coll.

of cable televisions. 'This sculpture is a probe, inspired by the celebrated "Voyagers" and other pioneers of space. Its function is to collect information and transmit it to us. But this space vessel is immobile because its voyage is time itself and its spatial characteristics are only in our thoughts.'[24]

Jim Pallas's electro-kinetic sculptures have been made with particular consideration for their cybernetic potential. Looking like giant toys, they move methodically, lights flashing on and off, and they periodically emit sounds as a reaction to the presence of the spectator. Traditional themes, such as self-portraits, figures, animals, and landscapes, are given a contemporary treatment by TTL logic devices and light-emitting diodes, i.e., computers and transistors. Pallas, however, does not limit himself to technological means. For the creation of his fanciful and imaginative characters, such as *The Blue Wazoo* (1977) or *The Nose Wazoo* (1990), he uses a repertoire of materials that includes pearl and crystal beads, sequins, feathers, horsehair, polythene bags and a variety of thin wire and steel rod. These robotic, interactive sculptures are 'performing pieces' that depend on a combination of computer logic and environmental stimuli.

Emerging Forms 3 (1990) by Hillary Kapan, shown at the 'Artifices' exhibition in 1990, is an interactive animation work. Kapan has written a programme which generates changing forms from a field of scattered pixels. By moving a 'mouse', the spectator is able to control and comprehend the rapid transformation of random motifs which appear, twist, flow and dissolve into new motifs as a result of ungraspable principles and invisible processes. The work becomes a minuscule world which is explored, as well as modified by, the spectator. Through interactivity, the spectator shares the experience of the artist and is encouraged to become an active participant, an artist in his or her own right.

According to Kapan,

as with preceding innovations, new ways of manipulating the given materials and information appear with the computer: the artist manipulates an electronic painting or the objects which don't exist in the physical world. Because it is stored as information, the imagery is able to produce forms difficult or impossible with real materials. Forces like gravity or friction can be accentuated or eliminated, objects can interpenetrate. Any colour or form can be modified over an entire surface, the saturation of complementary colours can be reduced, an

arrangement of lines can be simultaneously divided or contracted. Because the digital information can be exactly duplicated and modified indefinitely, and all the variations can be explored and retained, the work can be recalled, combined with other works. Such processes can be guided by instinct and controlled much as a sculptor models his clay.[25]

Jean-Louis Boissier's *The Bus* (1984–90), shown initially at the 'Les Immatériaux' exhibition held at the Georges Pompidou Centre, Paris, in 1985, and in a newer version at the 'Artifices' exhibition in 1990, consists of an interactive videodisk combined with sections of a bus belonging to the RATP, the official Parisian transport network. Standing in front of a section of the bus that includes the 'request stop' button and a screen which has been substituted for one of the bus windows, the spectator is able at any moment to arrest the flow of images of a landscape which unfolds on the route between Saint-Denis and Stains, and by this means to 'visit' eighty inhabitants, entering into their private worlds via their family albums. The work has been realized with the assistance of photography students. Boissier comments that 'The videodisk is an album of images. The software, a diagram of their

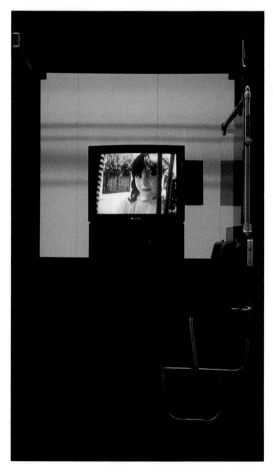

interaction, is itself an image, a map of the territory crossed. The order given is also literally taken from the real and the spectator finds by his action an everyday gesture. The computer organizes the data, then its collection; it is the instrument which responds to the desire to see, and offers reading as an alternative to seeing.'[26]

In Sonia Sheridan's *Generative Systems Programme* and other installations, the spectator can enter and modify the image and make it respond to his or her instructions, creating images from other images. Interactivity or feedback between the spectator, the programmer and the machine is a pre-eminent consideration. Sheridan's work with computers is only part of her preoccupation with contemporary communication systems, and this includes still and moving images, printing, drawing, painting and photography as well as aural, thermic and magnetic interventions. The software she uses is designed to be as simple as possible in order to convey visual messages which should be as easily accessible to the general public as to artists.

Programmed computer systems and cybernetic systems, provided with or without sensors, already have a history in pictorial and sculptural kinetic art. Vladimir Bonačić constructed *A Dynamic Object* (1969–71), an audio-kinetic pictorial work with computer-controlled light and sound effects. In England, Edward Ihnatowicz

produced an object called *Senster* (1971), that moved its arms towards a sound source controlled by a cybernetic system. Harold Cohen's computer-controlled robot, already mentioned, applied paint to a canvas placed flat on the floor as the robot moved in accordance with programmes incorporating random factors.

Nicholas Negroponte, who later directed the Media Lab at the Massachusetts Institute of Technology, created an installation called *Seek*, which was shown at the 'Software' exhibition at the Jewish Museum, New York, in 1970. It consisted of a group of cubical blocks with gerbils (small rodents) living among them. A computer-controlled motorized arm moved and rearranged the blocks. The computer system was equipped with pressure sensors to determine changes in block positions caused by the gerbils' movements. The system then attempted to place the blocks in positions responsive to the gerbils' 'desires' as indicated by the previous movements.

In 1989, Jean-François Lacalmontie, with the aid of Alain Longuet, created a computer installation entitled *Random Generation*. From thousands of signs, imprints and monograms traced with Chinese ink on paper, dozens of elementary forms were extracted for their emblematic shapes. A software programme was developed to assemble the forms and combine them in pseudo-random structures simulating the irruption of

176
Photo by Jean-Louis Boissier of **Sonia Sheridan** demonstrating her work at the Electra exhibition of 1983 to the French Minister of Culture Jack Lang and his wife, Frank Popper, who conceived the exhibition, and the Conservateur-en-chef of the Musée d'art moderne de la ville de Paris, Bernadette Contensou

177
Jean-François Lacalmontie
Random Generation (1989)

the pictorial gesture. The end result was an infinite series of original images which were born and died within ten seconds on the blank screen.

With regard to this work, Georges Collins wrote in the catalogue of the 'Artifices' exhibition:

> Kant attempts in the third Critique to regain 'the infancy of thought given to the world'. This thought is the imagination, the pure capacity of presentation. It is that which presents to the subject the forms which determine the judgement of taste. These forms are not those of the object, but free forms, 'arbitrary', as he says, 'composed of isolated characteristics and not determined by any supposed rule . . . floating patterns, so to speak, in the middle of diverse experiences.' Kant named them monograms. Lacalmontie produced such monograms for many years in parallel with, and as a development of, his painting. One day it occurred to him that it might be necessary to assume, despite all appearances, that there existed a determinate rule, with regularities and patterns, underlying his artistic activity. It was the pursuit of this line of thought that produced the happy meeting with Longuet. Rather than generate this kind of rule from the sum of all the monograms, Longuet proposed an approach which has provided eighty elementary forms drawn by hand and programmed with the aid of a combinatory. All future samples of this infinite series of monograms, all 'ready-made' cuttings, will be produced from this finite set.[27]

An interesting experience in numerized videotex, a scientific system of images originating from a databank and using a television or video network, has been made by Marc Denjean, who is less concerned with imposing new ideas and new techniques within the context of art than with the communication process itself. This is videotex at its purest, an experience directly accessible to the new generation of artists and public.

In the fourth category of works which also have the computer as their support, but whose calculated images, sculptures, robots, installations or games function in real time, sometimes allowing virtual worlds to be created, we can mention several outstanding works conceived by Jeffrey Shaw, Lynn Hershman, Sara

178
Kenneth Snelson
C_{60}, *Soccer Ball* (1989)
fantasy image of a 'fullerene' molecule composed of 60 carbon items linked together in the shape of a soccer ball

179
Kenneth Snelson
Forest Devils' Moon Night (1990)
An exotic landscape with four structures, replicas of an existing large outdoor sculpture. Here the objects reside in a strangely textured prairie composed on a Silicon Graphis computer using texture mapping and ray tracing. The structures were built part by part within the computer.

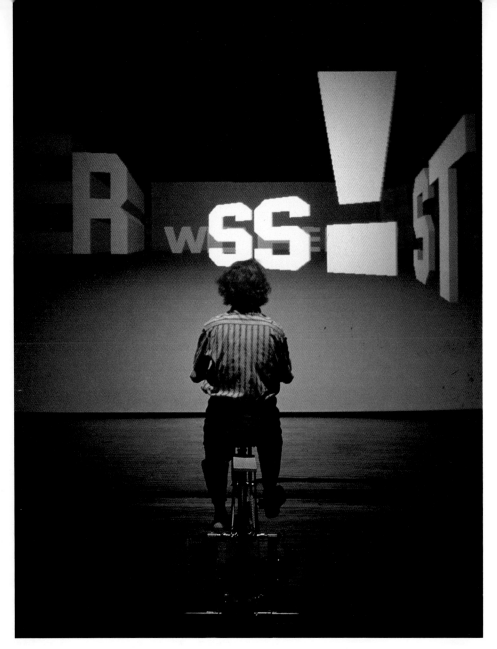

Roberts, John Manning, Nancy Burson, Ed Tannenbaum, Jane Veeder, Christopher Burnett, Myron W. Krueger, Richard Kriesche, Stephen Wilson, Waltraut Cooper, Edmond Couchot, Annie Luciani, Gilles Roussi, Norman White and Matt Mullican.

One of the most impressive of interactive computer/video installations is the work of Jeffrey Shaw. In collaboration with Dirk Groeneveld he has created *The Legible City*, limited in the first place to a partly real, partly imaginary bicycle ride through Manhattan, later extended to include also the city of Amsterdam. In this work the psychological identity of 'the city' is made tangible as a three-dimensional literary architecture through which the spectator travels interactively on a bicycle. Its streets, intersections, squares, etc., form the ground-plan of a spatial ordering of words and sentences, and bicycling in that city is a journey of reading. The large-screen video image is generated by

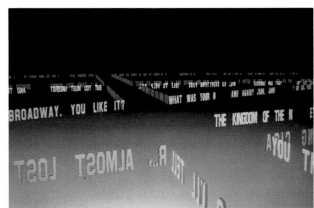

180–82
Jeffrey Shaw
three views of *The Legible City* (1990)

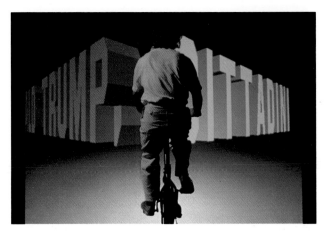

means of a computer graphic 3D animation system, connected to electronic sensors on the handlebars and pedals of an immobile bicycle. The image responds in real time to instructions concerning direction and speed that result from the action of the person who is 'riding' the bicycle.

In the first version of *Legible City*, the urban architecture of words and sentences, based on the street plan of a 6 km² area of central Manhattan, was a three-dimensional network of story-lines, and the way they were read was each time a unique consequence of the particular journey that a bicyclist was making there. For New York the text was based on statements made by people linked with the city, for Amsterdam on the historical chronicles of the town.

The rapid evolution of computer graphics visualization technologies generates new possibilities that are significant for the future development of *Legible City*.

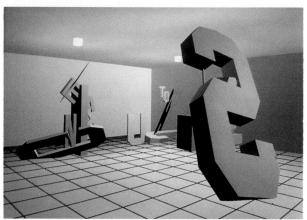

183–85
Three views of **Jeffrey Shaw's** *The Virtual Museum* (1991), an interactive installation of synthetized images – a development from an earlier work called *Alice's Rooms*.

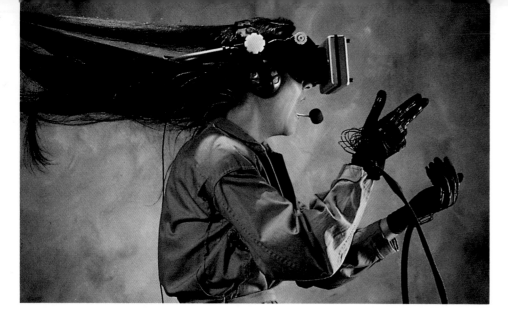

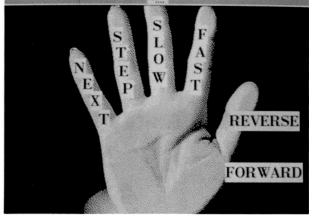

186
Scott Fisher (NASA)
Viewing System (1990)
a virtual environment based
on the interaction between
the head-mounted display
and the datagloves

For instance, using NASA's stereoscopic head-mounted display, the bicyclist could experience the work as a totally surrounding three-dimensional space of imagery. And using a telecommunication link-up, bicyclists in different parts of the world could simultaneously travel in the same virtual space.

Innovations in computer technology have extended the potentialities for interactive art in unprecedented ways. With or without video peripherals, computers can be used to emulate some of the characteristics of interpersonal communication. Lynn Hershman, Sara Roberts, and John Manning are among the artists who have created interactive computer installations that model the dynamics of human relationships.

In Lynn Hershman's interactive piece, *Deep Contact* (1990), a robotic *femme fatale* reacts to the touch of the interacting spectator with the help of Hypercard software and an Apple Mackintosh personal computer, which moderate the viewer's access to 57 video segments stored on videodisk.

187
Lynn Hershman
stills from *Deep Contact*
(1989–90)

188, 189
Lynn Hershman
two stills from the
interactive videodisk *Lorna*
(1980–83)

Sara Roberts created an interactive computer installation in 1989 titled *Margo*, a prototypical maternal figure with an emotional capacity that is influenced by the viewer's responses.

John Manning has dealt with relationships at a higher level of abstraction in his computer installation, *Who Says*. The artist wrote a programme in Hypertalk language to enable two Mackintosh Plus computers to

exchange dialogue. Ironically, rather than facilitate communication, *Who Says* was designed to demonstrate the way communication is blocked by the presence of rhetorical patterns, evasions and *non sequiturs*. The hollow banalities the two machines exchange bear an eerie resemblance to the language employed by bureaucrats and professional politicians.

Another type of interactive system is seen in computer games by Nancy Burson, Ed Tannenbaum and Jane Veeder. Developing the closed feedback-loop between viewer, video camera and monitor, in works such as Burson's *Composite Machine* (1988–89), these artists have added digital image-processing functions so that viewers can alter their electronic reflections. Tannenbaum's *SYMulation* (1986–88) affords viewers the opportunity to see the right or left sides of their faces duplicated to create two different symmetrical faces, and in Veeder's *Warp It Out* (1982) viewers can magnify, distort and add patterns to their physiognomies.

Christopher Burnett's electronic book *The Information Machine* (1988) is a personal database compiled by him about the 1964–65 New York World's Fair. Since the audience can reconfigure the material to create individualized versions of the database, they can subvert the presumed algorithmic character of digitized information, suggesting new paradigms for the artist/ audience relationship.[28]

Myron W. Krueger's *Video Place* is an interactive installation shown at the 'Images of the Future '89' exhibition in Montreal. For more than twenty years, Krueger has been developing a new art medium based on the computer's most unique feature, its ability to respond to real time. In *Video Place*, the computer perceives the visitor's image in motion, analyzes it, understands what it sees, and responds with graphics, video effects and synthesized sound. The spectator's movements determine entirely what he or she will perceive and experience although the laws of cause and effect are composed by the artist. From its conception in 1969 and its first performance in an exhibition called 'Metaplay' in 1970, *Video Place* has been conceived of as a telecommunication environment.[29]

190, 191
Myron Krueger
Individual Medley and *Two-Way Interaction* two stills from a set of 'interactions' which formed part of the *Video Place* standard repertory in 1989

Richard Kriesche's installation *Liberty Leading the People*, also exhibited at 'Images of the Future '89', was intended to be a revolutionary event in the constitution and transmission of messages. Analyzing Delacroix's famous painting with techniques currently used for the satellite transmission of images, Kriesche presented three states in the 'remote detection' of the painting via the gradual 'reduction' of the visual information it contains on a moveable three-sided panel. With this work Kriesche suggested that, ironically, there has been a real loss of information in today's world as a result of the explosion which has brought about a condition of over-information.[30]

The research of Stephen Wilson is concentrated on developing the imaginative aspects of human intelligence and especially the possibility of simulating thought processes. In his *The Responsive Linking Piece No. 1*, for example, instead of making a finished work, Wilson presents a collection of verbal or plastic information that could serve as a basis for one. A dialogue is established with each spectator or user, the outcome of which will depend as much on the personality of the viewer as on that of the artist.

Wilson has for some time concentrated on creating computer-mediated interactive events that explore artificial intelligence, as well as researching video-text information networks, synthesized speech, robotics and computer-environment linkages.

In *Parade of Shame* (1985), a series of eight computer graphic animations relating to issues of evolution and ecology, cable viewers in San Francisco could intervene in an ongoing event focussing on the vanishing of species. Viewers indicated choices by telephoning the station and pressing combinations on their 'touch-tone' phones. In another phase of the project, visitors could make choices about ways to integrate male and female points of view. For example, in *The Venus of Willendorf in Synthetic Speech Theatre* (1985), shown at the CADRE exhibition in San Jose, California, in 1985, the audience was able to affect a debate between four computer-generated personae, represented by digitized images, but speaking specific

words into a microphone. The computer-programmed debaters spoke with synthetic speech and 'understood' the audience through voice recognition devices. Wilson's *Stranger, Welcome to City Hall* was an interactive sculptural installation placed in San Francisco's City Hall lobby in August 1986. It consisted of two robots symbolizing city workers, who reacted with synthesized speech to visitors shaking any of their multiple hands.[31] More recently, Wilson has invented a 'Hypercard' in order to give artists and designers the possibility to incorporate time and interactivity into their works and to participate in the cultural and technological issues discussed in his book *Multimedia Design with Hyper Card*.[32]

Another interactive installation using electronics and the computer is Waltraut Cooper's *Klangmikado*. It is made up of giant acrylic rods whose motion sets off a different musical composition each time it is played. It was presented at the Kunsthaus in Hamburg in 1984, at 'Ars Electronica' in Linz in 1987 and at 'Images of the Future '89' at Montreal.

A now classic collaborative project, *The Bird's Feather* (1988–90), realized by Edmond Couchot with specialists in flight simulation (SOGITEC), is a three-dimensional image which can be transformed in real time through the computer by means of the spectator's breath.

In its 1990 version, *I Sow to the Four Winds*, Couchot, assisted by Michel Bret and Hélène Tramus, made an impressive demonstration of subtle interactive simulation that opened up entirely new avenues in the artistic use of computer technology. In this work a large dandelion head moves very slowly on a screen under the influence of a light 'virtual' breeze. When the spectator breathes on the screen, the pressure of the air detaches clumps of seeds that scatter and softly fall. The spectator can continue to blow until nothing remains to dislodge. Then a complete new flower appears on the screen and the game, always different, begins again.

In a related work, *The Veil*, a slightly open curtain seems to conceal something beyond in the depths of the screen. The veil quivers and swells as the spectator

blows on the screen in order to see more. The stronger the breath, the more the veil lifts and reveals the screen. The curtain is even able to slide on a rod and open completely. The hidden path appears then, but only on another veil.

Couchot offers the following explanation:

By digital processing, the image decomposes itself into its ultimate constituents – pixels. But while this decomposition renders it, theoretically at least, unalterable, infinitely reproducible, transmittable without any loss, and therefore totally stable, fixed, completely composed, at the same time it confers on the properties of the traditional image – photography, cinema, television, painting – the fluidity of numbers and language, the capacity to respond to the sightest demands of the viewer, to the most unexpected. The digital process of decomposition makes the image unstable, mobile, motile, changeable, penetrable. The life of the image, however, is able to last only the length of a breath. But in this breath, that sows to the four winds the fragments broken from its surface, it borrows also the power to be reborn elsewhere, different, to be finally more than an image.

In the world of interactive simulation, the infinite and the eternal are tamed, the ineluctable domesticated. Destiny – that which must occur, the inevitable chain of causes and effects, the supreme event dictated by the gods or imposed by a game of chance and necessity – no longer applies. Need one conclude, then, that in the manner in which tools have liberated the mechanical, constricting tasks of the hand, the body, the memory or the reason of man, interactive machines, in simulating the real and its eventual future, will henceforth liberate him from destiny? What will remain for the artist if art is – as Andreé Malraux put it in a nutshell – 'anti-destiny'? Perhaps the same and interminable work, consigned always to begin again: stitching up the fragments of the world torn by technique, trying to restore a symbolic coherence to things, a sense of which technique, sophisticated as it may be, as interactively intelligent as it might become, is totally impoverished.[33]

Annie Luciani's *Gestures and Movements* (1990), a video installation based on arrangement of interactive

192
Edmond Couchot, Michel Bret and **Marie-Hélène Tramus**
I Sow to the Four Winds (1990)

193
Gilles Roussi
The Great Technological Futility (1980) shown at the Electra exhibition in 1983

three-dimensional images, is a demonstration of an original approach to the synthetic interactive digital image for which the simulation of the tool of creation must precede the simulation of the results: some virtual bubbles and balls react directly to the hand movements of a manipulator, who responds tactilely to the feedback. The elements arrange themselves according to physical laws, rebounding, interacting with each other, deforming themselves, emitting sounds.

In Luciani's words:

> When one says of artistic creation that it aims for the non-real, the artificial, the non-natural, this occurs in a creative space where the means and results are in a large part natural objects. But if one says in a more general manner that the creative act seeks the frontier between the virtual and the natural, the place where artifice immerses itself in reality and is at each instant re-negotiable by the artist, and if one remarks that by virtue of mathematical programming the computer is the privileged space of the non-natural, of the written, one has to invert the traditional situation of creation, in order to allow the work on this frontier between the virtual and the natural to be practised. Thus the computer has to be charged with more of the natural . . . through the preliminary (human) gesture of the artist.[34]

194
ACROE (Annie Luciani, Claude Cadoz, Jean-Loup Flores), *Gestural Transducers* for the feedback of forces (Institut national polytechnique, Grenoble, France) (1986–91)

Gilles Roussi's *Dream Machines*, developed over many years, place the artist in the forefront of Computer Art concerned with robots, and in his case with 'good' robots. A work of 1980, *The Great Technological Futility*, exhibited at the 'Electra' exhibition in 1983, already expressed the subtlety and irony which characterize his artistic projects. As the title of this work indicates, from a strictly functional point of view the multiple elements of the apparatus have no effect. In the tradition of Jean Tinguely's 'poetic machines', Roussi uses sophisticated materials to produce a beautiful but ironic machine, which casually plays pointless games.

Roussi diverts electronics from the exactitude and definition of the engineer towards imaginative exploration and emotional experience. Instead of resolving, he questions, setting the game of art against the gambit of technology as the avenue to a utopia. Thus, the *Good Robot*, installed in an abandoned slaughterhouse, presages the time of 'worker robots'. It converses with the spectators, informing itself constantly of its surroundings. Roussi exploited here the myth of the robot as standing at the crossroads between a 'thinking machine' and an artificial man – investing it with emotions and sentiments.[35]

195
Giles Roussi
Ficus (1987)
commissioned by the
Hewlett Packard Foundation,
France

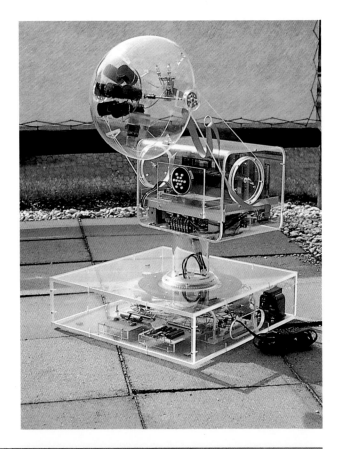

196
Norman White
Facing Out Laying Low
(1977) a microcomputer-
controlled interactive robot

Another artist working in this area, Norman White, combines in his *Helpless Robot* (1987–90) communications technology with robotics research. At present this work exists only as a prototype, but in its final form it will be a free-standing, electronically controlled kinetic sculpture with an overall height of about 5 ft and a diameter of 3–4 ft at the base. It will taper inwards towards the top, in a bi-symmetrical, yet somewhat irregular, organic way. Here and there, transparent acrylic panels will allow onlookers to glimpse the electronic equipment inside. Although its platform will be stationary, the sculpture will be free to rotate upon its base. Like the traditional mobile, the work will be essentially passive, depending upon external forces for its motion. However, whereas traditional mobiles harness wind or other natural forces, this work will have to enlist human muscle power with an electronically synthesized voice.

According to the artist, it could do this with a

polite 'Excuse me . . . have you got a moment?' or any one of a stock of such unimposing phrases. It might then ask to be rotated: 'Could you please turn me just a bit to the right . . . No! Not that way . . . the other way!' In this manner, as it senses cooperation, it tends to become ever more demanding, becoming in the end, if its human collaborators let it, dictatorial . . . Ultimately, my purpose behind the work is not to exploit, but to instruct.[36]

197
Norman White
The Helpless Robot
(1987–90)

198
Stelarc
Robot performance for amplified body and third hand
(1990–91)

199
Matt Mullican
Five into One (1991), new
version of *City Project*.
© Matt Mullican

Matt Mullican's interactive computer graphics are the outcome of previous research in more traditional media. His most ambitious work, *City Project*, was exhibited at The Museum of Modern Art, New York, in October 1989 and had been developed on a supercomputer. It was backed up by six laserdisks containing a walk through Mullican's city.

Seen from above, this city resembled a baseball field. It was made up of delimited and differently coloured zones. The red zone, called 'the Subjective', represented spirit. The black and white zones, called 'zones of signs', were those in which language existed only as signs and symbols. The yellow zone, 'The framed World', was a microcosm of the representation of the entire world; the blue, 'The unframed World', the nearest to the world in which we live, and the green, entitled 'The Elemental', represented nature and the material. When an imaginary stroller walked in a particular zone, the entire town took on the colour of that zone in order to abolish the limited geographical connotation in favour of a global social involvement in this city. Mullican now envisages the possibility of entering this symbolic space himself by using a helmet allowing stereoscopic vision coupled to a computer.

A most suprising development in applied Computer Art is represented by Vernon Reed's cybernetic jewellery or wearable microsystems. Each work contains an on-board programmable microcomputer, running a software programme to generate real-time graphics in a liquid crystal display panel designed by the artist. As far as is known, this is the only jewellery to employ fully programmable computer intelligence, as opposed to hardwired logic circuits. Motion and change are essential elements in these dramatic signs of the electronic age. Indeed, the generation of devices Reed is now designing incorporates bio-signal input to control software execution, although in 1992 this is still in its very early stages of development.

200
Vernon Reed
Twin Paradox Meltdown
(1989)
cybernetic necklace with
display stand

201
Vernon Reed
Dream Gate (detail, 1988)
sculpture with removable
cybernetic neckpiece

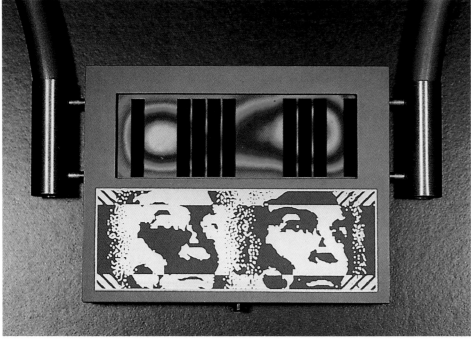

Reed considers that the computer has now touched deeply almost all areas of artistic endeavour. He believes that his work with this personal art form is laying the groundwork for a new kind of man-machine symbiosis that can be called 'bionic aesthetics'.

*

In this chapter my principal aim has been to demonstrate the existence of Computer Art and to describe its varied manifestations. I am convinced that the technical characteristics of Computer Art and its innovations are indissolubly linked with its aesthetic intentions; and equally that its aesthetic validity is dependent upon the technical innovations simultaneously accomplished by the artists. Although the range of aesthetic intentions is vast, it seems to me that two principal categories – the visual and the interactive – cover the variety of computer works, ranging from single images to installations in the four main classifications considered here.

In the visual category can be included such works as Kawaguchi's animated sea-images, Huitric and Nahas's algorithmic body animations and V. Magnenat-Thalmann and D. Thalmann's synthetic films. The interactive category, the one in which many new combined technical and aesthetic developments can be expected, includes such projects as those of Jeffrey Shaw, Edmond Couchot, and Jean-Louis Boissier.

In the interactive category, the artistic and functional autonomy of the image, its instantaneous transmission in real time, opens up new avenues that confirm the specificity of Computer Art and its claim to being an entirely new artistic medium or genre establishing an interface between the real and the virtual.

Let us note, however, the critical reservation of such theoreticians as Theodore Roszak who, although admitting that the computer has an exceptional ability to store and process information in obedience to strict logical procedures, contests the claim that it can function exactly like human memory, imitate precisely human reasoning and thought, or be the equivalent of the human brain.[37]

Many computer artists are trying to come to grips with the opposition between mind and the machine and are seeking means of transcending it by an artistic act combining reason with imagination. In this context it is interesting to note the opinions of Timothy Binkley, who contends that at present the computer in art should not be treated principally as a new medium, but rather for its 'conceptual' content. From an historical point of view, if Modernism was mainly concerned with new media and the idea of progress, and Conceptual Art can be regarded as acting as a kind of watershed between that and Postmodernist pluralism, present-day Computer Art can be understood as continuing all three strands, retaining an aloof concern with media, a conceptual orientation and a preoccupation with interactivity.[38]

Taking up another aspect of Computer Art, Binkley maintains that the computer is neither medium nor tool. In our perplexity over its paradoxically present-yet-absent images, the computer is sometimes assimilated to the mechanized media of photography and the cinema. But understanding its unique cultural role requires an appreciation of its fundamental differences from traditional media like painting, sculpture, photography and video. Functioning more like characters of an incorporeal metamedium, computers breed what have come to be called 'hypermedia', which reside in a paradoxical virtual reality where all properties exist as numbers. Hypermedia only purport to be what we know as media; they transcend their forebears in ways that give them an almost preternatural pliability involving magical metamorphoses and effortless interconnectivity, and making them capable of introducing radically new art forms.

Even more commonly the computer is called a tool. But it is not a tool of the familiar sort used in the manipulation of media. It can simulate an extravagant variety of practical, as well as fanciful, tools supporting multi-faceted hypermedia; but it ultimately challenges the tool/media distinction. It is both and neither, because the arena of its activity is abstract information and not concrete materials.[39]

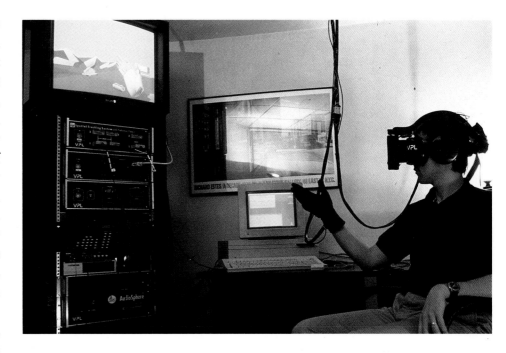

It may be noted that Michel Bret, in his defence of 'Procedural Art', says that while traditional tools enable visual artists to work only on objects, the computer gives them access to the processes and sources of creative activity.[40] Similarly, Roy Ascott, in defence of 'telematics' (the convergence of computers and telecommunications systems), maintains that the new techniques – videotex, telefacsimile, laserdisk and computer animation and simulation – must be regarded as more than new tools since they invite new relationships among people in the creative process and they imply a new visual language.[41]

We may conclude that Computer Art has been revolutionary in both the sensorial and the intellectual spheres. A new appeal has been made not only to the visual but also to the other senses, developing the research begun by Optical, Kinetic and Participatory Art. On the other hand, calculated and programmed art combined with the achievements in Conceptual Art have opened up the enormous possibilities of Computer Art in the area of full interactivity, by using the computer not only as a tool or medium but as a purveyor of abstract information and as a generator of virtual realities in cybernetic space.

202
Jaron Lanier
(VPL Research Company, Redwood, Silicon Valley, CA, and NASA project), 'Eyephones' and 'Dataglove' demonstration. These devices permit exploration of 'virtual worlds'. (The experimenter in the picture is *not* the conceiver of the project, Jaron Lanier.)

5

Communication Art

The evolution of human communication systems may be sketched out as follows:

First, the invention of cuneiform writing by the Sumerians nearly 6,000 years ago enabled us not only to hear but to fix the fleeting characteristics of the voice.

Some five and a half thousand years later, the invention of printing permitted the reproduction of written texts in a theoretically limitless number of copies, thus multiplying the means of recording, transmitting, and disseminating thought and knowledge.

The next step occurred with the invention of photography, of cinematography and subsequently television, commencing three hundred years after printing. The images established in the new media could be reproduced at will and made available in any location.

That development had its parallel in the invention of telephone and radio, enabling us to hear sound not only as it is borne by means of the voice, but also as it is transported over any distance.

Finally, the arrival of sophisticated information-processing technologies opened up the inexhaustible possibilities of combining the different ways of communicating – by text, by image, and by sound – that until then had undergone separate developments. The digitalization of information and the creation of computerized networks for its transportation have rendered modes of communication homogeneous and coherent. This has constituted a true revolution, which has radically extended the memory capacity and possibilities of communication. Thus, the field of word-processing was opened to writing; and the telephone network was extended by telex and the fax. Likewise, the area which combined information technologies, that of telematics, was expanded by tools associated with the audiovisual, the videophone and the videodisk, High Definition television and all the other techniques which belong to electron beam technology. The resulting instantaneous circulation of information without regard to geographical limitations has overthrown our traditional perceptions of the world.[1]

Although electrophotographic or copy art is not necessarily a communication art in the sense in which the term is used in this chapter, it was without doubt, at least on the technical level, one of the sources. In this category of artistic practice, it is possible to distinguish between electrostatic, photochemical and thermographic processes. Nowadays, however, the optical electrostatic process based on light, and the photochemical process consisting mainly of the projection of the image into a selenium surface and the thermographic process fixing the image onto the chosen support, have been superseded by digitalized processes.

Electrophotographic art can either transmit existing information (recount a symbolic or purely visual story, for example) or create new information (for instance, by manipulating everyday or 'poetic' objects in front of the machine). The great differences between the technical capacities of photocopying machines, as well as the extremely varied aesthetic aims of the artists and their modes of intervention in the technical processes, lend a great richness to this kind of artistic activity.

Three main aesthetic tendencies can be identified in electrophotographic or copy art. The first, which is technically closest to the art of photography, consists of bringing real objects into contact with the machine without any subsequent intervention by the artist. This is the most closely pre-determined type of copy art, since the artistic dimension emerges through direct intervention with the machine – as in the work of Pati Hill and James Durand.

For example, Pati Hill's *Chinese Scarf*, shown at the 'Electra' exhibition in 1983, is made up of pieces of fabric which are handled by the artist in such a way that the sequence and continuity of the creative act can be directly observed.

James Durand, in his early works, created a sort of performance by handling objects inside and in front of the copying machine. More recently, he has used telefax machines to create the performances at long distances. In 1991 he produced a large copy artwork, entitled *10.05 metres, 1 hour 40 minutes, 590 grams*, using a 'Bubble Jet' ink-printing process.

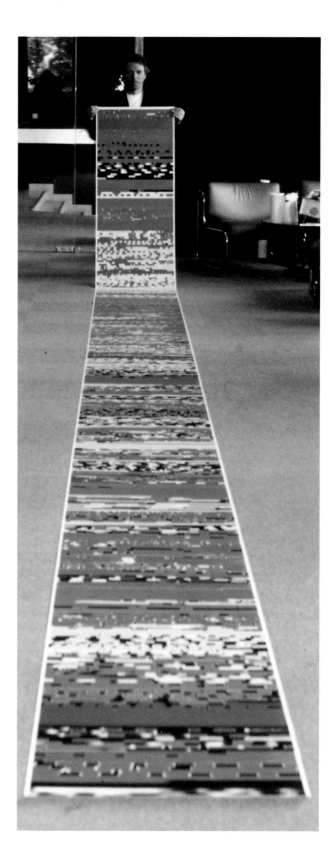

203
James Durand
10.05 metres, 1 hour 40 minutes, 590 grams (1991), 'bubble jet' art. Photo Nathalie Hamard-Wang

The second tendency in electrophotographic art, closest perhaps to printing techniques, is concerned with the transformation and combination of already existing images. One of the most common forms in this category is the artist's book. For example, Gudrun von Maltzan re-photocopies photocopies upon which she has drawn and then combines them in book form.

A third tendency, comparable to painting, constitutes a graphic vocabulary which enables the artist to make the photocopied objects lose their identity in favour of their formal plastic components, such as colour, volume, structure – as in Judith Christensen's sculptures shown at the 'Electra' exhibition in 1983, which are made by projecting light onto torn pieces of coloured paper.

Some recent work of David Hockney's can be assimilated to the categories of copy and telecommunication art, although it is also close to photography and video. Hockney's experiments are mainly conducted with a still video camera and a photocopying machine. In fact, he will photograph a person of his circle (a permanent theme in his work), making three separate exposures with the camera, then reuniting the pictures with the aid of a scanner in a laser printing process which produces black-and-white or colour prints directly on special paper. The artist considers these works to be visual poems without words. What is particularly striking in these laser/copy art portraits with their background setting is that they possess a third dimension, a perspective. Let us add that Hockney also takes full advantage of telecopying techniques (such as fax) and sometimes transmits his works over long distances to be completed at the receiving end, often on the actual exhibition site.

It was Simon Nora and Alain Minc who coined the term 'telematics' in 1987 to describe the new electronic technology derived from the convergence of computers and telecommunications systems, incorporating the telephone, the telex and the fax. The process of 'telematization' is most clearly seen in the ubiquitous and rapid growth in France of Minitel, the public video-text system that enables widespread interaction between users and databases across an enormous range of services.

The outstanding artist and theoretician in the field of telematics, Roy Ascott, has put to good use the central feature of the video system, its ability to facilitate interaction via the electronic space of computer memory and beyond the normal constraints of time and space that apply to face-to-face communication. His projects employing telematic media and interactive participation have included *The Pleating of the Text: A Planetary Fairy Tale* (in homage to Roland Barthes' *The Pleasure of the Text*), devised for the 'Electra' exhibition at the Musée d'Art Moderne de la Ville de Paris in 1983. It involved the creation of a text by the 'dispersed authorship' of groups of artists located in eleven cities around the world, each group participating through an electronic network. The story developed gradually as each day a piece of text was logged in from each

204, 205
Roy Ascott
The Pleating of the Text: A Planetary Fairy Tale (1983). The Villain (in Amsterdam); the Beast (in Alma-Quebec). Shown at Electra 1983

terminal. Most of the terminals were linked to data projectors so that the text being generated could be publicly accessible.

For Ascott, the art of our time is one of system, process, participation and interaction. As our values are relativistic, our culture pluralistic, our images and forms evanescent, it is the processes of interaction between human beings which create meaning and consequently cultures. Hence, those systems and processes which facilitate and amplify interaction are the ones that will be used by artists in order to encompass a world audience, with the aid of telematic systems based on computer-mediated cable and satellite links.

In accordance with this philosophy, an elaborate and complex multi-media interface was created by Ascott as part of the 'Electronic Arts Festival of Art and Technology' in Linz, Austria, in 1989. *Aspects of Gaia: Digital Pathways Across the Whole Earth* was a computer-networking project and interactive installation conceived in collaboration with Peter Appleton, Mathias Fuchs, Robert Pepperell and Miles Visman. It involved interaction in electronic dataspace between artists, musicians, scientists and other creative individuals from a number of different countries, and produced representations of the Earth (Gaia) from a multiplicity of perspectives: scientific, cultural, spiritual and mythological. Conceived of within the tradition of the *Gesamtkunstwerk*, or more appropriately *Gesamtdatenwerk*, these connecting pathways constituted a kind of conceptual umbrella or digital noosphere aspiring to planetary harmonization via the creative and energizing transformation and reconstitution of digital images, texts and sounds, which could be accessed and interacted with at many locations around the world.

Virtual space, virtual image and virtual reality are also categories of experience that can be shared through telematic networks conceived by Ascott. They too allow for movement through 'cyberspace' and engagement in a 'hyperreality' with the virtual presence of others who are physically removed. By the use of a headset, dataglove or other data-wear, these interactions and the feelings and perceptions generated in this way are

206
Roy Ascott
Aspects of Gaia: Digital Pathways across the Whole Earth (1989), shown at Ars Electronica, Linz, 1989

experienced as 'real'. According to Ascott, the passage from real to virtual should be seamless, just as the changes to social behaviour deriving from the omnipresent human/computer symbiosis are flowing unnoticed into our individual psyches.[2]

The activities of many of the artists claiming allegiance to communication aesthetics are of a different order. Under the leadership of Derrick de Kerckhove and Mario Costa, artists like Fred Forest, Christian Sevette, Stéphan Barron, Natan Karczmar, Robert Adrian and others have formulated projects within the framework of what has been named the Aesthetics of Communication Group.

Costa composed the first document outlining the double objective of this group in 1983: to elaborate an aesthetic and psycho-sociological theory linked to the new communications technology, and to connect interested artists and scholars throughout the world. The underlying commitment of the group is based on the ability of the new communication technologies to transform our experience of 'real' space and time and to create new kinds of events that are not dependent on place.

According to Costa, the aesthetics of communication presages a new age of spirit based on an extraordinary merging of arts, technology and science. It is an aesthetic of events occurring in real time and brought about by means of remote-controlled technology capable of visually uniting physically distinct places. In this type of event, it is not the exchanged content that matters, but rather the network that is activated and the functional conditions of exchange. The aesthetic object is replaced by the immateriality of field tensions and by vital and organic energy (mental, muscular, affective) and artificial or mechanical energy (electricity, electronics) that transforms our mundane object-centred sense of space and time. Equally, the subject is transformed, being no longer defined by the rigid opposition of self/not-self, but becoming part of this same flowing field of energy. Finally, the event activates a new phenomenology of virtual, deferred, or remote presence and evokes a feeling of the Kantian 'sublime', a sense of truly inexpressible awe.[3]

One event of this kind was planned to take place simultaneously in Toronto and Paris in November 1988 under the title of 'Transinteractivity', a name given by de Kerckhove to the extension of our powers of thought, feeling and action, stemming from the greatly expanded distances that can be reached by technology. According to him, communications media have been transforming us all considerably and call for a new approach to understand them. The artists who participated in this event were invited to bridge the gap between transpersonal technology and personal psychology.

Although a technical accident frustrated the full realization of a related 'visio-conference' (an exchange of images and texts), *Transinteractive Artists*, a book published in 1990 by the SNVB Foundation in Paris, summarized the intention of these artists and theoreticians.

It discussed the question that lies at the heart of the activities of all participants: what psychological and social effects can be expected from the dialogue with the new technological means which are beginning to transform our standards of time and space?

The document is divided into three parts, the first being devoted to interactivity, the second to the technological extension of our senses and the impact that this development could have on our spatial sensibility, and the third part dealing with the aesthetics of communication itself.[4]

In a related article in the journal *Leonardo*, de Kerckhove adumbrates a new spatial sensibility arising out of the Communication Arts. According to him, radio, telephone and computers are 'psychotechnologies', technological extensions of our mind which have global significance. Psychologically, however, Western society has not developed sufficiently to integrate the extended dimensions of our technological advance into its everyday fabric. Our response to the planetary environment at the social and political levels is still informed by obsolete and wholly inadequate Renaissance-based conceptions of human experience. Instead, we need a new spatial sensibility to appreciate the complexity of our satellite- and computer-networked environment. In this respect, the role of Communication Art is to articulate the ways in which communication technologies are affecting our psychological relationship to, and concepts of, space.[5]

An earlier event entitled 'ARTMEDIA: An International Meeting concerning Video and Communication Aesthetics', held in Salerno in May 1985 under the direction of Mario Costa, had given rise to a publication in which the aesthetics of communication was allocated a prominent place. Apart from three important contributions on the subject by Costa himself and de Kerckhove's text on 'Some psychotechnical foundations of communications aesthetics', there were articles by Robert Adrian, Roy Ascott, Fred Forest, Eric Gidney, Natan Karczmar, Tom Klinkowstein, Mit Mitropoulos and Jean-Marc Philippe.[6]

Mario Costa and Fred Forest together founded the Aesthetics of Communication Group as an international research consortium of artists and theorists in this area. Since abandoning traditional painting for Video Art in 1968, Forest has become one of the foremost communication artists.

According to Forest, the Aesthetics of Communication Group addresses itself to the technologically sophisticated environment of advanced industrial society, and proposes critical and creative reforms which constitute a rupture with traditional solutions. It places itself at the heart of the changes that are affecting the fields of industrial and communication technologies, taking for its object of investigation the new sensibility brought about by the rapid exchange of information over long distances. The forms that this aesthetic activity takes are the staging of physical presence at a distance, the telescoping of the immediate and the delayed, the playfulness of interactivity, the combination of memory and real time, and planetary communication, as well as the detailed study of human social groupings. Forest informs us that Communication Artists are concerned to draw attention to the splendid future awaiting an inventive use of these developments.

What stimulates the reflections of communication artists is less the character of networks from a technician's point of view as systems of distribution of information, than the notion of the electronic network as underpinning a symbolic order, one which opens doors to a new form of space, another perception of time, and a new realm of the imagination.[7]

Forest's research focuses on communication itself and he excels in the subtle art of mixing different types of media to create his systems. In using electronic newspapers in his latest installations, he is able to make the link between technology in everyday life and its artistic uses. In his installation *The Bible Culled from the Sands*, shown for the first time at the exhibition 'Artists and Light' in Rheims in 1991, red light from electronic diodes travels between two definitions, one of the Bible, the other of electronics, taken from a dictionary. Here communication is established on two levels, real and mechanical, through the constant flow of words and the continuous flux of light. Forest had originally given the work the title *The Electronic Bible and the Gulf War*, but the organizer of the Rheims event changed it. On a second recent occasion in Paris, Forest showed this

207
Fred Forest
Kunstland (Land of the Arts, 1984)
Kulturfabrik, Koblenz; interactive video and telephonic network installation

208
Fred Forest
Babel Conference (1983)
video and wireless installation, Espace Créatis, Paris – its purpose to criticize stereotyped speech, particularly by politicians

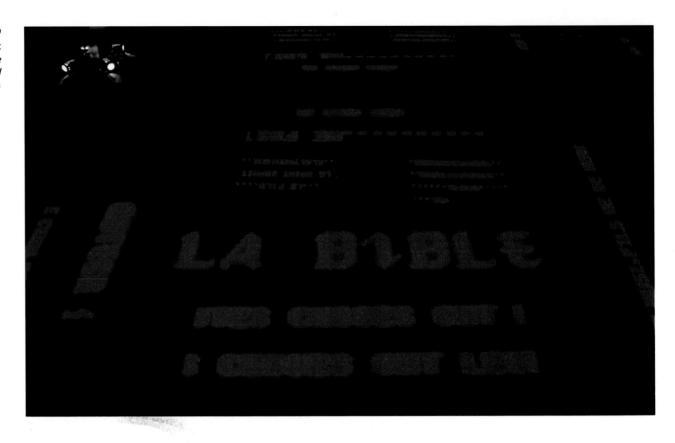

209
Fred Forest
*The Electronic Bible and the
Gulf War (The Bible Culled
from the Sands)* (1991)

210
Christian Sevette
The Transatlantic Touch
(1988)

work under its original title. He had been struck by the fact that the three main monotheistic religions had been involved in the Gulf War and wanted to show that there was a kind of reiteration of history by juxtaposing the utterances of iconic personalities (such as politicians and high-ranking military personnel) with quotations from the Old Testament. In order to do this, he selected passages from the Bible and from newspapers which resembled each other (such as long enumerations of arms equipment juxtaposed with Biblical genealogies), and made them appear simultaneously and in a permanent luminous flow of words on tablets on a fenced-off segment of the floor.

Christian Sevette, another member of the Aesthetics of Communication Group, born in Casablanca in 1949, obtained a degree in Fine Arts in Paris, where he is at present a set designer for the Opéra. He has introduced the concept of interactive figuration in order to best describe his personal position, illustrated since 1973 by his *Propositions of Figurative Communication*

which try to reconcile high-tech art and technology with the history of art by 'quoting' the works of classical artists such as Michelangelo and Tintoretto.[8] His many installations and performance pieces, and his dedication to Communication Art, have made him one of the main proselytizers of the new art form.

Jean-Claude Anglade, another artist of Aesthetics of Communication Group, is particularly interested in the collective process. According to him, the reception of an image involves an interactive relation with the imagination of the spectator. It is in this way that art invokes a common imagery which imprints a determinate form on artistic practice. Anglade claims that creative practice is haunted by the myth of Babel, caught between the affirmation of an individual identity and the search for a universal sensibility. It challenges the frontiers from behind which the individual and the collective jealously observe each other.

In *Image of the Valley* (1988), Anglade chose a site particularly appropriate to this myth – a water tower at the juncture of the main crossroad of Noisiel, a few miles east of Paris. With his architect, Christian de Porzamparc, he enveloped the tank of the tower with a ten-sided structure which rose in a spiral up to its summit and dominated Marne-la-Vallée, the adjacent New Town.

For Anglade, it was a matter of establishing a relationship between the place and its inhabitants, of organizing a creative game with the population living close to the water tower, in order to realize a gigantic collective image to be enclosed in the interior of the structure and appearing through an architectural form.

It is in this way that Anglade, with the participation of the inhabitants of Val Maubuée, made a giant 'stained glass' window using colour filters. The maquette for this was produced by a process of collective creation, combining elements in a random composition and installing it during the whole of 1988, whether in sunshine or moonlight.

Other communication artists like Jean-Marc Philippe and Pierre Comte have developed projects involving satellites. Philippe's *Celestial Wheel* (1981) and

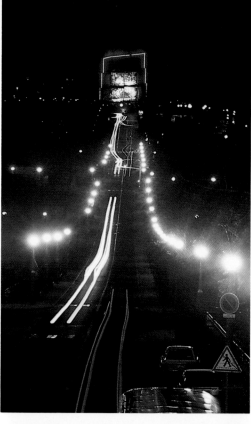

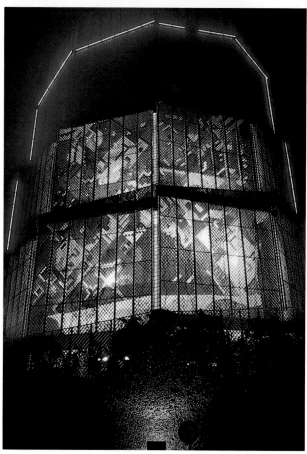

211, 212
Jean-Claude Anglade
Image of the Valley (1987–88)
two views of a stained-glass structure at Marne-la-Vallée (Noisiel), France

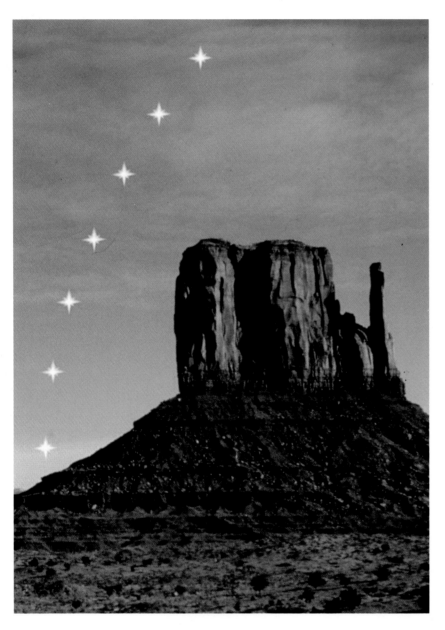

213
Jean-Marc Philippe
Celestial Wheel (1970–72)
With the use of a geo-stationary circle and 40 of the 200
satellites in orbit it would be possible to light up a crown of
stars around the planet and make the speed of light visible.

Comte's 1979–80 *ARSAT (Art Satellite)* project have
been developed with astrophysicists and not only allow
unusual perceptual experiences, but could even be used
as the basis for designs for orbital stations or other
cosmic projects. These projects are intended to give the
audience a new approach to the cosmos from a factual,
technical and scientific point of view by using its own
physical characteristics (distance, solar radiation, etc.).
Philippe has participated in many artistic events
involving Communication Art – including 'Electra' in
1983, 'Les Immatériaux' in 1985, 'Artmedia' in 1985,
and 'Transinteractivity' in 1988 –, written on space art
and artistic invention, and devised many projects, both
realized and unrealized, ranging from *Autopsy of a
Mask*, a programme of image-processing based on a
16th-century Benin mask, to more recent satellite
projects.

With *Celestial Wheel (The Fusion of Art and
Science)*, which consisted in part of encircling the Earth
with a corona of existing orbiting satellites, Jean–Marc
Philippe put forward one of his most ambitious projects.
Its vast scale relative to the Earth-bound observer was
intended to symbolize a new third millennial order as
much as to offer a new way of perceiving ourselves.
Thus it carried a simultaneously doubled perception of
space, both from a new point of physical observation
and as a metaphysical way of seeing.

Although this project raises problems mainly
discussed in our next chapter, dealing with the relation-
ship between art and nature and its scientific interpre-
tation, it is essentially a communication proposal. The
concept of the *Celestial Wheel* as an artistic use of space
can either kindle our imagination or irritate us. The
system envisaged by Philippe, based on the Earth and a
circle of about forty geostationary satellites in an
equidistant orbit about it, usually used for weather,
telecommunications or other utilitarian purposes, also
has some supplementary laser beams that can be
activated by remote control from the ground and can
then emit light signals that from Earth would appear
slightly brighter than Venus at its maximum luminosity.
Each individual's perception of the position of this circle

214, 215
Jean-Marc Philippe
Totem of the Future (1989)
as seen in different configurations in summer at a temperature
of 40° C and in winter at −5°C, San Francisco

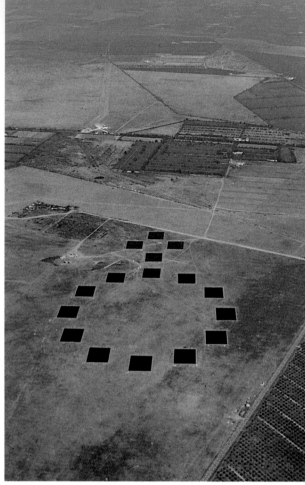

216
Pierre Comte
Art-Spot 'Earth Signature'
(1989)
On 6 October 1989, at 830
km from the earth, the
satellite SPOT I
photographed this symbol of
'Planet Earth' – the first
aesthetic event between
outer space and the
European continent. (Photo:
© SPOT Image)

217
Pierre Comte
Another satellite view of
'Earth Signature'. Copyright
reserved.

would depend upon his or her specific physical position. Hence *Celestial Wheel* would be perceived above our heads if we were looking at it from the Equator, and would approach the horizon as the observer was situated towards either of the Poles.

It would be possible, by simulating the displacement of light from one satellite to the other, to watch the light make its orbit every 0.9 sec.; for the first time, one would be able to see and feel the extraordinary speed of light both in its real-time displacement and at a scale perceptible to our senses. Furthermore, this spectacular light show could be applied to a variety of functions, even as signals to hypothetical extraterrestrials. This and other Space Art projects have caused concern amongst astronomers, space scientists and lay people about the legislative means of controlling such transnational events.[9]

Coming from a background in Conceptual Art, Comte has interested himself since 1979 in the new

dimension created by the various space research programmes. In developing his own theoretical interpretation of Space Art, he has identified two main types of artistic installations: those located on Earth and intended to be seen from space, and those in orbit and meant to be seen from Earth. He demonstrated both these aspects in his ARSAT project *Selenopolis*, shown at the exhibition 'Utopian Creators of Europe' at the Grand Palais, Paris, in 1989.[10]

Natan Karczmar is one of the first communication artists. His most significant work involves the generation of multiple video recordings of a given urban area, synchronized with a radio newscast and then replayed simultaneously on a single bank of video monitors. A more ambitious project by Karczmar, *Art Planet, 1989*, proposes to develop the domain of communication between museums. The aim is to create a distribution network which, by its existence, would encourage the museums to produce more video infor-

mation for the public, at first by simply using conventional video facilities but then seeking to expand its activities through other forms of communication technology.

Among the most striking video-to-video installations is Mit Mitropoulos's *Face-to-Face* series. The artist proposes that any telecommunications equipment can be described in simple terms, enabling us to be simultaneously conjoined and separate on a number of perceptual levels. Two-way interactive cable TV can explore the potential effect of interactive networks and communication technologies on the organization of space as well as behaviour in it. In *Face-to-Face 4*, an installation mounted in Holland in September 1989, two people could interact in space via television monitors though they were separated visually and physically by a vertical barrier. Over or around this they could hear and touch each other, or pass an object if one of them moved a certain distance through the space that separated them. Both participants had equal control of the event in so far as they had access to each other's space.[11]

Another artist of the Aesthetics of Communication Group, Stéphan Barron, began by studying engineering but became, in his own words, a 'bricoleur' (handyman) of the new effects of media technology. Since 1983 he has created several performances using telefax and radio across the Atlantic.

In a performance called *Lines* in September 1989, he drove with Sylvia Hansmann along the Greenwich Meridian from Villers-sur-Mer on the English Channel to Castellon de la Plana in Spain on the Mediterranean Sea. With a car fax they regularly sent images and texts relating to their trip to eight locations in Europe. This use of instantaneous communication technologies introduced a new way of representing a line, one of the most basic of human symbols. The faxes were projections of the Meridian which were 'fractalized', that is, the fragment of the line that was transmitted represented the whole. By experiencing their own meridian in this way, participants could think of themselves as 'measuring' it. Barron's intention was to create a planetary

218
Stéphan Barron
Lines (1989)

consciousness and ecological sensibility through the use of such long-range telecommunications. Although he considers this a typical Postmodern communications object, *Lines* continues in the tradition of previous avant-garde artistic activities, such as Land Art and Performance Art. It differs from them by not being limited to a concrete representation in front of the spectator.[12]

Another pioneer artist in the Aesthetics of Communication Group, Robert Adrian, has an eclectic multimedia approach which has been facilitated by the development of the Artex computer network. With support from the I.P. Sharp Company of Canada, which ran it under the direction of Adrian himself, Artex provided communication artists with a relatively cheap and accessible international network through which to meet, discuss, speculate, plan and execute projects over an extended period of time. Artex also made it possible to coordinate projects that used other, more temporary visual communication links, such as Slow Scan television and Telefax. In 1983, the Viennese BLIK Group, which Adrian set up, undertook the first serious attempt to establish a network outside the Western bloc countries through its *Telephone Music* projects, which offered a simple way of establishing contact between artists in Western and Eastern Europe. Although they tended to neglect interactive participation in favour of more conventional transmission of prepared works, perhaps, as Adrian expressed it, 'the content was in the contact'. The underlying importance of these projects lay in their ability to circumvent the normal political restrictions on artists' exchanges between Western and Eastern Europe and to facilitate a collaborative creative exploration.[13]

Influenced in his thinking by Postmodern theories which emphasize the socially constructed nature of reality, Adrian maintains that critics and the general public often have difficulty in appreciating telecommunications work as art within existing paradigms because it represents new complex, multi-faceted forms of cultural dialogue requiring dynamic intervention, appropriation and modification by involved partici-

pants. This was the case in Adrian's *Robot 1200 C*, which made use of various media, including Sharp Text and Slow Scan TV and was shown at the 1986 Venice Biennale.[14]

Adrian has adopted an extremely negative attitude towards the development of interactive and interpersonal communication between artists and non-professionals during the 1980s. He is disappointed that the revolution in this area, which was hoped for at the beginning of the decade, did not take place, partly because of the high cost of acquiring or hiring hardware, but also because of the attitudes of passive consumerism inculcated by late capitalist society. According to Adrian, artists in general, being themselves implicated in this system, have had a tendency to create telematic simulations of products rather than projects emphasizing process and interaction. This is mainly due to the functioning of electronic communication networks preoccupied by the production of consumer goods. He exempts from this criticism projects such as Ascott's *The Pleating of the Text* (1983), Norman White's *Hearsay* (1984), both using the I.P. Sharp Computer Mail Box, Norbert Hinterberger's *Farmhouse in Upper Austria* (1982), a telefax sculpture created for Adrian's 'The World in 24 Hours', a project that connected Linz with fifteen towns in various places in the world; and also the communication event for video and satellite, *Hole in Space* (1980), created by Mobile Image (Galloway and Rabinowitz).[15]

At ARTCOM Paris 86, a symposium conceived by Fred Forest and held in January 1986 at the Ecole Supérieure des Beaux-Arts on the subject of the aesthetics of communication, one of the themes discussed was the creative use of technology. In an attempt to bring about a deliberate despecialization of the different areas involved, there was a proposal systematically to put artists working in the field of communication aesthetics in direct contact with university staff, journalists, arts administrators and art critics.

A project which incorporates this theme is the interactive transmission of imaginary constructs called *City Portraits*, undertaken by Karen O'Rourke and her

219
The **Art-Réseau** group at work
(coordinator Karen O'Rourke).
Photo by Karen O'Rourke and
Gilberto Prado, 1991.

team. *City Portraits* was a project based at the University of Paris, involving artists, students, and teachers from eleven universities on three continents, who used documents sent by their correspondents abroad to construct portraits of cities they themselves had never seen. Through the exchange of images, the participants explored the workings of their imaginations and discovered their places of habitation as others see them. The city, both network and palimpsest, is the central theme, reflecting and at the same time being reflected in the structure of the exchange.[16]

This interpretation of the project can be expanded still further by considering the way in which it enters into the relatively recently developed pedagogic context of what is known as 'cultural studies'. Originating in an embattled programme at the University of Birmingham in the mid-1960s, cultural studies has gained acceptance as an interdisciplinary approach to the humanities, involving many previously separate academic discourses such as political theory, history, literature, sociology, and art history. Through such general themes as class, race and gender, it has spawned new areas of study, among them film theory, popular culture, and media and communication studies.[17]

City Portraits enters into this area in so far as it is concerned with aspects of communication on an urban scale – without discriminating among users' interests, without restriction of its geographical limits – and because of its interdisciplinary pedagogical character. In fact, this ambitious project attains its specific identity through the awareness that the participants are only temporarily related by the existence and specific structure of the project itself, a fact which is analogous to that of the urban condition. Very often it is not the artistic idea or the images that are important, but their articulation and interaction. This connecting tissue is at the heart of all telematic networking and could even be considered as being at the centre of all high-tech art as an international and transnational phenomenon involving many types of cultural investments.[18]

The large exhibition 'Communication Machines' at the City of Sciences and Industry, La Villette,

running from October 1991 to June 1992, was an comprehensive display of communication equipment. It was devised in three sections: the first, essentially pedagogic, presented and explained equipment related to the telephone, the computer and the audiovisual, and the elements connected with transmission technology. The second section was concerned with communication technology in so far as it is structuring contemporary life. More interactive, it permitted everyone to access usually specialized networks such as the stock exchange and air traffic and railway networks, and to experience new situations facilitated by such technology (for example, teleconferences, business meetings employing television relays). The third section, more critical in character, explored functions beyond communications where fiction and reality meet.

To these three sections was added a contribution by artists who make use of communications equipment as objects in themselves or as a means to create artwork. This section, organized by Jean-Louis Boissier, included all kinds of high-tech artworks and not just those in the area of Communication Art. Boissier tried to organize the technical and aesthetic characteristics of these works into three main groupings: those involving the transmission of messages, the use of networks, and digital imagery.[19]

The specificity of Communication Art can be understood by examining its evolution more closely. Two outstanding communication artists, Kit Galloway and Sherrie Rabinowitz, produced as early as 1977 the world's first interactive composite-image satellite dance performance, involving performers on the Atlantic and Pacific coasts of the U.S.A., at NASA's Goddard Space Flight Center, Maryland, and the Educational Television Center, Menlo Park, California.

As mentioned above, Galloway and Rabinowitz, associated in a group called Mobile Image, realized in 1980 the project called *Hole in Space*, which featured a satellite link between New York and Los Angeles. Video cameras and displays were installed in a storefront window in both cities so that the public could communi-

220
Kit Galloway and
Sherrie Rabinowitz
(Mobile Image) *Virtual Space/
Composite Image – Space
Dance from Satellite Art
Project* (1977).
The image of Mitsu (with
white hat) in Maryland was
mixed with the image of her
dance partners, Keija and
Soto, in California, enabling
them to dance together in
the same live image. ©
Galloway and Rabinowitz

cate by image and voice. There was no advance publicity and no signs or instructions at the sites. *Hole in Space* was simply discovered by passers-by who were suddenly confronted by images on the screen. The crowds drawn into this 'hole' in space/time were able to communicate with the opposite group in the other city with less inhibition, because neither group could see itself.

In 1984 Galloway and Rabinowitz devised the *Electronic Café* at the Museum of Contemporary Art in Los Angeles. This project combined six culturally distinct communities within Los Angeles in a telecommunications image bank and data-base network. Slow Scan television equipment, electronic writing tablets, computer terminals, printers, video cameras, screens and signboards were installed in each of the four cafés involved and in the Museum. Customers exchanged images of themselves and other people in the café, performed in front of the camera, and wrote poetry. The project created a gallery without walls for a participatory and public 'Art communication' event.[20]

An early telecommunications art event took place in 1977 when Douglas Davis, working with Nam June Paik and Joseph Beuys, created an extraordinary live telecast which was transmitted via satellite to more than thirty countries. The programme, which opened Documenta 6 at Kassel, concluded with Davis's 'The Last Nine Minutes', in which he tried to break through the TV screen and reach the other performers.[21]

Another event in the same year was the project *Send/Receive* organized by Liza Bear and Willoughby Sharp in New York and Sharon Grace and Carl Eugene Loeffler in San Francisco. Held at the Center for New Art Activities in New York and at ArtCom/La Mamelle Inc. in San Francisco, it employed a satellite and featured a 15 hour two-way interactive transmission between the two cities. In 1980 Loeffler conceived the event 'Artist's Use of Telecommunications' for the

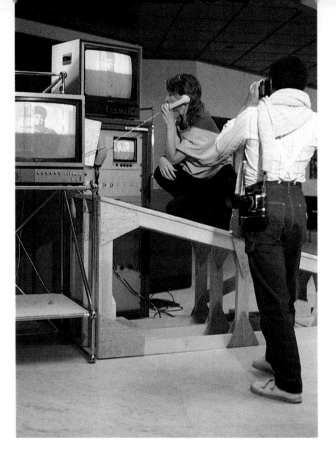

San Francisco Museum of Modern Art and in 1991 co-edited with Roy Ascott an issue of *Leonardo* entitled 'Connectivity: Art and Interactive Tele-communications'.

Still in the 1970s and early '80s, a number of telecommunication events were organized in Canada by Bill Bartlett, and in Austria by Robert Adrian (including *The World in 24 Hours*) at the 'Electronic Arts Festival' in Linz in 1982. During the same year, the project *Levittown* was conceived in Utrecht by Tom Klinkowstein, *Telesky* by Eric Gidney in Australia and *The Stock Exchange of the Imagination* by Fred Forest in Paris involving telematics, television, radio and telephone.

In the following year Ascott's *The Pleating of the Text* took place during the 'Electra' exhibition in Paris as well as Natan Karszmar's *Contact*, a work involving a network of 24 telephones in Tel Aviv.

Jacques Polieri, whose *Video Communication Games*, installed at the 1972 Munich Olympic Games, was an early example of an electronic interactive installation using multiple television monitors and giant video screens, showed his simultaneous interactive video-transmission, entitled *Men, Images, Machines*, in 1983. It involved a satellite relay between Tokyo, Cannes and New York and was projected on giant television screens in front of 2,000 spectators, permitting them to see immediately the most recent Japanese and American productions exploring the two complementary areas of robotics and digital imagery. These works were commented upon by Polieri in Cannes and leading specialists in these fields simultaneously present in Tokyo and New York.

In 1984, *The Transatlantic Touch* was organized by Christian Sevette to link Paris and Toronto, *Telefaxart* by Maria Grazia Mattei in Pavia, and *Labyrinth*, a telematic project between France and Italy, by Marc Denjean. That was also the year of Kit Galloway's and Sherrie Rabinowitz's *Electronic Café* and of the first Amateur Radio Transmission Slow Scan Television projects in the U.S.A.

Among the many specific communication events since that date, we may note Ascott's *Alice's Function in Wonderland*, conceived for the 'Les Immatériaux' exhibition in Paris in 1985, *Planetary Network* and *Laboratory Utopia* organized by Ascott, Don Foresta, Tom Sherman and Tommaso Trini at the Venice Biennale in 1986, and Stéphan Barron's *Telematic Night*, linking the cities of Caen, New York, Amiens, Brussels and Rome with a computer network.[22]

The technical specificity that most of these artistic events have in common is their multidisciplinary combination of word processing, telex and telefax and the videodisk, involving text, image, and sound in their most recent manifestations; writing, telephone and information techniques like telematics for the earlier events. The technical development occurring between these two stages is clearly discerned by Loeffler in *Leonardo*. He points out that the early '70s were only a starting point, but that the late '70s and the '80s brought forth highly visible projects, as well as an interest in telecomputing projects of duration and in the formation of ongoing networks. Another feature of the '80s decade was the emergence of independent telecomputing projects, whereas the most recent developments

concern information-based projects, such as the electronic magazines and newsletters that are distributed via various networks. Loeffler concludes that a rich and varied field of experience and practice now exists in art and communication technology and that the introduction of integrated system digital networks has created unparalleled venues for interaction, combining elements of text, image and sound.[23]

The view that the various telecommunications art practices present a definite coherence and specificity on a technical level can be extended to the aesthetic dimension. The aesthetic specificity of telecommunication, and Communication Art in general, which is closely related to its technical specificity, concerns both its creation and reception, which in this field become merged more than in any other art form. This specificity includes such characteristics as the creation of an event rather than a material object, the institution of a network of human relationships without discrimination, in real time and without geographical limitation, and thus an entirely new way of relating to space and time, and, most importantly, an interactivity planned and conceived by an artist that allows creative communication. Although interaction between sensorial and intellectual elements, as well as the idea of participation and interactivity between artist and the general public in many countries, are characteristics present in other branches of electronic art (and particularly in Computer Art), it is in the Communication Arts that it finds its purest expression.

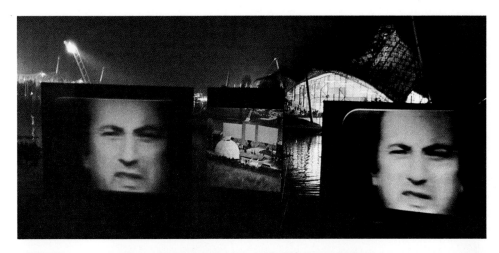

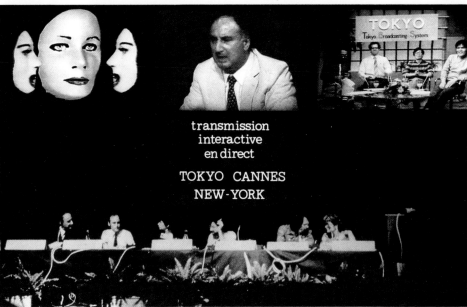

222
Jacques Polieri
Multivision installation,
Munich Olympic Games, 1972

223
Jacques Polieri
Men, Images, Machines (1983)

6

Art , Nature and Science

This chapter deals primarily with the creative potential of the arts in union with the sciences. Since the physical sciences cannot be dissociated from nature, ecologically oriented works are also considered here. Thus the discussion mainly concerns works of art which are directly inspired by natural phenomena or their scientific interpretation, and which frequently take the form of installations, demonstrations and performances. It is of course impossible to deal in detail with all the artists who have been more or less influenced by science or whose works have a close relationship with natural phenomena. I shall therefore limit myself to several examples of those who have been using advanced technologies in order to bring about an interface between art, nature and science, as well as a few artists who are at the centre of this set of problems without specifically using these technologies.

Todd Siler is an example of the first group. In his *Brain Theatre of Mental Imagery* (1983), a mixed-media work on synthetic canvas with retro-relief printing process, aluminium and glass, he combined art, neurophysiology and nuclear physics in order to explore the interconnectedness of the human brain and the physical universe. Small paintings mounted on a large 'cortical screen' represented the brain as a kind of star whose systems have a dynamic resemblance to the fusion and fission processes that form our physical universe. These works speculate on the emergence of brain functions ('cerebral fusion') at the instant of intuition and the divergence of the functions ('cerebral fission') in moments of analytic reasoning and expression.

The Brain Theatre of Mental Imagery is closely connected in Siler's work with his 'Cerebrarium', an artistic device for interpreting human mental processes. It consists of moveable rear-view projection screens (symbolizing the different layers of the visual cortex) and projectors that present his views on the workings of the mind. The 'Cerebrarium' is designed to stimulate the processes of analogical or associative thinking through visual metaphors and similes, and seeks poetically to transform current research in brain science and nuclear physics.

224
Todd Siler
Metaphorm 5. Breaking the Mind Barrier: The Symmetries of Nature (1986)

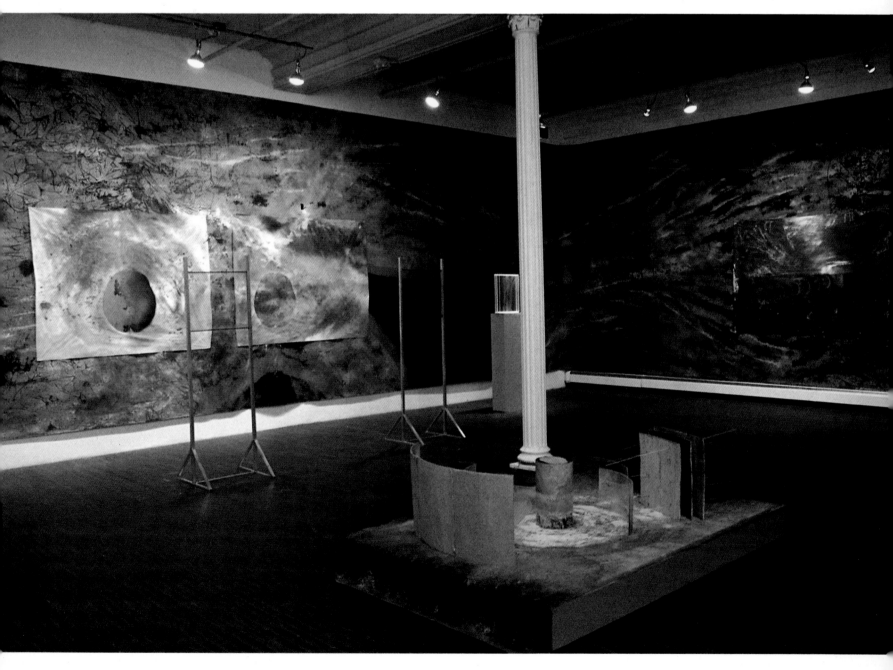

Siler has published a book, *Breaking the Mind Barrier*, which is also the title of one of his mixed-media collages on synthetic canvas with photostrobe and audiotape. This multidisciplinary work delves into the unsuspected relationship between the workings of the human brain and the things that the brain creates: from symbols and poetry to the tools of advanced technology. Its overall tone is philosophical and questioning; it attempts to connect thoughts and their biological processes. Specifically, the work explores the 'creative impulse' behind the invention of an advanced weapon. The installation consists of an 8 ft high, free-standing column of light which visually divides two 8×18 ft paintings that converge in the corner of a room. At irregular intervals, the crescendo of a subtly pulsating sound triggers a flash of white light which fuses the paintings, simulating an instant of cosmic creation and destruction.

The general purpose of Siler's project, as outlined in his book, is to decode the universe by decoding the brain, and vice versa. The combination of art, neuroscience and cosmology attempts to illustrate the integrated relationship between the mind, life and the universe, and to break the barriers that separate culture, knowledge and experience in re-examining and stressing the role of nature itself and of our collective mind. It looks towards a future art united with an enlightened science inspired by the arts. Let us add that for Siler self-discovery is also associated with nature.[1]

Siler has coined the term 'metaphorms' (or forming metaphors), which for him are an expression of nature's unity and a means of exploring the world. Siler uses this concept also to describe works of art, since through this process we can relate information from one discipline to another. It is his view that metaphorms can be methods of inquiry in art, and as the brain is the source and medium of all metaphorms, we can find forms in art that reflect both the brain and the universe.

Shawn Alan Brixey, a member along with Siler of the Center of Advanced Visual Studies of the Massachusetts Institute of Technology, is a specialist in installations and performances based on the scientific

analysis of natural phenomena. His *Photon Voice* (1986) is an optical transmission performance/installation designed to integrate stereo sound and moving images, and transform them into sunlight. The empirical and poetic foundations of this work lie in the constancy of the speed of light and the contraction and dilation of space and time in accordance with Einstein's Special Theory of Relativity, in relation to a frame of reference that is not our own – that of the photon.

Brixey's installation *Sky Chasm*, given at Documenta 8 in Kassel in 1987, was an audible holography and light transmission performance. Here synthetic crystals created brilliant spectrum colours when people passed behind them, altering the wave function and polarity of light.

For his piece *Aqua Echo* (1987), in collaboration with Laura Knott, Brixey used an audible laser interferometer and ice crystal nucleation (freezing) and recording mechanisms. The interferometer created light waves and turned them into sound waves. These in

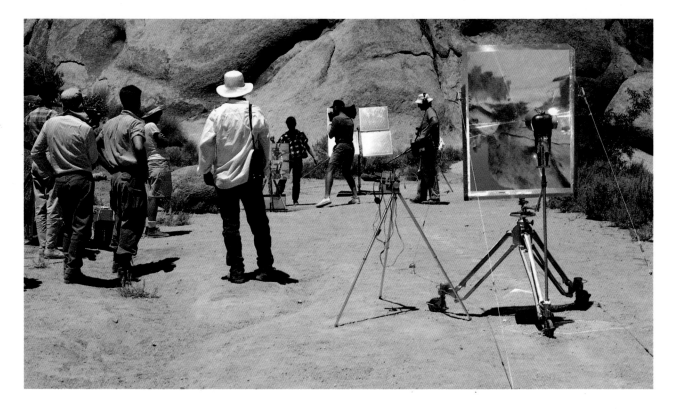

227
Shawn Alan Brixey *et al.*
Photon Voice (1986)
part of the event *Desert Sun,
Desert Moon*, Lone Pine,
CA, 1986

turn were introduced into water; this was frozen into crystals which retained the memory of the process before finally evaporating. In this work Brixey was principally concerned with the mechanisms that trigger the process of forming crystals of ice, i.e., changing water from one state to another, and the human effect on these states, reflecting the macroscopic environment in its microscopic architecture.

Concerning their work, Brixey and Knott have written,

> A quest for the phenomena themselves . . . How do you make art to celebrate not just man alone, but the universe as well? How do you communicate with the wild abyss? The greatest sensual evidence of [the] interdisciplinary nature of our work manifests itself in what we build: the art apparatus serves physically as an aperture, a life support system for phenomena.

For Brixey, who regards himself as a 'phenomena artist', synthesizing physics, art, astronomy and cosmology,

The universe is a boundless stage and elusive map of human knowledge. As Einstein once said, 'He to whom this emotion is strange – who can no longer stand up rapt and in awe – is as good as dead: his eyes are closed.'

Jürgen Claus has observed that with these works we are in the presence of a cosmic code that is captured in a holographic code.[2] At an early stage Claus was also principally concerned with an artistic event in which water, as one of the fundamental elements of the physical universe, was predominant. In the second half of the '60s he began to develop spaces using electricity and electronics. He wanted to install a 'fluid space' in which images from film and slide projections appeared simultaneously in order to create multi-dimensionality. When he began to work in the naturally multi-dimensional space of underwater his experiences affected his artistic concepts. He used electricity and electronics as extensions of human sensory organs; light was as important as acoustics and both related to his physiological reactions.

228
Jürgen Claus
Planet Ocean (1988)

229, 230
Jürgen Claus
Sun Sculptures (1983)

231
Jürgen Claus
The Carousel of Suns (1991)

In his *Planet Ocean* project, Claus was concerned with the 'ecologization' of technology based on the physical sciences. It involved, besides water, two lasers, two video cameras, neon light and a mirrored sphere representing the Earth. The work attempted to act as a metaphor for the profound changes in our perceptions of our planet and planetary system as we move towards holistic awareness of the physical universe.[3]

After having explored the elements of earth and water, Claus turned his attention to the relationship between water and light, particularly by creating solar energy sculptures using photo-electric cells. This 'eco-technology' is intended to take us into the solar age.

In his *Sun Sculptures I, II,* and *III* (1983), Claus used solar energy to produce electricity under water from photovoltaic cells mounted on floating platforms on the ocean's surface. The cells transformed natural solar energy into electricity, which was then stored in batteries. This electricity was used to bring light to the 24-hour cycle of light blue and dark blue illumination of the 'Planet Ocean'. Thus natural light was needed to evoke visually the complex structures and colours of an underwater environment.[4]

These 'sun sculptures', on which Claus has been working for several years, are vertical constructions with a projected height of approximately 30 metres in their

final stage. They have wings furnished with solar cells that follow the position of the sun by means of a computer 'brain', which he calls a SOLART expert system. This is a computer graphic interaction system through which images and information can be called up. The data-bank contains technical and environmental information, for instance about light, photovoltaics, and the distribution of natural energies in the landscape. This facility is necessary since these sculptures are in a real sense responsive, environmental, energy-transforming systems.

As regards the outlook for artistic expert systems, according to Claus one has to search for new and more specific connotations within the artistic and scientific matrix. In his view such basic connotations – indeed a new kind of paradigm or metaparadigm – are related to the fact that 'organic' machines made by artists, engineers and scientists using electronic technology at its most advanced stage (including responsive interaction in an ecologically responsible way) could serve human and natural survival and/or vital reconstruction as metaphors, symbols, realities.[5]

In his *Carousel of Suns*, created in collaboration with his wife Nora for the exhibition 'Artists and Light' at the Manège of Rheims in 1991, Claus occupied a space with a surface area of 530 sq. metres. This installation was bathed in a bluish light, and argon gas writing served as a metaphor announcing the Solar Age.

Two circles made up of three suns rotated slowly, intersecting with each other in a beam of yellow light. A laser beam travelled across this space at different points. This beam was not only the result of its material source, argon or krypton, but as much an outcome of the manner in which it lingered in a veil of mist – in other words, it is also the result of the way it blends into the environment. This work, produced by various technological means, was intended to be perceived and interpreted as a single form and as an illustration of the unity between natural and man-made environments.

Another outstanding case illustrating the relationship between art, nature and technology is Otto Piene's activity, which is now dominated by his preoccupation with what he calls 'sky art'. At all stages of his career Piene has exploited the technical possibilities at his disposal in relationship to his aesthetic investigation into the natural elements, particularly air and light – as well as the conquest of space.

Born in Germany in 1928, Piene experienced the devastation of World War II and was impressed by the visual pyrotechnics of aerial combat, something which surfaced in his art in the form of his large-scale, multimedia sky events. When Piene founded the Zero Group with Heinz Mack at the end of the 1950s, their object was to break with the post-war dominance of abstract painting. Their intention was to start on a new basis which would appeal to the new generation and which

232
Zero Group
demonstration in Düsseldorf,
1961

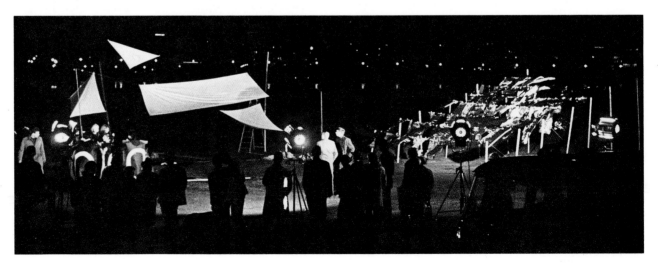

would also establish a topical relationship with both nature and technology.

At that time Piene's main preoccupation was with light vibration, but in 1968, the date of his first large-scale outdoor sculpture, *Light Line Experiment*, an added environmental concern became apparent. This was also the year when Piene went to the Massachusetts Institute of Technology's Center for Advanced Visual Studies, where he was able to continue to develop his artistic aims with the aid of the latest technology. He returned to the Center six years later as its director, succeeding Gyorgy Kepes in the post.

In order to create environments and at the same time enter as far as possible into the Earth's atmosphere and even beyond, Piene chose to work with different technologically operated devices. These range from kinetic sculptures to programmed light installations, laser light projections and scanning, computer processing, holography and telecommunications. Piene always links the use of these highly technical environmental devices to the question of the relationship between nature and technology. His preoccupation with the natural elements, earth, air, fire and water, which led to the vast events organized in the '80s under the label of Sky Art Conferences, dates from a 1969 exhibition entitled 'Elements' and an open-air display, *The Field of Hot Air Sculpture over a Fire in the Snow*, held at the Massachusetts Institute of Technology.

Works like *Olympic Rainbow*, shown at the Olympic Games in Munich in 1972, involving mass participation through telecommunication facilities, were early stepping stones in the development of Sky Art. In these works, Piene used modern telecommunications to extend Sky Art by adding an element of scale different from the actual scale of the event itself.

One aspect of Piene's involvement with technology is illustrated by the fact that he participated as an artist and organizer of the multi-technological event *Centerbeam* held in parallel with Documenta 6 at Kassel (1977), in the National Mall, Washington, D.C. (1978) and at M.I.T. (1980). His *Milwaukee Anemone* was flanked by laser projections on steam by Paul Earls and

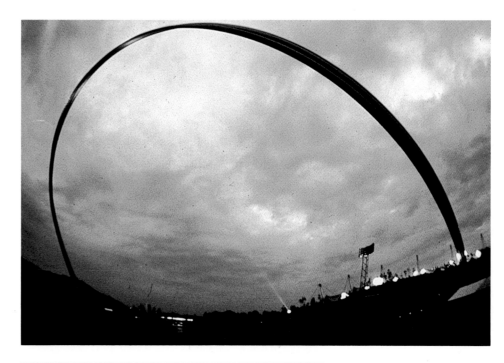

233
Otto Piene
Olympic Rainbow (1972),
Munich

234
Otto Piene
Blackstacks (1976).
Photo: Eric Sutherland

Joan Brigham and holograms by Harriet Casdin-Silver. An important but less obvious aspect of this event, and more particularly of the performances associated with his sky opera *Icarus*, produced with Earls, involved the use of technological media to explore the correspondence between indoor and outdoor space. Video, for example, made it possible for the outdoor production of *Icarus* to be experienced indoors, the limited space of the video screen substituting for the expanse of real and environmental space. Lasers and various kinds of light projections were used to suggest sky, sun and other large-scale natural phenomena lying beyond the confines of a traditional theatrical space. This electronic transformation reduced the dimensions of the actual event, but increased the potential size of the viewing audience.

Piene was attracted to Sky Art because it had certain qualities that intimate traditional media did not offer – specifically, a complex interplay between audience, artwork, technology and nature. As a result, Sky Art is capable of transforming themes and phenomena into engaging communal forms of imagery, providing an effective way of making art more public. Piene has contributed decisively to the social designs of Sky Art by producing large polysensorial events that address audiences on a large scale.

The first Sky Art Conference, held in 1981 in Cambridge, Mass., covered a large spectrum of the art/technology problem and was focused on the idea that Sky Art not only aspired to the scale of space but also to

235
Otto Piene *Sky Cry*, at the Sky Art Festival (Alaska) in the Anchorage Delaney memorial park, a large public open space, formerly an air strip, 1988

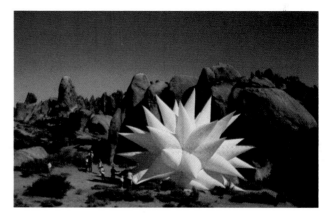

236
Otto Piene
Berlin Star (1984–86),
part of the event *Desert Sun, Desert Moon.*

dissemination in space. One of the highlights of this conference was the showing of Piene's *Blue Star Linz* (1980), an air-inflated helium sculpture, 50 ft in diameter and almost 300 ft high. At the Sky Art Conference in 1982, held in Linz, Piene not only produced the opera *Icarus* with Earls, but also collaborated in Charlotte Moorman's sky event called *Sky Kiss*. In 1983, at the Sky Art Conference held this time in Munich, events staged by Piene included *Iowa Star* and *Brussels Flower*. At that conference Piene showed for the first time *Centerdisk*, an optical memory system which was conceived as a research project for exploring the interrelationships between art, science and technology.

Of a Sky Art event held in Alaska in 1986 in conjunction with the 4th Sky Art Conference held once again at Cambridge, Mass., Piene wrote:

> Sky Art comes in humble praise of nature . . . here technology helps to distribute and connect while we keep it from dulling the senses and numbing the imagination. Vision and other sensory and mental faculties can draw them all together, the smallest of humans, the grandest in nature, the most refined and far-reaching technology inspired by science. Together they support human sensibility in scale for *homo faber*, *homo ludens*, *homo sapiens*.[6]

The interactive and pluri-artist Steve Mann, in his performance *Doppler Dance, A Sculpture of Waves*, installs six 'pieces', each of which contains one or more radar units that are placed around a stage. These interactive microwave sculptures can 'see' those who see them, even (through walls) those who are approaching them from other rooms. *Doppler Dance*, with its radars, responds to the viewer through various media such as sound and light. Dancers are free to interact with each piece in sequence or simultaneously.

Mann has constructed his wave sculptures on different levels. The slow-moving waves of sound and light form the basis for a dynamic performance art. The dancers, by virtue of their performance, indirectly explore the invisible microwave sculpture by first exploring the observable slow waves. Only when integrated with observable media can the microwave sculpture itself be appreciated.

Mann's novel application of radar includes a preference for sounds linked intimately to the human body. This mapping gives rise to a somewhat dissonant sound where there is a sense of every movement, no matter how slight, perceptible within the Doppler spectrum. Rather than simply using radar as a triggering device to control other musical instruments such as synthesizers, Mann treats it as an instrument in its own right.

Jean Gallagher is a multi-media installation artist who has combined painting and sculpture with computer-generated slide projections and sound (sampled sound combined with synthesized sound). Trained as a painter, Gallagher uses slide projections as comparative analysis for temporary, site-specific two-dimensional colour images that can be seen as a new way to

237
Steve Mann
Doppler Dance (1988–91)

think about drawing and painting. In an installation called *Kam E Flazh* (the title derived from the phonetic spelling of 'camouflage'), shown at the Nexus Contemporary Art Center in Atlanta in 1988, Gallagher, using a computer graphics system, 'painted' hundreds of non-objective camouflage patterns, from which she produced slides. Working with a choreographer, she directed four dancers through short performances, then sandwiched camouflage patterns with sequential slides taken from performances, adding a soundtrack composed of sounds from industrial and natural environments as well as human groans and sighs.

Gallagher notes that a single human performer experiences the possibility of an attacker lurking in his or her territory. Formally, the skin colour of the performer is altered by his or her physiological reaction to fear. On the basis that animals rely on camouflage to blend into the environment, Gallagher points out that the conceptual basis of *Kam E Flazh* grew out of an awareness of contemporary society's indifference towards the rights of animals.[7]

The Italian artist Piero Gilardi, who realized his first *Nature-Carpets* in 1965 and participated in the current artistic trends of the time, Arte Povera, Land Art, Anti-Form Art, began in 1969 a transcultural project directed towards the theoretical analysis of the relationship between art and life. It is from this perspective that he experimented in 1985 with the new technologies through the elaboration of a large project, *Ixiana*, a megasculpture shown at the Museé des Arts Decoratifs in Paris in 1989.

Between 1986 and 1991, with Riccardo Colella, he has integrated interactive computer technology with the 'artificial nature' of his *Nature-Carpets* in a series of electronic *Dancing Trees* and the installation *Inverosimile*, shown at the Castello di Volpaia in 1990 and later in galleries in Paris and Turin. *Inverosimile* is divided into 20-minute programmed cycles which simulate the

changing light conditions during a day from dawn to sunset. The spectator can circulate between three rows of vines, reacting through sound and light to his or her movements, which can create atmospheric changes in the entire decor and thus function as an actor and co-producer of a virtual reality.[8]

On the other hand Chris Burden, an artist who was originally active in Body and Performance Art, is now engaged in a very personal didactic project with respect to art and technology, intending to use the former to make the latter accessible to the lay person. Two of his works, closely related to each other, *B-Car* (1975) and *C.B.T.V. (To Einstein)* (1977), are meant to be physical 'thought-objects' or material demonstrations of the conflict between theory and practice. Burden's original conception for *B-Car* was to build the prototype of a cheap energy-efficient car (called the Echo-Rotor), but when this goal proved unachievable *B-Car* became a personal gesture. This took the form of performances in which he reassembled the work within a given time. The obsessive art of building the car became 'the essential experience' in realizing his artistic goal.[9]

239
Piero Gilardi
Inverosimile (1990)

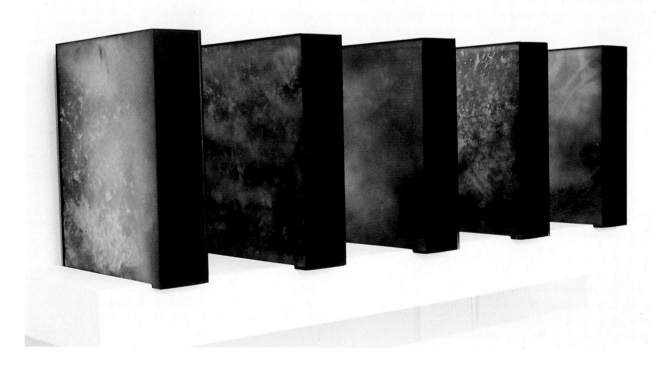

240
Sara Garden Armstrong
Two overlapping programmed cycles of LED and incandescent light play in five interacting units (1992)

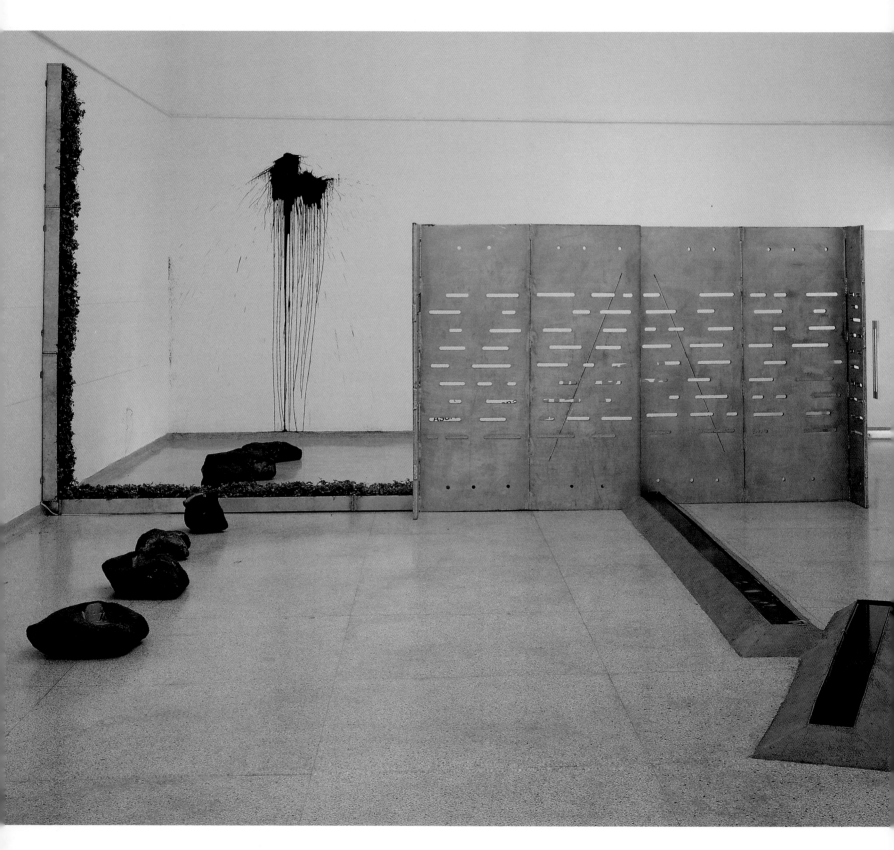

The Venezuelan artist Asdrubal Colmenarez, after creating various works in which the spectator was physically implicated (such as his 'psychomagnetic tactile bands', strips of magnetized metal that could be torn in pieces and rearranged by the spectator into letters, words and phrases), is engaged in research that aims at inducing the spectator to question himself about the relationship between nature and advanced technology. In an installation entitled *Prelude, Fugue No. 7* (1991), such man-made elements as computer-calculated aluminium walls and bauxite basins filled with water are combined with plants like ivy and grass. Through this mixture of technically produced and organic forms that surround the spectator, he or she is called upon to exercise the quality of discernment and to discover the necessity of coming to terms with both nature and technology.

Helen and Newton Harrison, two artists who are outstanding practitioners of the interface between art, nature and technology, direct their audience to changes in nature caused by human intervention in works such as the *Lagoon Series* (in the mid-'70s) and *First Meditation on the Condition of the Great Lakes of North America* (1977–78). They consider not only humanity's relationship to nature, but also the role of artists as naturalists, conservationists, environmental activists and 'information explorers' helping to dispel ignorance of our endangered environment by inviting spectators to understand ecological development through their works.

They advocate an ecologically appropriate use of technology in vast projects such as their bio-sculpture *Breathing Space for the River Sava* (1990), which won a prize at Artec '91 in Nagoya, Japan. This is a poetic

241
Asdrubal Colmenarez
Prelude, Fugue No. 7 (1991)

242
Helen and **Newton Harrison**
Breathing Space for the River Sava (1990)

proposal in text, photography, drawing, and collage to make a nature corridor that runs the length of the Sava River in Yugoslavia, from its source near the Austrian border until it joins Western Europe, containing the wetland ecology that used to exist in many other parts of Europe.

Erik Samakh has been known for many years for his acoustic pieces involving animal sounds. One such work is *Animal in Cage*, a visual and aural interactive installation presented at Hanover, then at Rennes, in 1988. It is composed of an empty cage, but the position and gestures of the spectators release various animal cries. The computer which determines these utterances works through the combination of information collected by solar pads, radar and sound meters. The spectators are meant to feel, for example, that they ought to stay still for a long time in order to hear the call of a bird. Even if they see that they are at the origin of these events they don't necessarily understand the logic behind them. The attitude and behaviour of the animals, or perhaps of one hybrid animal, are suggested as much by their apparent autonomous responses as by their reaction to the gestures of the spectators.

The fascinating history of artistic endeavour which explored the relationship between art and nature (without necessarily making use of advanced technologies) can be followed in two excellent publications, Lucy Lippard's *Overlay: Contemporary Art and the Art of Prehistory*[10] and John Beardsley's *Earthworks and Beyond: Contemporary Art with Landscape*.[11] This is not the place to discuss the work of such well-known artists in this area as Ian Hamilton Finlay, Richard Fleischner, Nancy Holt, Carl André, Robert Morris, Athena Tacha and many others. However, I shall just recall Walter De Maria's *Lightning Field*, James Turrell's *Roden Crater Project*, Christo's *Running Fence* and Richard Long's *Stone Circles*.

De Maria's work, completed in 1977 and situated in a flat, semi-arid basin near Quemado, New Mexico, is ringed by distant mountains in an area of seemingly limitless vistas, with a relatively high incidence of lightning strikes. It is composed of 400 stainless steel poles, 2 in. in diameter, standing at an average height of 20 ft $7\frac{1}{2}$ in., mounted in such a way that all the tops are level. They are arranged in a grid with 16 rows of 25 poles stretching east to west and 25 rows of 16 poles stretching north to south. The poles are 225 ft apart, 311 ft on the diagonal, and the total east-west dimension of the piece is exactly one mile, the north-south distance just over one km. De Maria planned his work to attract the lightning and to celebrate thereby its power and visual splendour.

The Roden Crater, a volcano on the edge of the Painted Desert, was chosen by James Turrell for his project, not only because of its form and surroundings but because he felt that the volcano itself was a powerful entity. Essentially the project was intended to create a crater-shaped space, in which the size and shape of the sky could be perceived dynamically.

This basic preoccupation has found a new expression in a series called *Perceptual Cells (Telephone Booths)* and in particular in *Phone Booth, Change of State* (1991). These works are based around 'cells' which are small individual structures similar to telephone booths. The spectator/participant must stand

243
Erik Samakh
Installation for Communicating Frogs (1991), an aquatic installation with live frogs, intended to establish 'strange conversations' and interactivity through use of the computer

inside the booth in order for his or her perception to be manipulated by a combination of light and sound effects. Using controls inside the booth, the spectator can change the intensity of the stimuli. The underlying purpose of these booths is to generate contrasting sensations of reality, between enclosure in a narrow space and the indefinable perception of the individually adjustable internal light. Turrell has stated it is important to understand that his work has no image. 'There is nothing inside . . . Absolutely nothing . . . It is non-vicarious art.'[12]

Among Christo's enormous range of realized projects, which are motivated by his preoccupation with packing up not only objects and buildings, but also natural sites, in order to comment on the relationship between economic and cultural consumer society and our environment, such as *Wrapped Coast* (Little Bay, Australia, 1969), *Valley Curtain* (Grand Hogback, Rifle, Colorado, 1971), *Ocean Front* (Newport, Rhode Island, 1974), *Running Fence* (Sonoma, California, 1975–76), and *Surrounded Islands* (Biscayne Bay, Florida, 1980–83), his aims and enterprise are perhaps best expressed in *Running Fence*.

What is particularly striking in this work is not only the vastness of the actual realization encompassing the natural site, but also the minute planning of the artistic operation which allowed him to overcome the enormous technical, administrative and legal difficulties.

Like the other environmental sculpture projects named, *Running Fence* was a temporary outdoor structure that involved large numbers of people in the planning and construction. It was seen by a public which by and large does not ordinarily visit art galleries or museums. One of Christo's aims was to encourage these viewers to make critical observations on the project and to formulate their own aesthetic judgment.

Running Fence was situated north of San Francisco. The fence, which was also to be seen at the time as a critical commentary on the Berlin Wall, was almost 20 ft high and more than 25 miles long, crossing the land of 59 farmers. It followed the undulating slopes of the hills until it arrived at Bodega Bay on the Pacific coast.

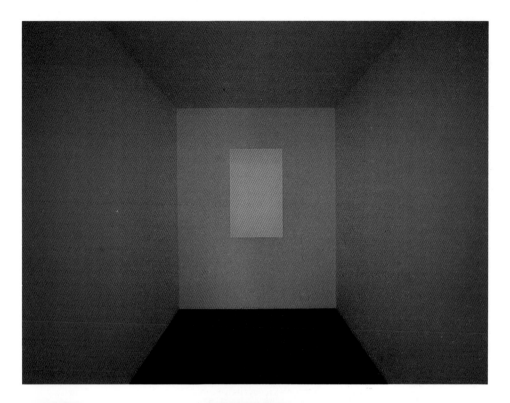

244
James Turrell
Catso Purple (1967)
shown at the exhibition
'Nature artificielle', Espace
Electra, Paris, 1990

245
Christo
Valley Curtain (1971)

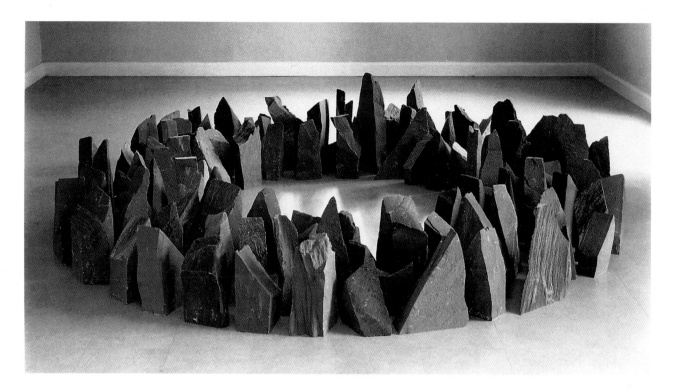

246
Richard Long
Elterwater Stone Ring (1985)
Abbot Hall Art Gallery,
Kendal (England)

247
Robert Smithson
Spiral Jetty
Utah (1970)

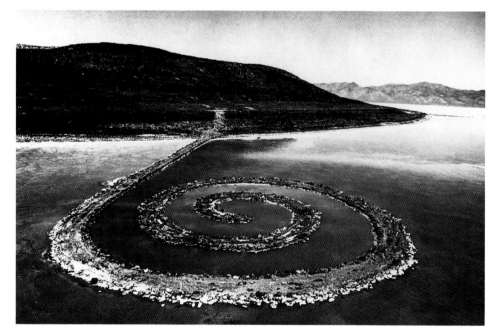

Running Fence was a good example of a spectacular artistic undertaking that brought to light and commented on the multiple forces that are implicated in the possession of land.

Richard Long, along with Dennis Oppenheim, Robert Smithson, Jan Dibbets and Walter de Maria, is one of the main representatives of Land Art who was already active in the late 1960s. Not only in his *Stone Circles* and arrangements of sticks, pieces of brushwood, pine needles or sea weed presented in basic shapes, does he intervene in a subtle way in nature, but also in those long walks across moors and wildernesses of which he gives symbolic accounts in galleries and museums. Long makes images which resonate in the imagination, that (in his own words) 'mark the earth and the mind' and make a plea for a considered, sensitive intervention by man in nature.

In this chapter I have been primarily concerned with art as a function of the efforts of *artists* who give an aesthetic content to scientific or technical developments, or to the scientific interpretation of natural phenomena. How-

248
Philippe de Reffye
A Growing Lichee (1988), synthesized image, still from the videodisk *Images de synthèse scientifiques*, Passages de l'Image, Centre Pompidou, conceived by Jean-Louis Boissier, 1990

249
Arthur Olson
(Research Institute of Scripps Clinic, La Jolla, California), medical scientific image (1988). © TSRI 1988

250
David J. Hoffman
Infodesign (1987). Department of Mathematics, University of Massachusetts

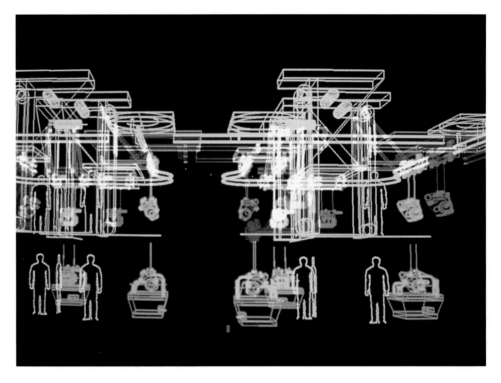

ever, the impressive computer-synthesized, purely scientific images, selected and compiled by Jean-Louis Boissier and shown at various art exhibitions such as 'Artifices' and 'Passages de l'image', both in 1990, remind us that photography and film too were treated as mainly scientific tools in their early days. Many of these computer projects replicate the appearance and movements of the human body while others seek to capture landscape features and natural phenomena, re-enacting early uses of photography.

We have seen that a good number of artists of quality, inspired by scientific interpretations of nature, whether using advanced technologies or not, have created works or made public events which have proved that the interface between art, nature and science is an open-ended one and deeply implicated in the ecological concerns of the art of our age of technology. The artistic use of this interface seems to show a way of reconciliation between the apparent contradictions of a rapid scientific and technological development of society that simultaneously jeopardizes the appreciation and conservation of our natural resources.

251
French-Egyptian Study Centre for the temples of Karnak (sponsored by Electricité de France). Computer-assisted reconstruction of one of the stages in the historical evolution of the forms and volumes of the pillared hall of the temple of Amun Re at Karnak, 1989

7

Social and Aesthetic Implications of the Art of the Electronic Age

The immediate social implications of the advent of technological art can be measured by the impact of a number of exhibitions and events that have taken place since the early 1980s in Europe, America and Japan.

The 'Electra' exhibition, which I conceived and helped to organize at the Museé d'Art Moderne de la Ville de Paris in 1983, focused mainly on how the artistic imagination had reacted to the introduction of electricity and electronics into the fabric of everyday life in the 20th century. The exhibition attempted to suggest that a scientifically based technology can help to liberate an artist's creative powers as well as the public's capacity for appreciation and interactive involvement. More than 150,000 people visited the exhibition and associated events. The main sections of the exhibition concerned the history of the electric and electronic medium, electrophotography, video and the digital image. 'Electra' was considered a ground-breaking event in so far as it showed the radical development of the artistic use of the four main technologies described in this book, laser and holography, video, computer and telecommunications.

If the 'Electra' exhibition put the accent on artistic projects involved with science and technology, 'Les Immatériaux', which was organized by Jean-François Lyotard and Thierry Chaput at the Centre Pompidou in Paris in 1985, was more concerned with the philosophical implications and problems of this relationship. In situating the products of the artistic imagination and techno-scientific invention on the same plane, it took an important, if problematic, aesthetic decision. A second area of concern was the relationship of technological art to Postmodernism.

The overall theme of the exhibition was the transformation of the material world both by the mass media, where the new or the real are filtered through the techniques of communication, and by technology, where matter itself becomes impalpable, as invisible as rays and wavelengths.

It is this tendency towards de-materialization, so characteristic of the technological age, to which people must respond with a different sensibility and a renewed

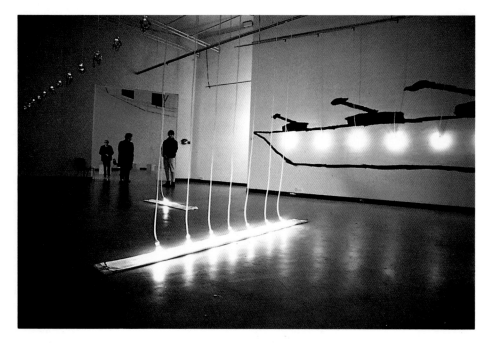

252
Sarkis
installation at Electra, 1983: included *La Source éclairée* (1987), *Les douze ampoules rouges de Kriegsschatz* (1977–83), and *Le grand bateau de l'enfant de Kriegsschatz* (1982–83)

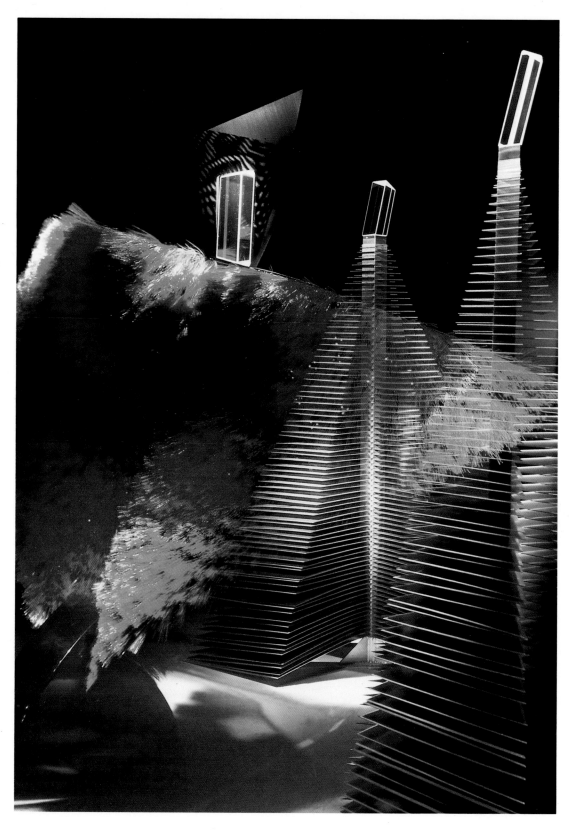

253
Liliane Lijn
Lady of the Wild Things
(1983)
voice-activated mixed media
performing sculpture, shown
at Electra, 1983. Photo:
Pierre Berenger, Electricité
de France – Sodel Conseil

254
View of the exhibition 'Kunst und Technologie', organized in 1984 by Jürgen Claus at the Bundesministerium für Forschung und Technologie in Bonn

255
View of part of the exhibition 'Les Immatériaux' at the Centre Pompidou, Paris, in 1985

perception, reflecting the changes in our knowledge and environment. It raises the question whether, in an epoch in which our means of knowing, of questioning and surviving, multiply themselves, we are becoming freer, more informed and more intelligent.

If the exhibition was an excellent demonstration, both critical and affirmative, of the entry of technology into everyday life, it was disappointing in so far as it did not sufficiently show the ways in which artists have taken account of these developments. More emphasis could have been placed on the fact that, in the post-modern era, mastery of the new technologies and their utilization by creative individuals affect, on the one hand, the quality of our environment, and on the other, are a benefit to humanity.

In putting both artistic and scientific images on the same plane, this exhibition neglected the on-going role of artists at the end of the 20th century. It intentionally created a confusion between artistic imagination and scientific invention, although the functioning of these two aspects of the mind are very different. The conditions for the scientific imagination to be intelligible and legimate – in a discovery such as relativity or quantum mechanics, for example – must be defined within an already established logical language, much more, at any rate, than in the case of the artistic imagination. Artists are freer to apply their imagination to aesthetic problems, even while conforming to certain constraints arising from the techniques or technologies used. They are able to employ a diversity of means, always remaining open to new experiences. Their freedom of imagination, however, imposes on them the rigour of an exceptional lucidity and moral responsibility. In fact, the artist must grasp the applications of his or her researches in daily life even more than the scientist who has historically often discovered their implications much later.

The general title of the 42nd Venice Biennale in 1986 was 'Art and Science', signalling the renewed interest in the 1980s in this constant element of modern art. The Biennale, however, in order to remain true to its own reputation and that of Venice, emphasized museological values and themes; in the final version of the principal exhibition, such sections as art and alchemy and the 'Wunderkammer' overshadowed the sections on technology and information-processing or those devoted to chromatic order systems and avant-garde colour. Nevertheless, the main import of this exhibition was to bring modern art and science closer together. It was presumed that such a *rapprochement* would eventually re-establish the unity that supposedly existed between these two fields of human creativity in earlier eras – for example, at the time of Leonardo da Vinci.

At the 1990 Venice Biennale, communication artist Jenny Holzer was the first woman as well as the first technology artist to receive the distinction of exhibiting alone in the United States pavilion. This artist's impact is exceptional in terms of both her work and the public recognition she has received. In works such as *Protect Me from What I Want* (1986), a Spectacolor billboard

256
Jenny Holzer
Survival Series (1983)

in Times Square, New York, Holzer used the common-place to voice the unconscious, and communicated messages via electronic signboards to an expanded public outside the gallery and museum system.

In the 1990 Venice Biennale, she not only installed fourteen pieces, including four LED (light emitting diode) signs inside the United States pavilion, but she also orchestrated numerous works of art throughout the urban tissue of Venice, the Lido, Jesolo and Mestre. Here, as in most of her production in the last ten years, Holzer's preferred themes – sex, death and war – treated artistically, competed with the mainly utilitarian or commercial advertising signage as a sort of guerilla warfare. Her texts often appear on posters, t-shirts, stickers, metal plaques, magazines, park benches, billboards and monumental electronic signs, but her favourite signature medium is the LED sign similar to those used in supermarkets, airports and banks for information and advertising. Ranging from the subtle to the spectacular, her work always masquerades as a public service message of a decidedly subversive kind.

257
Yaacov Agam
Visual Music Orchestration
shown at Artec '89

258
Wen-Ying Tsai
Desert Spring (1991)

A very special event was 'Arttransition '90', organized by Otto Piene and Cynthia Goodman at the Massachusetts Institute of Technology. This was an international conference on art, science and technology which focused on artwork in new media, including laser, holography, computer art and music. It highlighted recent collaborations between artists, scientists and engineers, and the growing number of art and technology centres and new media departments in colleges and universities world-wide. Topics of discussion included 'Sky Art', 'The Global House', 'The Economics of Art and Technology', 'The Feminine in Art, Science and Technology', 'Networking and Telecommunications' and 'Art and Biotechnology'.

The First International Biennale, ARTEC '89, held in Nagoya, Japan, on one of the sites of the World Design Exhibition and at the Nagoya Science Museum, consisted of a competition and exhibition as well as a public symposium. It was visited by 1.4 million people during its 135-day run. Prizes were awarded to Yaacov Agam for his *Visual Music Orchestration*, a computer-animated work, Paula Dawson for her large-scale holographic installation *To Absent Friends*, Ed Emsh-willer for his video installation entitled *The Blue Wall* and Tatsuo Miyajima for what he calls a 'counter' installation, *Double Focus (Counter Circle)*.

Two years later, ARTEC '91 was held at the Nagoya City Art Museum and at the Nagoya Science Museum, and like the First Biennale was organized by Shigeki Mori. It repeated the same format but included a new theme exhibition entitled 'TV Games: Towards Another Reality' and a performance and film section. The main exhibition and international competition (nearly half the invited competitors coming from the U.S.A.) comprised a large number of video instal-lations. The first prize went to Wen-Ying Tsai and the three other prizes to Helen and Newton Harrison, Gary Hill and Thomas Shannon.

Tsai's elaborate installation, *Desert Spring* (1991), was a cybernetic sculptural system that focused on the homeostatic relation of art to its environment. It also involved upward-falling fountains, which have been

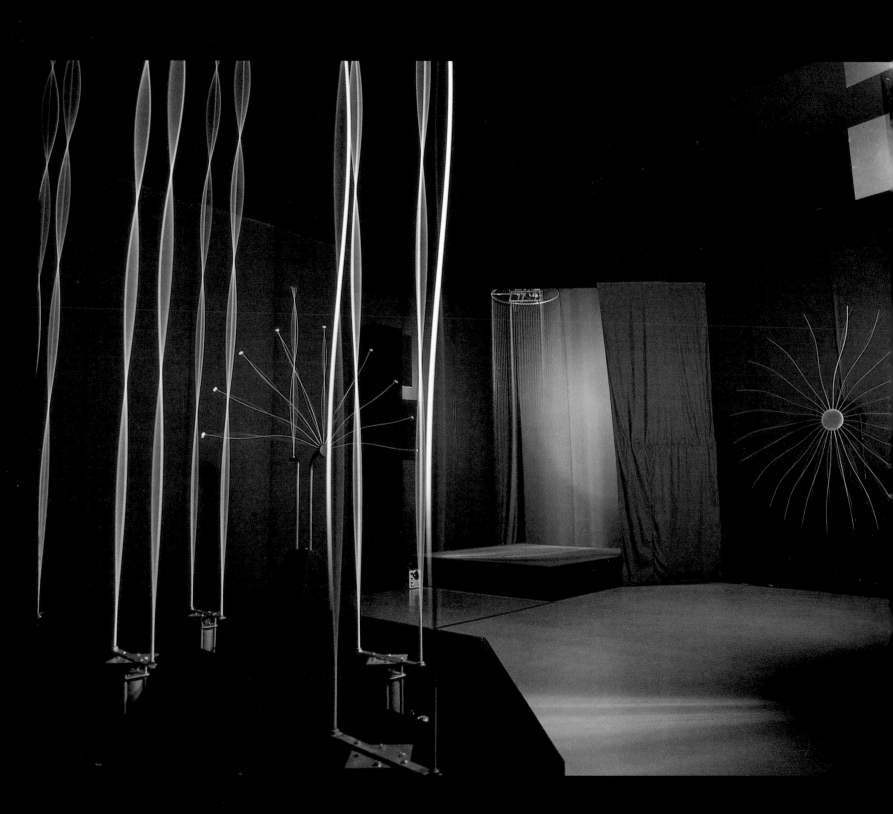

alluded to in earlier chapters. It represented a new generation of environmental sculptures based on the concepts of stability and disturbance. The work was endowed with virtual intelligence which enabled it to maintain its internal stability by coordinating real-time spontaneous and interactive responses that automatically compensate for changes in the environment. When spectators enter the threshold of this darkened space, their presence is sensed by the sculpture's infra-red and audio antennae; thus, by their movement and sound, the spectators stimulate and destablize the sculpture from normal relaxed undulation to excited rapid palpitation. It is only when the spectator leaves that the sculpture returns to its usual tranquil undulating state, as if awaiting the next round of confrontation.

The prize which went to the Harrisons was for the bio-sculpture *Breathing Space for the River Sava*, discussed in Chapter VI; to Gary Hill, for the video installation *Between Cinema and a Hard Place*, mentioned in Chapter III; and that to Thomas Shannon was for his *Spawn Memory*, which is a device for sculpting images in the air. This 'integrated medium' sculpture is, physically speaking, a small sphere which emits tiny bubbles or vapour 'flying' through the exhibition space on four suspension wires whose positions are choreographically programmed. The lines are controlled by four small boxes placed in the corners of the space which also contain light and sound sources. Thus the arts of drawing, dance, sculpture, drama, music and lighting are integrated into one medium. The materiality of the medium is minimized so that the transient sequences of shape, light and sound provide the central experience, preserved only in the memory of the spectators.

Ginette Major and Hervé Fischer's exhibitions 'Images of the Future', held at the Cité des Arts et des Nouvelles Technologies in Montreal since 1986, were remarkable showpieces of technological art. The first exhibition, in 1986, focused on computer images; the one in 1987 on holography, laser images, computer music, multi-sensory and multi-media environments and Video Art; and in 1988 the exhibition stressed light and movement.

In 1989, 'Images of the Future' celebrated the Bicentennial of the French Revolution and the Declaration of the Rights of Man and of the Citizen. Artists, institutions and companies, mainly from France, Canada, the U.S.A., Austria and Germany, took part. The most advanced technologies were presented with the intention of suggesting that today's technological revolution is comparable in historical and political impact to the 1789 French Revolution. Some outstanding works were Bill Bell's *Tri-colour Lightstick* (1988), Michaël Gaumnitz's *The French Revolution: Heads and Tales* (1989), Richard Kriesche's installation of two video panels, *Liberty Leading the People*, Myron Krueger's interactive installation *Video Place*, and Nam June Paik's 3 m-high video sculpture, *David and Marat* (1989).

'Images of the Future '90' highlighted three special areas: an extensive holographic exhibition composed mainly of European works, but with American and Canadian contributions; a Young People's Space that

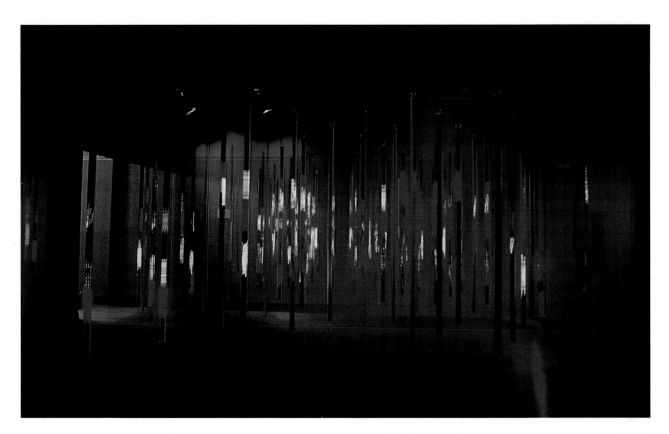

260
Bill Bell
Poissons d'avril 1991
an installation of 12
lightsticks and 100 mirrors,
shown at Rheims, 1991

combined artistic, scientific and educational sections; and a cinema section showing a selection of international computer-animated films. Outstanding works here were Brigitte Burgmer's *Holographic Sculpture*, Jean Dupuy's interactive sculpture *Cone Pyramid*, Georges Dyens's holosculpture *Building the Universe*, Alain Fleischer's installation *The Voyage of the Ice Breaker in Mirrorland*, and Karl X. Hauser's neon installation *Wall-o-Fish*. Notable among the video installations were Michel Jaffrenou's *Parade*, among the holographic installations Dieter Jung's *Palindrome* and among the video/computer animations, the works of Yoichiro Kawagushi.

The most constant and elaborate manifestation of pluralistic technological art has taken place in Linz, Austria, where 'Ars Electronica' has been mounted annually since 1979. This enterprise has regularly tried to cover the whole art/technology spectrum in architecture, the visual and performance arts and music. Notable events have been the laser/video concert given

261
Karl X. Hauser
Wall-o-Fish (1989)
neon sculpture animated
with the aid of a
microcomputer

by David Tudor and Lowell Cross and co-designed by Carson Jeffries in 1980, the Sky Art Conference of 1982, and the synthesis of art, technology and society attempted in 1984, where the focus was on digital art, holography, music and theatre. It was also an occasion to ask, as did Dr Hannes Leopoldseder, Managing Director of the Austrian Broadcasting Corporation:

> . . . which term will definitely be used in a historical review of the closing decades of the 20th century: Information Society, The Era of Electronics, Post-Industrial Society, Third Industrial Revolution, Age of Cybernetics, Silicon Age, Computer Culture, High Technology Culture, [or] New Age?[1]

Two years later (1986) 'Ars Electronica' contained a remarkable section of technical 'workshops' called 'terminal art', which was organized by Jürgen Claus. In 1989 it used the title 'In the Network of Systems: Art as Communication', and a special number of *Kunstforum* was devoted to the same theme.[2] Its special concern was communication, interaction and dialogue; the role of media telecommunication in the computer culture, and the function that art can perform within such social systems. It was proclaimed an experimental laboratory and for this purpose was divided into three groups, one bringing together telecommunication experiments, the second interactive projects, and the third proposals on the theme of the computer culture. The last section was mainly devoted to discussions on the implications of the Prix Ars Electronica and a symposium under the title 'Liberation of the Media', alluding to the development of new technologies that had allowed artists to conceive multi-media projects and thus to create an artistic discipline through the interaction of a variety of different media.

'Ars Electronica' in 1990 was entitled 'Digital Dreams – Virtual Worlds'. As pointed out in its catalogue, the festival wanted, in its interdisciplinary approach, to embrace the newest, and hitherto most radical, expressions of digital fantasies: the creation of artificial realities as an outcome of computer-controlled machine worlds which would react intelligently to our

needs, and the production of other computer-controlled artificial intelligence works belonging to the hypermedia and virtual worlds. The programme covered the relationship to and affinities with 'digital dreams' in mathematical methods of composition, the digitalization of sound images, adoption of fractal theories, machine-controlled theatre, intermedia performances and installations. The related symposium addressed a number of topics, including advances in theories about thinking with the help of new models of the brain and the state of artificial intelligence machines. A session called 'Virtual Worlds – Artificial Realities' dealt with contemporary interaction between humans and machines, and the new shape of human action in a virtual world with three-dimensional 'cyber-models'. It was suggested that the last boundaries between reality and imagination should be torn down, enabling entry into cyberspace; the artificial digital simulation of reality would thus lead to the transition from automaton to hypermaton, that is, from a merely mechanical machine to one with multiple references. In the session 'Cyberspace – Virtual Visions' reference was made to the California companies setting out to realize the visions of science-fiction author William Gibson. A viewing system such as the dataglove or sensitive body dress makes the step into cyberspace experienceable. If virtual reality seems today to be little more than a futuristic fantasy, it may very well develop into a revolution in the near future.

The latest technical developments and the question of virtual reality have been discussed by Randall A. Stickrod in his article 'Multimedia, Virtual Reality and All That Babble'.[3] According to him 'multimedia' is a term coined by Apple Computer to encompass computer graphics, video, audio and hypertext on a personal computer. The multimedia phenomenon encompasses the ability to generate and animate photorealistic images and generate output on a host of media, adding a kinetic dimension to the digital artist's toolkit. Animation is now available to the ordinary user. 'Virtual reality' has the potential to become an entirely new genre of art – perhaps in terms of the ultimately

personalized expression of Performance Art, although for the time being it remains an expensive and impractical tool.[4]

The 1991 'Ars Electronica' exhibition was subtitled 'Out of Control', referring to the potential dangers in the rapid technologization of our lives, which alters the relationships among people and nations, and between people and nature in both the ecological and biological senses. This theme, although chosen before the Gulf War, covered the important role technology plays in modern warfare. On the other hand, an interactive event at this same show demonstrated that advanced technological means can also be used to detect, to avoid and to fight damage, destruction and catastrophes.

The chief organizer of the 1992 'Ars Electronica', Peter Weibel, is trying, in his choice of 'The World from Within' as its main theme, to provide a starting point for

265
John Hersey
Smart Drugs (1991)
shown at Ars Electronica,
1991

a new science, even a new vision of the world, called 'Endophysics'. This is held to be a science which will eventually do away with the illusion of the external observer who, in classical physics, believes that he can completely describe the world from outside. Only being placed within the phenomena themselves, can the observer comprehend the environment with the aid of the latest scientific insights and achievements. A symposium is to be held with the aim of illustrating and supporting this thought, linking it to the hypothesis that nano-technology (the technique which will enable us to enter into the micro-domain) and 'virtual reality' can be considered borderline cases of endophysics. The corresponding art exhibitions and competitions at 'Ars Electronica' 1992 will consist again of computer graphic works and animations, interactive art works, multimedia performances, media operas and electronic music.

In a less ambitious, more specialized, vein the exhibition entitled 'Artifices: Invention, Simulation', which was held in October 1990 at Saint-Denis, was concerned with demonstrating the different artistic traditions that have established a connection with technological innovations in information science. Jean-Louis Boissier was the main organizer of that exhibition and observed that,

> To orient oneself in this unknown territory among the works of individual authors who are both artists and engineers, one must look at the exact role the computer plays at one stage or another of their creative processes. It may be that computer science has generated images destined to be registered in video or on other supports, or it may be that it is directly active in the exposed image.

One part of the exhibition was given over to works which mainly involved synthetic images on the video screen, worlds invented on the basis of purely mathematical fictions. The other part was devoted to works that provoked a great degree of interactivity with the public. Thus the exhibition showed videos using the graphic palette, microcomputer animations, computer-printout prints, synthetic image videos, interactive synthetic images and interactive videodisks.

Among exhibitions largely, or entirely, involved with Computer Art and which have had a wide public appeal, are the 'Siggraph' art shows, held since 1981 in various locations, mainly in the U.S.A., and the 'Artware; Kunst und Electronik' shows held in Hanover and other German cities since 1986. Other recent exhibitions of note have been Cynthia Goodman's 'Digital Visions (Computers and Art)' at the Everson Museum of Art in Syracuse and 'The Interactive Image' at the Museum of Science and Technology in Chicago (both in 1987); 'The Technological Imagination, Machines in the Garden of Art', in Minneapolis in 1989; and 'Computers and the Creative Process' at the University of Oregon Museum of Art in Eugene in 1990.

Also in that year an interesting initiative took place at the 'Fête de l'Image' at Lille. It was organized by Joël Boutteville, who assembled the works of computer artists living in Hungary. The whole spectrum of Computer Art was covered by these artists while working in the most restricted economic conditions. Aron Gábor and László Révécz presented fixed image computer graphics produced on the screen and photographed; Tamás Waliczky and László Kiss worked on computer animation, Agnès Hegedüs on computer video works and János Sugár on computer-assisted drawings used for sculpture installation; György Galántai showed images composed from personal souvenirs on a computer screen.

267–69
János Sugár
The Technique of the Inca Walls
(1990)
György Galántai
Etudes (1990)
Aron Gábor
Pyramides (1989)
all shown at the 'Fête de l'Image'
exhibition in Lille, 1990

In the same period, exhibitions have taken place in the area of Holographic Art – such as those held during the International Symposia on Display Holography at Lake Forest, Illinois, between 1988 and 1991. In Video and combined Video/Computer Art there have been such shows as 'Video Art: The Electronic Medium' at the Museum of Contemporary Art in Chicago in 1980, the 'Ars et Machina' exhibitions and the Festivals of the Electronic Arts held between 1981 and 1990 at Rennes, France, and 'Passages de l'image' (Transformations of the Image) shown at the Centre Georges Pompidou in 1990 before travelling via Toronto and Columbus, Ohio, to the Museum of Modern Art in San Francisco in 1992. In Communication Art the exhibition 'Communication Machines' at the Cité des Arts et de l'Industrie at La Villette, Paris, in October 1991 was particularly significant.

The development in the teaching and research institutions and artistic organizations that have specialized in the area of technological art has been widespread and worldwide. Well known examples in the U.S.A. have already been mentioned. Among the artists' organizations perhaps the most influential has been that of the Ylem artists using the science and technology network in Orinda, California, under the direction of Beverly Reiser.

270
Claude Basdevant
Collision de vortex (1988)
visualization of a mathematical module, shown by Jean-Louis Boissier on a videodisk at Passages de l'Image, 1990

271
Beverly Reiser
Neon Spring (1986)

272
Frank Malina paints the 'rotors' of *Paths in Space* (1963), in his lumidyne system. The principal composition, painted on the 'stator', is not visible here.

In Britain, the Computer Arts Society in London under John Lansdown, and the Gwent College of Higher Education at Caerleon, Wales, under Roy Ascott, have been particularly active.

French institutions of this kind have been installed at the University of Paris VIII at Saint-Denis (Arts et Technologies de l'Image [ATI]) under the direction of Edmond Couchot, at the University of Paris I where Anne-Marie Duguet is responsible for Video Art and François Molnar for Computer Art, and at the University of Paris Dauphine with Élie Théophilakis responsible for CETECH (Centre Europeén de Technoculture). There is also in Paris an artists' and theoreticians' organization, Ars Technica, under the direction of Claude Faure, which is closely connected with La Cité des Sciences et de l'Industrie at La Villette. The Centre Georges Pompidou houses a number of facilities covered by the art/science/technology interface, particularly the unit directed by Christine van Assche.

In Germany, the leading centres of the arts, sciences and technologies interface are the Kunsthoch-schule für Media in Cologne, founded by Manfred Eisenbeis and then directed by Heide Hagebölling, the Karlsruhe Zentrum für Kunst und Medientechnologie (Centre for Art and Media), the Institut für neue Medien in Frankfurt under the direction of Peter Weibel, and the German Society for Holography in Osnabrück. There is also a project for a large-scale multi-media technology centre, the Media Park at Cologne, in preparation.

In the Netherlands, the ASTN (Art, Science and Technology Networks) at Utrecht, working in liaison with its Boston counterpart under the direction of Ray Lauzzana, and the Media Art Development Foundation of Maarten Noyons in Amsterdam are among the most active.

The outstanding journal in the area of technological art is without doubt *Leonardo*, founded in 1967 by Frank J. Malina, and directed, since his death in 1981, by his son Roger. Malina was a rare combination of scientist, artist and humanist, internationally famous for his work on

early rocket development and his pioneering contribution to Kinetic Art. His lifelong efforts to promote international cooperation in science and technology and the visual arts are still bearing fruit. In the twenty-five years of its existence, *Leonardo* has published innumerable articles in the fields of science, technology and art, as well as articles by specialists covering the whole range of this book (which is particularly indebted to it). In collaboration with ISAST (the International Society of the Arts, Sciences and Technology), it has created a number of annual awards promoting artistic and theoretical research in this field.[5]

Among the periodical publications which have from time to time focused on technological art or one of its aspects are *Kunstforum* in several recent issues (Nos. 77, 78, 97, 98, and 103), *Art Journal* (Fall 1985, Fall 1990), and *Art Press* (No. 122 and the special number, 'New Technologies', 1991).

Indicative of the recent growth in this field is the publication of the International Directory of Electronic Arts, compiled by Annick Bureaud, whose first edition, in 1990, contained over 2,000 entries (artists, theorists and institutions). As Otto Piene states in its foreword: 'No matter how diverse the categorized institutions are, their number signals a fundamental change in the practice of art, life and research as we begin the last decade of the 20th century.'[6]

One way of categorizing all these various tendencies is to suggest that the principal aesthetic implications of technological art are bound up with the notions and practice of interactivity, simulation and artificial intelligence.

As regards the passage from participation to interactivity in visual art, the concept of participation suffered a partial eclipse during the 1970s. However, a direct link can be established between the participatory achievements of Op and Kinetic Art in the '50s and '60s and the technological art of the '80s and at the beginning of the '90s. It is particularly in the sectors concerned with interactivity that the most significant artistic achievements can be observed.

If in laser and holographic work interactivity is limited to the spectator's awareness and perception of complex natural phenomena coupled with artistic goals, in many computer and combined computer-video works and in most telecommunication art it is at the very heart of the technical devices as well as of the artistic process.

Striking examples that have been analyzed in previous chapters include Jeffrey Shaw's *Legible City*, Edmond Couchot's *Feather*, Roy Ascott's 'fairy tale' *The Pleating of the Text*, Jean-Louis Boissier's *Bus*, Lynn Hershman's interactive piece *Deep Contact*, and Myron W. Krueger's *Video Place*.

The term 'interactive art', which came into use at the beginning of the 1990s, identifies a very wide range of experimentation and innovation in a variety of media. Interactive art presents a flow of data (images, text, sound) and an array of cybernetic, adaptive and (one might say) *intelligent* structures, environments and networks (as performances, events, personal encounters and private experiences) in such a way that the observer can affect the flow, alter the structure, interact with the environment or navigate the network, thus becoming directly involved in acts of transformation and creation.[7]

Stephen Wilson's *Father Why*, which enables the user's voice to control a simulated walk through San Francisco's multicultural Mission District and to investigate the dreams and disillusionment of its immigrant population, illustrates the case that can be made for stressing the cultural importance of Interactive Art.

It is Wilson's view that

We are at a cultural crossroad in the evolution of technology. Computers promise great opportunity and great danger. They could usher in a dark age of increasing passivity and centralization and a decay into faceless mass society; or they could bring about a great flowering of individual choice, expression and access to information.[8]

Since the 1980s Wilson has committed himself to bringing about the second alternative by creating

interactive networks that require the audience to act as co-creators; the audience's choices shape the flow of events. These works can also be called interactive because they require spectators to interact with each other in making these decisions. Jean-Louis Boissier, however, argues that interactivity is not the causal factor in the establishment of the new art form but only one of its most important effects.

Roy Ascott stated in 1991 that

> What we are seeing develop in this new field is a broad range of attitudes, systems, structures and strategies involving the full sensorium of the body and engaging the mind and emotions in the creation of complex multimedia environments rich in their potential for meaning and experience. Take, for example, the six works which have secured top recognition in the first two years of Interactive Art submissions to Ars Electronica. The winner of the Golden Nica in 1990, Myron Kreuger, and the winner of this year's award, Paul Sermon, in many ways mark out the breadth of the domain. On the one hand, Krueger, one of the first, some twenty years ago, to research the possibilities of interactivity in artificial space, comes from a base in computer science and brings into the domain of art a 'videoplace' within which the users might play and interact on screen with exhilarating degrees of freedom, intermingling with, affecting and transforming computer-generated graphic objects, images and sound. On the other, Sermon, trained in fine art, seeks through the technological and layered complexity of hypermedia and global telecommunication networks, a semantic space in which users of the systems he creates can criticize the dominant media, can navigate the dataspace for new information and insights, and can generate meanings and attitudes to the social formations in which they find themselves embedded. These two works alone, in many ways, can be seen to encapsulate both the history of the field of interactive arts and its future – from opening up a space for interactive and collaborative work to providing that space with a spiritual, moral or intellectual gravity within which meaningful content can be generated.[9]

A most impressive contribution to the problem of interactivity in art was provided by Peter Weibel in his articles in the special number of *Kunstforum* devoted to interactive arts and entitled 'In the Network of Systems'. His 'Polylog: For an Interactive Art', written in collaboration with Gerhard Johann Lischka, and his 'Materials Relating to the Birth of a New Art Tendency: Interactive Art, Ars Electronica in Linz', were of major importance in a publication which also contained important articles by Roy Ascott, Carl Loeffler, Richard Kriesche, Robert Adrian X and Stephen Wilson.[10]

The more general problems of interactivity were addressed by the participants in the forum 'Towards an Interactive Culture?' organized by Claude Faure and Antonia Bacchetti in May 1988 at the Cité des Sciences et de l'Industrie at La Villette.[11] At this forum, Christian Marbach asked the question: at what price and with what success would it be possible for the new technologies to master interactivity? Faure aligned interactivity and simulation, and raised other questions: how do the new technologies influence our perception? how do they create new languages and new images? how do they modify our cultural practices?

The forum was divided into two parts. The first dealt with interactivity in relation to technoscientific culture, the second with interactivity as an instrument of creation, in the service of artists and the public at large. Concerning the first point, Jean-Paul Natali drew attention to the necessity to quantify interactivity in order to determine its degree of effectiveness; Gillian Thomas outlined the benefits to be gained from attending to senses other than sight – to smell, taste and hearing; Jean-Louis Weissberg highlighted the fact that in communication the act of seeing is modified, that the technologies of sight assist, objectify and radicalize the abstract components of human perception. To see is not only a passive reception but also a projection. The computerized ingenuity of simulation and the organization of interactive imagery externalize the conceptual pathways of looking.

Instead of interaction, Philippe Quéau preferred to use the term 'alteraction' – that is to say, 'to make other'. He suggested that the notion of the model should replace that of form and that the creators of models are

demiurges who create symbolic worlds with a life of their own.

Concerning interactivity as a subject of artistic creation, I tried at the forum to limit its meaning by saying that in an aesthetic context, although the term could designate either the relationship between the artist and the work in the course of its making or between the ultimate work and the spectator, it is necessary to retain a historically defensible application in which the aesthetic intentions of artists are accompanied by a very clear awareness of the technical processes involved.

Artists such as Fred Forest, Christian Sevette, Stéphan Barron and Jean-Marc Philippe argued that

the concept of interactivity came not only from computer science and its derivatives, which are all capable of simulating a dialogue, but also from a new understanding of communication. Today one is able to speak of a meeting-place based on communication in which the interactive processes become a reality on a planetary, even universal, scale. The contributions to the forum at La Villette covered a large panorama of diverse aspects of the term interactivity and its pedagogical, creative and cultural functions.

The relationship between the notions of interactivity, simulation and artificial intelligence has been examined by Marie-Hélène Tramus. She assumes that interactivity can be considered as a simulation of

273
An exact replica of the control room of a nuclear power centre set up as a teaching device in Bugey, Ain – an explicit form of virtual reality. Photo: P. Berenger, Phototèque Sodel-EDF

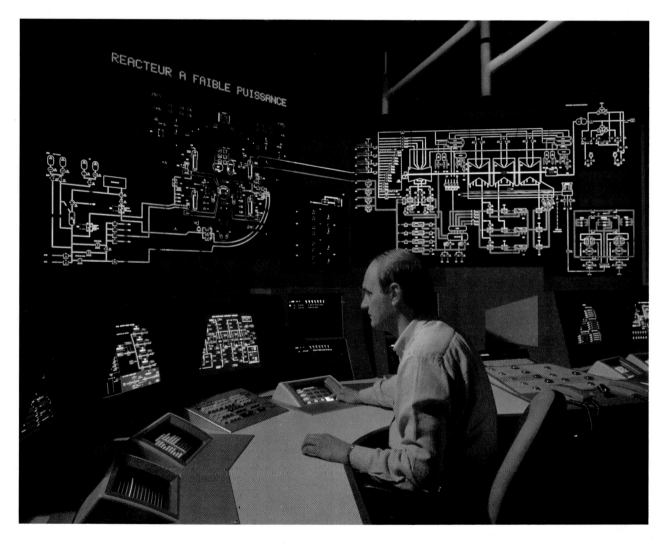

interaction. If interaction refers to the individual's relations to both natural and artificial realities, interactivity refers to relations to virtual realities. Tramus suggests that interactivity is the transformation of reality. It permits the transformation of natural reality (all that exists outside of the works of man) and artificial reality (all that is produced by human skill) into the virtual realities of simulation. That is, interactivity is the simulation of interaction, rendering possible the dialogue between these different realities.

As regards the term artificial intelligence and its relationship to interactivity and simulation, Tramus argues:

> In the man-machine relationship, interactivity would be an essential intermediary which would not only play a passive linking role but a role of transformation. This coupling of man to machine, this synergy, is possible when a single function is made by the two beings. But this coupling exists when there is a convertibility between one and the other. Thus, interactivity would participate in this convertibility, to this common coding, which permits the synergy, that is to say, the coordinated action of several participants . . .[12]

Simulation in the context of the new technologies is mainly concerned with the construction of a model as close as possible to the real. This model becomes visible in certain works, such as Jeffrey Shaw's and Dirk Groeneveld's *Legible City*, through the interactivity of the spectator.

The theoreticians who have put the notion of simulation at the centre of their preoccupations have approached it from different points of view. For Jean Baudrillard, who associates simulation with the 'desertion of the real', the notion of abstraction traditionally associated with cartography, the double, or the mirror all presuppose some real referent. In simulation, however, what is simulated is no longer the territory, an original substance or being, but a model of the real. This shift in levels has catapulted us into the hyperreal. From now on it is the map that precedes, and thus generates, the territory.[13]

Adopting the opposite position, Philippe Quéau regards simulation as a new writing tool: it opens up new territory for creation and knowledge. Since mathematics can be assimilated to an art of symbolic manipulation, one can now mathematically simulate origins. Digital images are thus captured through a logico-mathematical information language.[14]

According to Florian Rötzer, simulation with the assistance of the computer is the result of perceptions which have been transferred from the human being to machines equipped with sensorial input. Thus simulation can be the result of a total programming of the environment.

At present we are faced with the elaboration of techniques that simulate human behaviour and perception. Soon the result of our knowledge could be applied to (or transformed into an application for) the development of our aesthetic environment, although only on a virtual level. One could produce new performances which go beyond the imitation of the real environment and which do not even use elements of reality. Virtual worlds can be created with the active (interactive) participation of the public.[15]

An artist like Nicole Stenger gives three possibilities for the use of simulation in Computer Art. First, the simulation of traditional techniques (the computer, with its own languages pretending to be a paint brush, is treated simply as a tool). Secondly, simulation can be used with a desire to prove that this equipment can describe the world as it is, i.e., to reproduce the real world. Thirdly, there is also the possibility of making use of simulation with complete liberty by trying to achieve everything that seems impossible and thereby creating virtual space in which gravity and materials can be transcended.

There is no doubt that this conjunction of the real and the virtual engendered by simulation is at the heart of present research by many technological artists. They consider that 'virtual space', 'virtual environments', or 'virtual realities' in general usher in an entirely new era in art, allowing the participants a multi-sensorial experience never encountered before.

The key words 'artificial intelligence' as an aesthetic problem open up a vast, time-worn discussion of the relationship between man and the machine. Artificial intelligence embraces techniques which enable machines, and in particular computers, to simulate human thought processes, particularly those of memory and deducation.

According to Jean-François Colonna, artificial intelligence is above all an intellectual technology. The 'expert system' as a branch of artificial intelligence can be either a 'profound simulation, reproducing in its deepest structure the cognitive function of the human expert system', or a 'weak simulation, purely operational, which produces only an approximation of the results of the reasonings of the expert system, but without necessarily passing through similar logical pathways.'[16]

Richard Kriesche's *Brainwork*, with its accompanying catalogue, was an attempt at introducing the cultural dimension implied in the 'digital code', made up of the most varied information, into the space created by the new media. This space development has a socio-cultural dimension that requires advanced technology.

According to Kriesche, the aim of all art is to make the whole world a work of art. Today art no longer has its own specific function. Whatever functions have been ascribed to art – such as insight, discovery, catharsis, expression or representation – are met far more effectively today by the cinema, TV, psychotherapy.

In the face of electronic reality, art, having once been a problem of materials, becomes a digital problem. From questioning our views of the world, it has moved on to questioning the world itself. The social significance and the role of art are to be found in the context of digital image processing (in storing, processing and transmitting information).

Artificial intelligence in the arts represents the paradigm shift in response to the phenomenon of universal digitalization. Art no longer means the production of artifacts of a painterly or electronic nature – but rather the discovery of the inner logic of a digital world view.

274
Jean-François Colonna
Fractal a two-dimensional representation of part of a 'Mandelbrot set' (useful for understanding and defining certain natural shapes and phenomena). Detail of a fresco in the hall of the Ecole Polytechnique at Palaiseau, in Paris (1984).

275
Richard Kriesche
Hand and Head (1984)

276
Stephen Wilson
Excursions in Emotional Hyperspace (Cadre Show, 1987). Four computerized mannequins responding to the presence of viewers.

277
Stephen Wilson
Is Anyone There? (1991), interactive installation using a telemarketing technique

Art is neither learning nor perception, but a process of encoding in a manner analogous to the 'neuronal firing patterns' described by Flanagan, Buglariello, Karl Popper and Pribram. In the context of natural and artificial intelligence, art becomes a process encoded in what Kriesche calls 'artinese' language linking the inner and outer worlds, the medium and the work of art.[17]

Stephen Wilson may once again be cited as an example of an artist putting artificial intelligence at the centre of his preoccupations. His interactive computer systems take into account subtle characteristics, such as emotions, taste and humour, and make the computer simulate them. Wilson sees computer artists using Artificial Intelligence Systems also as a way of 'humanizing' such systems. He claims that the application of artificial intelligence in Computer Art has already contributed significantly to the study of art, to the distinction between the finished work of art and the processes which precede its making, and to the relation between viewers and these works of art.[18]

More recently Wilson, like Ascott and others, has developed many works and theories which we have mentioned in the course of this book, instituting an art of intelligent systems in which the interplay between artificial and human intelligence is complete and where each participating individual can be directly instrumental in the creation of meaning and enhanced experience.

These combined artistic practices and aesthetic theories show the intimate relationship that exists between the three notions of artificial intelligence, simulation and interactivity, while at the same time adding a new chapter to the long-standing relationship between man and the machine.

Conclusion

The foregoing chapters have sought to give an overview of the different components that make up the art of our technological age. While it has obviously been impossible to cover in detail all the artists working in these areas, I hope I have succeeded in showing the extent of this art form in all its variety.

As to the relationship between technical and aesthetic factors in the different branches of technological art and the unifying factors that justify my use of the term, I have discussed the great range of individual artistic activity while at the same time isolating the main technical and aesthetic issues in each of the advanced technological art forms in question.

Thus it appears that the technical and aesthetic characteristics already present in Light Art have found their sequel and development in Laser and Holographic Art.

The preoccupation in experimental film with time and space and its critical attitude towards mainstream media have been followed up in Video Art.

The double origin of Computer Art has been identified in calculated, programmed art and Conceptual Art. The role of the computer in art goes beyond its function as a tool or as a medium; it operates rather as a purveyor of information and as an intellectual instrument to reach the multisensorial space of 'virtual realities'.

The progression from participatory art to the different communication arts allowed, in many cases, full interactivity between the numerous categories of people involved in this process.

A few artists, inspired by either the natural elements or their scientific interpretation, have clearly shown the link between the technical and aesthetic premises that underlay the environmental art of the '60s and '70s, and the ecological concerns of technological art.

As to the technical, and particularly aesthetic, factors that allow us to speak in general of a technological art, it would be foolish to pretend that all the works comprising this art category possess a single, unified, common factor or display a common style in which the

forms are identical or even comparable. It seems clear, however, that on a creative level there are many characteristics which allow the grouping together of a number of diverse art works. Notable among these are interaction and interactivity, multisensoriality, the creative process itself; and in addition a concern with the temporal and spatial dimensions as well as emotional and mental states.

Among the types of participation and interactivity used or advocated by technological artists are two-way communication and exchange between people (both artists and spectators) and machines. The artist aims for an expansion of communication possibilities, to stimulate new relationships between people in the creative process and an interaction between people that creates meaning and thus a culture. Interaction is considered as an international and transnational phenomenon involving many types of cultural commitments that can create networks of human relationship without discrimination. The principal aim is an interactivity instigated by the artist that allows creative communication, one which employs constructive, critical and innovative attitudes. In enabling new types of social interactions, technological art can also claim to represent most effectively the changes that are occurring in our social fabric with all their contradictions.

A common aesthetic factor in technological art regarding the visual and the multisensorial is the new way human perception can be stimulated by creating the conditions in which the metamorphosis of form and colour, the immateriality of objects, the paradox of image and reality in illusionism and, above all, the unseen aspects of our universe can become perceptible. This is the area of 'virtual reality', in which important developments can be expected, particularly through the possibilities of acting on the images of 'virtual' objects or creating a human 'interface' through 'dataware' that makes perceptible, visually or otherwise, the movements and positions of parts of one's own body and that of others in 'cyberspace'. The artistic exploitation of these new perceptual, cognitive and interactive possibilities has only just begun.

It is the process of artistic creation and aesthetic exploration that concerns technological artists more than the production of finite works of art. They want to create new, open-ended works with new materials by manipulating a model or in some cases by creating an event rather than a material form or oeuvre.

The temporal and spatial dimensions play a decisive role in most technological works of art, often being related to scientific discoveries that are consciously or sometimes unconsciously incorporated by the artists in their works. They are seeking to create alternative ways of being aware of time, of its immediacy and its duration, by using the possibilities of feedback and time lag, and of space by stimulating spatial imagination and awareness. In some works, floating in space or an infinite, constantly moving space is evoked, in others physically distinct places are united, a new spatial sensibility is sought through the artistic use of outer space or by creating a space without walls. A unity between natural and man-made environments is the aim of many works in which the interface between science, technology and nature is directed to produce the 'ecologization' of technology.

A special effort has been made by technological artists to create new emotional conditions in the spectator through performances which use experimental psychology in order to stimulate the mental faculties. Technological artists approach technology as a tool not only of the hand but also of the mind, one which can change our mental processes and enhance our sensibilities.

Among these new emotional conditions are a feeling of expansiveness and, at the other end of the scale, an awareness of the psychological and physical limits in extreme situations; the experience of electronics diverted from exactitude and definition towards imaginative exploration; and the response to thoughts, feelings and actions extended across the expanded distances that can be reached by technology.

The attempts by technological artists to intervene aesthetically in the functioning of the mind include those that seek to provoke and elevate it, raise conscious-

ness, reinforce intuitive knowledge by conceptual processes, make mental imagery evolve – as well as simulating memory, reasoning and other thought processes. In general, by investing the art of thinking with a creative multisensorial dimension, these artists are trying to promote the imaginative aspects of human intelligence and to transcend the opposition of mind and machine through an artistic act. Since these artists are working primarily with abstract information and not with concrete materials, they hope to give direct mental and sensorial access to the sources and processes of creative activity.

However, the artistic characteristics of technological art that predominate are those of implicating the spectator in a very special way, either by the visual qualities of the work, by its appeal to multisensoriality (as in the case of works involving 'virtual reality'), or by other means of involving the spectator on a physical interactive level.

Questions about the place of technological art in the contemporary art scene must address not only its material characteristics but also its relation to the debate over the issue of Modernism and Postmodernism. According to such theorists as Charles Jencks, Ihab Hassan and others,[1] Postmodernism eclectically combines a plurality of preceding artistic styles, it revives history and tradition as well as ornament and decoration. Complexity, contradiction and ambiguity are favoured over simplicity, purity and rationality; and a mixture of high and low culture, fine art and commercial styles, is encouraged. Multi-layered readings are both permitted and encouraged, and an appeal is made to audiences at different levels of knowledge and sophistication. Postmodernists are concerned with *meaning* – that is, they treat art, architecture and design as 'languages' which can be used to construct all kinds of different statements.

The same theorists describe Modernism as a purist rejection of both stylistic anarchism and historical tradition. Decoration and ornamentation are dismissed as superficial in favour of simplicity, clarity, uniformity, purity, order and rationality. Modernism attempts to establish a radically new art for a world in which improved human behaviour will be realized. It rejects national, regional and vernacular styles in favour of an international style.

Charles Jencks has introduced into this opposition the notion of Late Modernism: a purely stylistic option in favour of experimentalism in the arts with the aid of what he calls ultra-technology. Yet Jencks fully assumes the paradoxical dualism which the hybrid name of Postmodernism entails – continuation of Modernism and its transcendence.

Can technological art be assimilated to any of these three categorizations? At first sight it seems to participate to some extent in certain of the characteristics of all three. For example, it exhibits Postmodernist pluralism, multi-layered readings and preoccupation with language, although it prefers a mathematical language. On the other hand, it exhibits the Modernist preoccupation with rationality, innovation and originality.

As for Late Modernism, if this is at all a valid concept, technological art clearly displays its predilection for an intense experimentation with and testing of technological processes with a view to obtaining new aesthetic results.

Although technological art is clearly the art form most representative of our Electronic Age, its full implications lie in the future. The artists have in common a preoccupation with exploiting a vast spectrum of aesthetic categories in their work with the various advanced technologies. At the same time, what separates them from the previous generation of artists also working with technological factors (and in some cases from their own previous research) is their awareness of the extent of social and cultural change produced by the latest technological developments. In the 1980s and early '90s these artists have been trying to bring about a significant relationship between basic human experiences – physical, psychological and mental – and the radical and global intrusion into them of the new technologies, in all walks of life, with all the beneficial effects, potential hazards and immense possibilities they offer.

Notes and References

CHAPTER 1

1 Douglas DAVIS, *Art and the Future*, New York 1973, pp. 16–17.
2 Frank POPPER, 'Aux confins de l'art', *L'année 1913*, L. Brion-Guerry (ed.), vol. 1, Paris 1971, pp. 375–94.
3 Giacomo BALLA and Fortunato DEPERO, 'Manifesto: Ricostruzione futurista dell'Universo', 1915, published in Teresa FIORI and Maria DRUDI GAMBILLO, *Archivi del Futurismo*, vol. 1, Rome 1962, pp. 49–51.
4 Frank POPPER, *Origins and Development of Kinetic Art*, London/Greenwich, Connecticut, 1968.
5 Frank POPPER, Exhibition catalogue, *Kunst–Licht–Kunst*, Stedelijk Van Abbemuseum, Eindhoven 1966.
6 Marc PIEMONTESE (ed.), Exhibition catalogue, *Les Artistes et la lumière*, Rheims 1991.
7 Aude BODET, 'Néon. De l'Electricité dans l'art', *Beaux-Arts*, no. 8 (Paris, Dec. 1983), pp. 52–57.
8 Pontus HULTEN, Exhibition catalogue, *The Machine as Seen at the End of the Mechanical Age*, New York 1968.
9 Exhibition catalogue, *The 42nd Biennale of Venice*, 1986, p. 204 (Italian ed.).
10 Chapter VI below.
11 Margot LOVEJOY, 'Art, Technology and Postmodernism: Paradigms, Parallels, and Paradoxes', *Art Journal* (New York, Fall 1990), pp. 257 ff.
12 Terry GIPS, 'Computers and Art', *ibid.*, p. 231.
13 Terry GIPS, *ibid.*, p. 232.
14 Georges LEGRADY, 'Image, Language, and Belief in Synthesis', *ibid.*, pp. 266 ff.
15 Frank POPPER, *Art: Action and Participation*, London/New York 1975.
16 Christine TAMBLYN, 'Computer Art as Conceptual Art', *Art Journal* (Fall 1990), pp. 253 ff.

CHAPTER 2

1 Pierre RESTANY, *Dani KARAVAN: L'axe majeur de Cergy-Pontoise*, Cergy-Pontoise 1987.
2 Peter ZEC, 'The Aesthetic Message of Holography', *Leonardo*, vol. 22, nos. 3/4 (1989), pp. 425–30; and Peter ZEC, *Holographie: Geschichte, Technik, Kunst*, Cologne 1987.
3 Margaret BENYON, 'Cosmetic Series 1986–1987: A Personal Account', *Leonardo*, vol. 22, nos. 3/4 (1989), pp. 307–12; cf. also M. BENYON, 'Holography as an Art Medium', *Leonardo*, vol. 6, nos. 1, 1–9 (1973), and 'On the Second Decade of Holography As Art and My Recent Holograms', *Leonardo*, vol. 15, no. 2 (1982), pp. 89–95.
4 Harriet CASDIN-SILVER, 'My First Ten Years as an Artist-Holographer (1968–1977)', *Leonardo*, vol. 22, nos. 3/4 (1989), p. 317.
5 The full text of the poem by Hans Magnus Enzensberger for Dieter Jung's holographic installations reads as follows:

> It is easy to build
> a poem in the air
> All you need
> are a few well-lit words
> light-footed
> light-fingered
> light-minded words
>
> and your breath is enough
> to make them soar
> and to keep them poised
> transparently
> hanging in the balance
> floating in mid-air
> hovering
> between me and death
>
> A few words
> lighter than air
> will do
> and the lights go out
> and they sink
> slowly
> on the dark face
> of the earth
>
> Never mind
>
> It is easy to build.

6 Dieter JUNG, 'Holographic Space: A Historical View and Some Personal Experiences', *Leonardo*, vol. 22, nos. 3/4 (1989), pp. 331–36.

7 Cf. Kevin MURRAY'S essay in *Perspecta*, an exhibition catalogue which quotes Heidegger's *Question Concerning Technology*, New York 1977.

8 'Eidola' refers to the belief of Greek atomists that the visible world is produced by effluxes from the objects.

9 Paula DAWSON, Paper presented at the International Symposium on Display Holography, Lake Forest College, Illinois. Cf. also Richard D. RALLISON, 'Artists of Holography against Great Odds', *Leonardo*, vol. 22, nos. 3/4 (1989), pp. 341–42.

10 Interview with the artists in Paris on 18 Mar. 1991.

11 Exhibition catalogue, *Images du futur*, Montreal 1988, p. 67; and Rudie BERKHOUT, 'Holography: Exploring a New Art Realm: Shaping Empty Space with Light', *Leonardo*, vol. 22, nos. 3/4 (1989), pp. 313–16.

12 Hervé FISCHER in Exhibition catalogue, *Georges DYENS, Big Bang* II, New York 1988.

13 Exhibition catalogue, *Les artistes et la lumière*, Rheims 1991, p. 42.

14 Ans Van BERKUM and Tom BLEKKENHORST, *Science and Art*, Utrecht 1990, p. 62.

15 Brigitte BURGMER, 'Studies on Holographic Anamorphoses: 500 Years After', *Leonardo*, vol. 22, nos. 3/4 (1989), pp. 379–82.

16 Brigitte BURGMER, *Holographic Art-Perception, Evolution, Future*, La Coruña 1987.

17 Philippe BOISSONNET, 'Holography and the Imaginary Double. The Image of the Body', *Leonardo*, vol. 22, nos. 3/4 (1989), pp. 375–78.

18 Exhibition catalogue, *Dédales 84*, La Chartreuse, Villeneuve-les-Avignon 1984, vol. 2, p. 11.

19 Doris VILA, 'Chasing Rainbows: One Holographer's Approach', *Leonardo*, vol. 22, nos. 3/4 (1989), pp. 345–48.

20 Lóránd HEGYI, Foreword to Exhibition catalogue, *Attila Csaji*, Budapest-Mücsarnok 1989 (unpaginated).

21 Frank POPPER, Exhibition catalogue, *Electra*, Paris 1983, pp. 330–31.

CHAPTER 3

1 Pierre RESTANY, 'Catherine Ikam, le grand jeu de la vidéo', Exhibition catalogue, *Catherine Ikam*, Chapelle des Jésuites, Nîmes 1991.

2 Hermine FREED, 'Time of Time', *Arts Magazine* (June 1975); Hermine FREED, 'Where do we come from? Where are we? Where are we going?', in Beryl KOROT and Ira SCHNEIDER (eds), *Video Art: An Anthology*, New York 1976, pp. 210–13.

3 Bruce KURTZ, 'The Present Tense', in KOROT and SCHNEIDER, *op.cit.*, pp. 234 ff.

4 Vittorio FAGONE, 'Video as Visual Art. History and Perspectives', Exhibition catalogue, *Artec 89*, Nagoya 1989, pp. 125–33; and Vittorio FAGONE, *L'immagine video*, Milan 1990.

5 Ann-Sargent WOOSTER, 'Why Don't They Tell Stories Like They Used To?', *Art Journal* (Fall 1985), pp. 204–12.

6 Lucinda FURLONG, 'Tracking Video Art: Image Processing as a Genre', *ibid.*, pp. 236–37.

7 Bettina GRUBER and Maria VEDDER, *Kunst und Video*, Cologne 1983, p. 101.

8 *Artur Matuck*, Exhibition catalogue, Itaugaleria, São Paulo 1990.

9 Benjamin BUCHLOH, 'From Gadget Video to Agit Video', *Art Journal* (Fall 1985), pp. 219–21.

10 Jalal AL-DIN RUMI, *Teachings of Rumi*, New York 1975.

11 Bill VIOLA'S statement 'Program Notes', Whitney Museum of American Art, New York 1982, quoted by Ann-Sargent WOOSTER, n. 5 above.

12 Douglas DAVIS, 'Video in the Mid-Seventies', in KOROT and SCHNEIDER, n. 3 above, pp. 196–99.

13 Wulf HERZOGENRATH and Edith DECKER, *Video Skulptur*, Cologne 1989, pp. 102–05.

14 Catherine MILLET, 'Interview with Michel Jaffrenou', *Art Press*, Special Number 'New Technologies' (1991), pp. 23–26.

15 For most of the preceding analyses of the work of video artists I am indebted to HERZOGENRATH and DECKER, *op.cit.*, and to GRUBER and VEDDER, *Kunst und Video*, *op.cit.*

16 Peter WEIBEL, in Exhibition catalogue, *ARS ELECTRONICA*, Linz 1988.

17 Dominique BELLOIR, 'The Miracle Screen', *Media Art Festival*, Exhibition catalogue, Osnabrück 1988, pp. 231–32.

18 Anne-Marie DUGUET, *ibid.*, p. 242.

19 Jean-Paul FARGIER, *ibid.*, pp. 238–39.

20 Benjamin BUCHLOH, *op.cit.*, pp. 219–21, and Sara HORNBACHER, 'Video: the Reflexive Medium', *Art Journal* (Fall 1985), p. 191.

21 Katherine DIECKMANN, 'Electra Myths: Video, Modernism, Postmodernism', *ibid.*, p. 199.

22 Deirdre BOYLE, 'Subject to Change: Guerrilla Television Revisited', *ibid.*, pp. 228–32. Cf. also Barbara LONDON, 'Independent Video', *Artforum* (September 1980), pp. 39–40 and 'Video: A Selected Chronology 1963–1983', *Art Journal* (Fall 1985), pp. 249 ff.

CHAPTER 4

1 Cynthia GOODMAN, *Digital Visions*, New York 1987, p. 70.

2 *ibid.*, p. 103.

3 Donald MICHIE and Rory JOHNSON, *The Creative Computer*, Harmondsworth 1984.

4 C. GOODMAN, *op.cit.*, pp. 59–61.

5 *Ibid.*, p. 59.

6 Margot LOVEJOY, *Postmodernist Currents: Art and Artists in the Age of Electronic Media*, Ann Arbor, Michigan, 1989.

7 John PEARSON, 'The Computer: Liberator or Jailer of the Creative Spirit?', *Leonardo*, Electronic Art Supplemental Issue (1988), pp. 73 ff.

8 Lillian F. SCHWARTZ, 'The Staging of Leonardo's *Last Supper*: A Computer-based exploration of its perspective', *ibid.*, pp. 89 ff.

9 *Art Show (Installation artistique) PIXIM 88*, Exhibition catalogue, Grande Halle de la Villette, Paris 1988, sector 19.

10 Jean-Louis BOISSIER, 'Artifices:

invention, simulation', *Artifices*, Exhibition catalogue, Saint-Denis 1990, pp. 6–7.

11 *OENOLOGY: MIGUEL CHEVALIER*, Exhibition catalogue, Château Pichon, Longueville 1991.

12 *INTERCONNECTIONS*, Exhibition catalogue, Levallois-Perret 1990.

13 *ART SHOW (Installation artistique) PIXIM 88*, *op.cit.*, Sector 13.

14 *ARTIFICES*, *op.cit.*, p. 16.

15 *ART SHOW (Installation artistique) PIXIM 88*, *op.cit.*, Sector 24.

16 *ARTIFICES*, *op.cit.*, p. 18.

17 *Ibid.*, p. 36.

18 Michel BRET, 'Procedural Art with Computer Graphics Technology', *Leonardo*, vol. 21, no. 1 (1988), pp. 3–9.

19 *ART SHOW (Installation artistique) PIXIM 88*, *op.cit.*, Sector 26.

20 Richard W. GASSEN, in Exhibition catalogue, *Manfred Mohr: Algorithmic Works 1967–1987*, Wilhelm Hack Museum, Ludwigshafen 1987, pp. 15–16.

21 Reproduced in Exhibition catalogue, *Images du Futur '89*, Montreal 1989, p. 74.

22 Nadia MAGNENAT-THALMANN, 'The Making of a Film with Synthetic Actors', *Leonardo*, Electronic Art Supplemental Issue (1988), pp. 55–62.

23 Brian REFFIN SMITH, 'Beyond Computer Art', *Leonardo*, Computer Art in Context, Supplemental Issue (1989), pp. 39 ff.

24 Exhibition catalogue, *CNN, Cable News Nature: Philippe Jeantet*, Carré des Arts, Parc Floral, Vincennes 1991.

25 *ARTIFICES*, *op.cit.*, p. 22.

26 *Ibid.*, p. 44.

27 *Ibid.*, p. 24.

28 Christine TAMBLYN, 'Computer Art as Conceptual Art', *Art Journal* (Fall 1990), pp. 253 ff.

29 *Images du Futur '89*, *op.cit.*, p.43.

30 *Ibid.*, p. 42.

31 Stephen WILSON, 'Interactive Art and Cultural Change', *Leonardo*, vol 23, nos. 2–3 (1990), pp. 255–62.

32 Stephen WILSON, *Multimedia Design with Hyper Card*, Englewood Cliffs, N.J., 1991.

33 *ARTIFICES*, *op.cit.*, p. 38.

34 *Ibid.*, p. 40.

35 Christine BERGÉ, 'Machines à rêve, Le "Bon Robot" de Gilles Roussi', *Europe* (May 1987).

36 Hannes LEOPOLDSEDER (ed.), *Der Prix Ars electronica*, Linz 1990, p. 181.

37 Theodore ROSZAK, *The Cult of Information: the folklore of computers and the true art of thinking*, New York 1986.

38 Timothy BINKLEY, 'The Wizard of Ethereal Pictures and Virtual Places', *Leonardo*, Computer Art in Context, Supplemental Issue (1989), p. 19.

39 Timothy BINKLEY, 'The Quickening of Galatea: Virtual Creation without Tools or Media', *Art Journal* (Fall 1990), pp. 233–40.

40 Michel BRET, cf. n. 18 above.

41 Roy ASCOTT, 'On Networking', *Leonardo*, vol. 21, no. 3 (1988), p. 231.

CHAPTER 5

1 Leaflet accompanying the exhibition *Communication Machines*, Cité des Sciences et de l'Industrie, La Villette, Paris, 1991/92.

2 Roy ASCOTT, 'Gesamtdatenwerk, Konnektivität, Transformation und Transzendenz', *Kunstforum* (Cologne, September/October 1989), vol. 103, pp. 100–09.

3 Mario COSTA, 'Technology, Artistic Production and the Aesthetics of Communication', *Leonardo*, vol. 24, no. 2, (1991), pp. 123–26.

4 *Les Transinteractifs, Actes du colloque, 4–5 Nov. 1988 au Centre Culturel Canadien*, Paris, Espace SNVB International, 1990.

5 Derrick de KERCKHOVE, 'Communication Arts for a New Spatial Sensibility', *Leonardo*, vol. 24, no. 2 (1991), pp. 131 ff.

6 *Artmedia: Rassegna Internazionale d'Estetica del Video e della Communicazione*, Salerno, May 1985.

7 Fred FOREST, 'L'esthétique de la communication', *Les Transinteractifs*, *op.cit.*, p. 91.

8 Christian SEVETTE, 'Histoire de l'art/ Translation du Corps. Figuration interactive', *ibid.*, pp. 115 ff.

9 Jean-Marc PHILIPPE, 'Space Art: A Call for a Space Art Ethics Committee', *Leonardo*, vol. 23, no. 1 (1990), pp. 129–32.

10 Cf. Exhibition catalogue, *L'Europe des Créateurs, Utopies 89*, Paris 1989, pp. 142–43.

11 Mit MITROPOULOS, 'A Sequence of Video-to-Video Installations Illustrating the Together/Separate Principle, with Reference to Two-Way Interactive Cable TV Systems', *Leonardo*, vol. 24, no. 2 (1991), pp. 207–11.

12 Stéphan BARRON, 'Lines. A Project by Stéphan Barron and Sylvia Hansmann', *Leonardo*, vol. 24, no. 2 (1991), pp. 185–86.

13 Eric GIDNEY, 'Art and Telecommunication – 10 Years On', *Leonardo*, vol 24, no. 2 (1991), pp. 147–52.

14 Exhibition catalogue, *42nd Biennale of Venice*, 1986, p. 199 (Italian ed.).

15 Robert ADRIAN X, 'Elektronischer Raum', *Kunstforum*, no. 103, Special Number 'Im Netz der Systeme' (Sep.–Oct. 1989), pp. 142–47.

16 Karen O'ROURKE, 'City Portraits: An Experience in the Interactive Transmission of Imagination', *Leonardo*, vol. 24, no. 2 (1991), pp. 215–20.

17 James CLIFFORD, 'The transit lounge of culture', *The Times Literary Supplement* (London, 3 May 1991), pp. 7–8.

18 Karen O'ROURKE, 'Notes on Fax Art', *New Observations*, no. 76 (15 May–30 Jun. 1990), pp. 24–25.

19 Jean-Louis BOISSIER, 'Machines à communiquer faites oeuvres', in Lucien SFEZ (ed.), *Qu'est-ce la communication?*, Paris 1991.

20 Cf. Gene YOUNGBLOOD, 'Virtual Space: The Electronic Environments of Mobile Image', Exhibition catalogue, *Electronic Café*, Los Angeles, Museum of Contemporary Art, 1984; and Eric GIDNEY, *op.cit.*, n. 13 above.

21 Eric GIDNEY, 'The artist's use of telecommunication', *Art and Telecommunication*, Vienna and Vancouver 1984, p. 9.

22 Carl Eugene LOEFFLER and Roy ASCOTT, 'Chronology and Working Survey of Select Telecommunications

Activity', *Leonardo*, vol. 24. no. 2 (1991), pp. 236–40.

23 Carl Eugene LOEFFLER, 'Modem dialling out', *ibid.*, pp. 113–14.

CHAPTER 6

1 Todd SILER, *Breaking the Mind Barrier*, New York 1990.

2 Shawn A. BRIXEY and Laura KNOTT, *Aqua Echo*, unpublished manuscript (1987), quoted in Jürgen CLAUS, 'The Cosmic Code and the Digital Code', *Leonardo*, vol. 24, no. 2, (1991), p. 121.

3 Cf. *Sky Art Conference* catalogue, M.I.T., Cambridge, Mass., 1981.

4 Cf. *Electra, op.cit.*, p. 298.

5 Jürgen CLAUS, 'The Expert System Artist', Report for the XXII AICA Congress, 'Art and Technoculture at the End of the Post-Modern', Buenos Aires 1988.

6 Otto PIENE, with Robert RUSSETT, 'Sky, Scale and Technology in Art', *Leonardo*, vol. 19, no. 3 (1986), pp. 193 ff.

7 In *Art Letter* of the Art Department, California State University (Chico 1991), p. 2.

8 Anne TRONCHE, Preface to Exhibition catalogue, *Piero Gilardi*, Galerie di Meo (Paris) and Galleria Rocca 6 (Turin), 1991.

9 *Chris Burden, A Twenty Years Survey*, Exhibition catalogue, Newport Harbor Art Museum, Newport Beach, California, 1988.

10 Lucy LIPPARD, *Overlay: Contemporary Art and the Art of Prehistory*, New York 1983.

11 John Beardsley, *Earthworks and Beyond: Contemporary Art with Landscape*, New York 1984.

12 James TURRELL, *Long Green*, Zürich 1990, p. 124.

CHAPTER 7

1 Exhibition catalogue, *Ars Electronica*, 1984, p. 12.

2 *Kunstforum*, no. 103 (Sep.–Oct. 1989).

3 Randall A. STICKROD, 'Multimedia, Virtual Reality and all that Babble', *Leonardo*, vol. 24, no. 1 (1991), p. 3.

4 Cf. also Myron W. KRUEGER, 'Videoplace: A Report from the Artificial Reality Laboratory', *Leonardo*, vol. 18, no. 3 (1985); Stephen R. ELLIS, 'Pictorial Communication: Pictures and the Synthetic Universe', *Leonardo*, vol. 23, no. 1 (1990); Myron W. KRUEGER, *Artificial Reality II*, Reading (Mass.) 1991; Howard RHEINGOLD, *Virtual Reality*, New York 1991.

5 *Leonardo*, 672 S. Van Ness Ave., San Francisco, CA 94110, U.S.A.

6 Otto PIENE, 'Such Growth', *KANAL guide: International Directory of Electronic Arts: Art and Technology*, Paris 1990–91, pp. 8 ff.

7 Roy ASCOTT, 'The Art of Intelligent Systems', Exhibition catalogue *Ars Electronica*, Linz 1991.

8 Stephen WILSON, 'Interactive Art and Cultural Change', *Leonardo*, vol. 23, nos. 2–3 (1990), pp. 255 ff.

9 Roy ASCOTT, 'The Art of Intelligent Systems', *loc.cit.*

10 *Kunstforum*, cf. n. 2 above.

11 *Vers une culture de l'interactivité?*, Cité des Sciences et de l'industrie, La Villette, published by Espace SNVB International, Paris 1989.

12 Marie-Hélène TRAMUS, *Dispositifs interactifs d'images de synthèse*, unpublished dissertation, University of Paris VIII, 1990.

13 Jean BAUDRILLARD, *Simulacres et Simulation*, Paris 1981.

14 Philippe QUÉAU, *Éloge de la simulation: de la vie des langages à la synthèse des images*, Seyssel 1986.

15 Florian RÖTZER, at the Symposium on Cyberspace, Munich, Apr. 1991.

16 Jean-François COLONNA *et al.*, 'Les Premiers Pas de L'Image Intelligente', *La Recherche*, no. 196 (Feb. 1988), pp. 254–56.

17 O.J. FLANAGAN, *The Science of Mind*, Cambridge (Mass.) 1984; G. BUGLARIELLO, 'Hyperintelligence – the next evolutionary step', *The Futurist*, (Bethesda, Md., Dec. 1984); Karl R. POPPER and J.C. ECCLES, *The Self and the Brain*, New York/Berlin 1977; Karl. H. PRIBRAM, *Languages of the Brain*, Monterey (CA) 1977; all quoted in Richard KRIESCHE (ed.), *Artificial Intelligence in the Arts*, no. 1, 'Brainwork', Exhibition Catalogue, *Steirischer Herbst*, Graz/Los Angeles 1985.

18 Stephen WILSON, 'Computer Art: Artificial Intelligence and the Arts', *Leonardo*, vol. 16, no. 1 (1983), pp. 15–20.

CONCLUSION

1 Charles JENCKS, *The Language of Post-Modern Architecture*, London 1977; *What is Post-Modernism?*, London 1986; Ihab & Sally HASSAN (eds.), *Innovation – renovation: New perspectives on the humanities*, Madison (Wisc.) 1983; Jean-François LYOTARD, *La Condition postmoderne*, Paris 1979; John A. WALKER, *Art in the Age of Mass Media*, London 1983.

Bibliography

Ars Electronica, exhibition catalogues, Linz 1979–1991

ARTCOM Paris 86: Rencontres et performances sur l'esthétique de la communication, Ecole Nationale Supérieure des Beaux-Arts, Paris January 1986

ARTEC 89 and *ARTEC 91*, exhibition catalogues, First and Second Biennales in Nagoya, Japan, 1989, 1991

Art Journal, special numbers: vol. 45, no. 3, *Video: the reflexive Medium* (Fall 1985); vol. 49, no. 3, *Computers and Art: Issues of Content* (Fall 1990)

Art Press (Paris), special numbers: no. 122, *Communications* (Feb. 1988); *Nouvelles technologies* (1991)

Arveiller, Jacques, 'Art et informatique', *Encyclopaedia Universalis*, Corpus vol. 12 (Paris 1989), pp. 326–30

Ascott, Roy, 'Connectivity: Art and Interactive Telecommunications', *Leonardo*, vol. 24, no. 2 (Oxford 1991), pp. 115–18

Ascott, Roy, 'On Networking', *Leonardo*, vol. 21, no. 3 (Oxford 1988)

Bailly, Jean-Christophe, *Piotr Kowalski*, Paris 1988

Battcock, Gregory (ed.), *New Artists Video*, New York 1978

Baudrillard, Jean, *Simulacres et simulation*, Paris 1981

Beardsley, John, *Earthworks and Beyond: Contemporary Art with Landscape*, New York 1984

Beaune, Jean-Claude, *L'automate et ses mobiles*, Paris 1980

Belloir, Dominique, *Video Art Explorations*, Cahiers du Cinéma, hors-série 10, Paris 1981

Benedict, Michael, *Cyberspace*, Cambridge, MA 1990

Bense, Max *et al.*, *Kunst aus dem Komputer*, Stuttgart 1967

Benthall, Jonathan, *Science and Technology in Art Today*, London 1972

Benyon, Margaret, 'Holography as an Art Medium', *Leonardo*, vol. 6, no. 1 (1973)

Benyon, Margaret, 'On the Second Decade of Holography as Art and My Recent Holograms', *Leonardo*, vol. 15, no. 2 (1982), pp. 89–95

Berger, René, *Art et communication*, Tournai 1972

Berger, René and Eby, Lloyd (eds.), *Art and Technology*, New York 1986

Berkum, Ans van and Blekkenhorst, Tom, *Science and Art*, Utrecht (The Fentener van Vlissingen Fund) 1986

Bihalji-Merin, Oto, *La Fin de l'art à l'ère de la science?*, Brussels 1970

Bloch, Dany, *L'art vidéo*, Condé-sur-Noireau 1983

Bloch, Dany, *L'art vidéo 1960–1980/82*, Locarno 1982

Boden, Margaret, *Artificial Intelligence and Natural Man*, New York 1977

Boissier, Jean-Louis (ed.), *Artifices. Art à l'ordinateur: invention, simulation*, exhibition catalogue, Saint-Denis 1990

Boissier, Jean-Louis, 'Machines à communiquer faites oeuvres', in Sfez, Lucien (ed.), *Qu'est-ce la communication?*, Paris 1991

Boissier, Jean Louis, *PIXIM*, exhibition catalogue, Paris 1988

Brand, Stewart, *The Media Lab: Inventing the Future*, New York 1987

Brett, Guy, *Kinetic Art*, London/New York 1968

Bureaud, Annick, *International Directory of Electronic Arts; Art and Technology*, Paris 1990–91

Burnham, Jack, *Beyond Modern Sculpture: The Effects of Science and Technology on the Sculpture of This Century*, New York 1968

Burnham, Jack, *Software, Information Technology. Its New Meaning for Art*, exhibition catalogue, New York 1970

Calvesi, Maurizio, *General Catalogue, XLII International Art Exhibition, The Biennale of Venice, Art and Science*, Milan 1986

Cauquelin, Anne *et al.*, *Paysages virtuels, image vidéo, image de synthèse*, Paris 1988

Claus, Jürgen, *Das elektronische Bauhaus. Gestaltung mit Umwelt*, Zürich 1987

Claus, Jürgen, *ChippppKunst. Computer, Holographie, Kybernetik, Laser*, Frankfurt/Berlin 1985

Claus, Jürgen, *Elektronisches Gestalten in Kunst und Design; Richtungen-Institutionen-Begriffe*, Reinbek-Hamburg 1991

Costa, Mario, *Artmedia*: Rassegna internazionale di estetica del video e della communicazione, Salerno 1985

Couchot, Edmond, *Images: De l'art optique au*

numérique, Paris 1988

Csuri, Charles, *Interactive Sound and Visual Systems*, exhibition catalogue, Columbus, Ohio, 1970

Davis, Douglas, *Art and the Future: A History/Prophecy of the Collaboration between Science, Technology and Art*, New York 1973

Decker, Edith, *Paik-Video*, Cologne 1988

Decker, Edith and Weibel, Peter, *Vom Verschwinden der Ferne, Telekommunikation und Kunst*, Cologne 1990

De Kerckhove, Derrick, *La Civilisation vidéo-chrétienne*, Paris 1990

De Kerckhove, Derrick, *Les Transinteractifs*, exhibition catalogue, Paris 1988

De Kerckhove, Derrick, and Sevette, Christian (eds.), *Les Transinteractifs*, symposium proceedings (1988), Paris 1990

Deken, Joseph, *Computer Images*, London 1983

Dertouzos, Michael L. and Moses, Joel, *The Computer Age: A Twenty-Year View*, Cambridge, Mass., 1979 (2nd edition 1980)

Duguet, Anne-Marie (ed.), *PLEIAS, Formation, Art, Images de Synthèse*, University of Paris I, 1988

Duguet, Anne-Marie, *Vidéo, La mémoire au poing*, Paris 1980

Eisenbeis, Manfred and Hagebölling, Heide (eds), *Synthesis – Die visuellen Künste in der elektronischen Kultur*, Symposium proceedings, Offenbach/Main 1989.

European Media Art Festival, exhibition catalogue, Osnabrück 1988

Fagone, Vittorio, *L'immagine video. Arti visuali e nuovi media elettronici*, Milan 1990

Fargier, Jean-Paul, *Nam June Paik*, Paris 1989

Faure, Claude, and Bacchetti, Antonia (eds.), *Vers une culture de l'interactivité?*, Paris 1989

Fernandez, Gaston, 'Art et science, pour quel destin?', *La Part de l'oeil*, v. 19–29

Fischer, Hervé and Major, Ginette, *Images du futur*, exhibition catalogue, Montreal 1986–91

Foresta, Don, *Mondes multiples*, Paris 1991

Franke, Herbert W., *Computer Art*, London/New York 1971

Franke, Herbert W. and Jäger, Gottfried, *Apparative Kunst: Vom Kaleidoskop zum Computer*, Cologne 1973

Freed, Hermine, 'Time of Time', *Arts Magazine*, Jun. 1975

Friedhoff, Richard Mark and Benzon, William, *Visualization: The Second Computer Revolution*, New York 1989

Galloway, David (ed.), *Artware: Kunst und Elektronik*, Hanover 1988

Goodman, Cynthia, *Digital Visions*, New York 1987

Graham, Dan, *Video-Architecture-Television: Writing on Video and Video Works*, New York/Nova Scotia 1979

Gruber, Bettina and Vedder, Maria, *Kunst und Video: Internationale Entwicklung und Künstler*, Cologne 1983

Grundmann, Heidi (ed.), *Art and Communication*, Vienna/Vancouver 1984

Hanhardt, John (ed.), *Nam June Paik*, exhibition catalogue, New York 1982

Herzogenrath, Wulf and Decker, Edith (eds.), *Video-Skulptur retrospektiv und aktuell: 1964–1989*, Cologne 1989

Holton, Gerald James, *The Scientific Imagination: Case Studies*, Cambridge 1978

Holton, Gerald James, *Thematic Origins of Scientific Thought: Kepler to Einstein*, Cambridge, MA, 1973

Hultén, K.G. Pontus, *The Machine as Seen at the End of the Mechanical Age*, exhibition catalogue, New York 1968

Kepes, Gyorgy, *New Landscape in Art and Science*, Chicago 1956

Klonaris, Maria and Thomadaki, Catherina (eds.), *Art, cinéma, vidéo, ordinateur*, Paris 1990

Korot, Beryl and Schneider, Ira (eds.), *Video Art: An Anthology*, New York 1976

Kostelanetz, Richard, *Metamorphosis in the Arts*, New York 1980

Kriesche, Richard *et al.*, *Artificial Intelligence in the Arts* ('Brainwork'), exhibition catalogue, Graz 1985

Kriesche, Richard (ed.), *Entgrenzte Grenzen*, exhibition catalogue, Graz 1987

Krueger, Myron W., *Artificial Reality*, Reading, MA 1983 (new edition, *Artificial Reality* II, 1991)

Kultermann, Udo, *The New Sculpture*, New York/London 1968

Kunstforum International, Special Numbers: 97, *Aesthetik des Immateriellen* (November-December 1988); 98, *Kunst und die neuen Technologien* (Jan.–Feb. 1989); 103, *Im Netz der Systeme* (Sep.–Oct. 1989)

Lassalle, Hélène, 'La Technologie dans l'art contemporain', *Encyclopaedia Universalis*, Universalia (1982), pp. 423–26

Leavitt, Ruth (ed.), *Artist and Computer*, New York 1976

Le Bot, Marc, *Peinture et machinisme*, Paris 1973

Leonardo (Oxford 1967–92), special numbers:
'Electronic Art', supplemental issue, 1988
'Computer Art in Context', supplemental issue, 1989
'Holography as an Art Medium', vol. 22, nos. 3–4 (1989)
'Connectivity: Art and Interactive Telecommunications', vol. 24, no. 2 (1991)

Lippard, Lucy, *Overlay: Contemporary Art and the Art of Prehistory*, New York 1983

London, Barbara, 'Independent Video', *Artforum* (Sep. 1980), pp. 39–40

Lovejoy, Margot, *Postmodern Currents: Art and Artists in the Age of Electronic Media*, Ann Arbor, Michigan, 1989

Lyotard, Jean-François and Chaput, Thierry, *Les Immatériaux*, exhibition catalogue (2 vols), Paris 1985

Magnenat-Thalmann, Nadia and Thalmann, Daniel, *Computer Animation: Theory and Practice*, New York 1985

Malina, Frank J. (ed.), *Kinetic Art, Theory and Practice* (selections from the journal *Leonardo*), New York 1974

Malina, Frank J. (ed.), *Visual Art, Mathematics and Computers* (selections from the journal *Leonardo*), Oxford/New York 1979

Mallary, Robert, 'Computer Sculpture', *Artforum* (New York, May 1969)

Mandelbrojt, Jacques, *Les Cheveux de la réalité*, Nice 1991

Mandelbrot, Benoît, *Les objets fractals: forme, hasard et dimension* (Paris 1975); revised edition 1989 with an added 'Survol du langage fractal'

McLuhan, Marshall, *Understanding Media; The Extensions of Man*, New York 1965

Michie, Donald and Johnston, Rory, *The Creative Computer: Machine Intelligence and Human Knowledge*, Harmondsworth 1984

Minsky, Marvin, *The Society of Mind*, New York 1985

Moholy-Nagy, Laszlo, *Vision in Motion*, Chicago 1947

Moles, Abraham A., *Art et ordinateur*, Paris 1971 (new ed. 1990)

Molnar, François (ed.), *L'ordinateur et les arts visuels*, Paris 1977

Nora, Simon and Minc, Alain, *L'informatisation de la société*, Paris 1978

Piemontese, Marc (ed.), *Les Artistes et la lumière*, exhibition catalogue, Rheims 1991

Piene, Otto with Russet, Robert, 'Sky, Scale and Technology in Art', *Leonardo*, vol. 19, no. 3 (1986), pp. 193–200

Polieri, Jacques, *Jeu(x) de communication*, Paris 1981

Popper, Frank, *Art – Action and Participation*, London/New York 1975

Popper, Frank, 'Aux confins de l'art', in Brion-Guerry, Liliane (ed.), *L'Année 1913*, Paris 1971, vol. 1, pp. 375–94

Popper, Frank, *Electra: Electricity and Electronics in the Art of the XXth Century*, exhibition catalogue, Paris 1983

Popper, Frank, *Kunst-Licht-Kunst*, exhibition catalogue, Eindhoven 1966

Popper, Frank, *Origins and Development of Kinetic Art*, London/Greenwich, Connecticut, 1968

Quéau, Philippe, *Eloge de la simulation. De la vie des langages à la synthèse des images*, Seyssel 1986

Quéau, Philippe, *Metaxu. Théorie de l'art intermédiaire*, Seyssel 1989.

Ramon, Jean-François and Colleony, Jacques, *Art – Sciences et techniques: quels liens nouveaux?*, Paris 1990

Reichardt, Jasia, *The Computer in Art*, London/New York 1970

Reichardt, Jasia (ed.), *Cybernetic Serendipity: The Computer and the Arts*, exhibition catalogue, London 1968

Restany, Pierre, *Catherine Ikam: Le grand jeu de la vidéo*, Paris 1991

Restany, Pierre, *Dani Karavan, L'axe majeure de Cergy-Pontoise*, Cergy-Pontoise 1987

Rheingold, Howard, *Virtual Reality*, New York 1991

Rickey, George, *Constructivism: Origin and Evolution*, New York 1968

Rötzer, Florian (ed.), 'Aesthetik des Immateriellen', *Kunstforum*, vol. 97 (Nov.–Dec. 1988)

Rötzer, Florian (ed.), *Digitaler Schein: Aesthetik der elektronischen Medien*, Frankfurt-am-Main 1991

Rötzer, Florian (ed.), 'Kunst und die neuen Technologien', *Kunstforum*, vol. 98 (Jan.–Feb. 1989)

Sculpture (Washington, D.C.), Special issue, 'Art and Technology', vol. 10, no. 3, May–Jun. 1991

Sfez, Lucien (ed.), *Qu'est-ce la communication?*, Paris 1991

Shamberg, Michael, *Guerrilla Television*, New York 1971

Siggraph, exhibition catalogues, New York 1982–91

Siler, Todd, *Breaking the Mind Barrier: The Artscience of Neurocosmology*, New York 1990

Siler, Todd, 'Neurocosmology: Ideas and Images towards an Art-Science-Technology Synthesis', *Leonardo*, vol. 18, no. 1 (1985), pp. 1–10

Théophilakis, Elie (ed.), *Modernes et après? 'Les Immatériaux'*, Paris 1985

Thom, René, *Modèles mathématiques de la morphogénèse*, Paris 1971

Thom, René, *Paraboles et catastrophes*, Paris 1983 (2nd ed. 1989)

Tramus, Marie-Hélène, *Dispositifs interactifs d'images de synthèse*, unpublished dissertation, University of Paris VIII, 1990

Truckenbrod, Joan, *Creative Computer Imaging*, Englewood Cliffs, N.J., 1988

Tuchman, Maurice, *A & T, a report on the art and technology program of the Los Angeles County Museum of Art, 1967–1971*, Los Angeles 1971

Turkle, Sherry, *The Second Self: Computers and the Human Spirit*, London/New York 1984

Urbons, Klaus, *Copy Art*, Cologne 1991

Virilio, Paul, *La Machine de vision*, Paris 1988

Virilio, Paul, *L'espace critique*, Paris 1984

Weibel, Peter, *Die Beschleunigung der Bilder*, Bern 1987

Weibel, Peter, 'Zur Geschichte und Aesthetik der digitalen Kunst', in exhibition catalogue *Ars electronica*, Linz 1984

Wick, Rainer, *Zur Soziologie intermediärer Kunstpraxis: Happening, Fluxus, Aktionen*, Doctoral dissertation, University of Cologne 1975

Wiener, Norbert, *Cybernetics, or Control and Communication in the Animal and the Machine*, New York 1948 (2nd ed. Cambridge, MA, 1962)

Wiener, Norbert, *The Human Use of Human Beings, Cybernetics and Society*, London 1950

Wilson, Stephen, *Multimedia Design with Hyper Card*, Englewood Cliffs, N.J., 1991

Wilson, Stephen, *Using Computers to Create Art*, Englewood Cliffs, N.J., 1986

Winston, P.H., *Artificial Intelligence*, Reading, MA, 1977

Youngblood, Gene, *Expanded Cinema*, New York 1970

Zajec, Edward, 'Orphics: Computer Graphics and the Shaping of Time with Color', *Leonardo*, supplemental issue: Electronic Art (1986), pp. 111–16

Zec, Peter, *Holographie: Geschichte, Technik, Kunst*, Cologne 1987

Acknowledgments

I should like to express, first of all, my heartfelt thanks to Stanley Baron of Thames and Hudson, who has assisted me with great competence and enthusiasm at all stages of the production of this book. Special thanks are also due to Bernard Hemingway for obtaining a readable version of the manuscript and to Stephen Bann for his comments on it. Maggi Smith, of Thames and Hudson, also merits my thanks for the imaginative way she devised the layout of the book.

It is impossible to acknowledge individually all the precious help given to me by artists, colleagues and institutions throughout the world. However, I would like to show my particular gratitude for the supply of good and most useful documents and for stimulating exchanges of ideas to Roger and Marjorie Malina and the editors of the journal *Leonardo*; Jean-Louis Boissier, Edmond Couchot and the members of the Arts and Technology of the Image unit at the University of Paris VIII at Saint-Denis; Shigeki Mori and the staff of the Council of the International Biennale on Art and Technology of Nagoya, Japan; Martine Moinot and Christine van Assche of the Centre Georges Pompidou, Paris; as well as to Roy Ascott, Joël Boutteville, Annick Bureaud, Jürgen Claus, Claude Faure, Hervé Fischer, Fred Forest, Don Foresta, Marc Piemontese, Florian Rötzer and Jacques-Elisée Veuillet.

Frank Popper

The author would like to thank the Musée d'Art Moderne de la Ville de Paris for permission to include in this book certain passages from *Electra*, an exhibition catalogue compiled by the author and published by the Musée in 1983.

The illustrations 65 (Dawson), 97 (Emshwiller), 109 (Hill), 242 (Harrisons), 257 (Agam), 258 (Tsai) and 259 (Shannon) are © The Council for the International Biennale in Nagoya, ARTEC, and the photos are by Akira Otaka.

Illustration 199, *Five into One*, © Matt Mullican. Co-production CNAP-Ministère de la Culture-CNBDI-Angoulême/Le Fresnoy-Tourcoing/CNC/Fonds de Soutien à la Création Audiovisuelle Régions Nord-Pas de Calais/Videosystem.

Index

Page numbers in italics refer to illustrations.